THE ARTISTS IN PERSPECTIVE SERIES
H. W. Janson, general editor

The ARTISTS IN PERSPECTIVE *series presents individual illustrated volumes of interpretive essays on the most significant painters, sculptors, architects, and genres of world art.*

Each volume provides an understanding of art and artists through both esthetic and cultural evaluations.

GEORGE C. BAUER, editor of this volume, is Assistant Professor of Art History at the University of California, Irvine, and is presently a visiting member of the Institute for Advanced Study in Princeton, New Jersey.

BERNINI

in Perspective

Edited by
GEORGE C. BAUER

A SPECTRUM BOOK

Prentice-Hall, Inc., Englewood Cliffs, New Jersey

Library of Congress Cataloging in Publication Data
Main entry under title:

Bernini in perspective.

 (Artists in perspective series) (A Spectrum Book)
 Bibliography: p.
 1. Bernini, Giovanni Lorenzo, 1598–1680.
I. Bauer, George C.
 N6923.B5B47 730'.92'4 75–31546
 ISBN 0–13–074500–6
 ISBN 0–13–074492–1 pbk.

To my mother
and the memory of my father

© 1976 BY PRENTICE-HALL, INC.
ENGLEWOOD CLIFFS, NEW JERSEY

A SPECTRUM BOOK

1 2 3 4 5 6 7 8 9 10

Printed in the United States of America

PRENTICE-HALL INTERNATIONAL, INC. (LONDON)
PRENTICE-HALL OF AUSTRALIA PTY., LTD. (SYDNEY)
PRENTICE-HALL OF CANADA, LTD. (TORONTO)
PRENTICE-HALL OF INDIA PRIVATE LIMITED (NEW DELHI)
PRENTICE-HALL OF JAPAN, INC. (TOKYO)
PRENTICE-HALL OF SOUTHEAST ASIA (PTE.) LTD. (SINGAPORE)

CONTENTS

v

PREFACE

Gian Lorenzo Bernini (1598–1680) was recognized as the foremost artist of his day. The contemporary measures of his distinction—the patronage and pleasure of princes, popes, and kings—were reflected in an unequalled European reputation whose long decline and steady restoration speak for the vitality of the art upon which it was based. As is true for other artists in this series, this critical history is described by multifarious and frequently vociferous differences of opinion. What follows, then, must necessarily be a selection. The critics whose opinions I have included make up what I take to be the major line of development in this history. They have been chosen not only for their different interpretations of Bernini's art, but also to illustrate the historical continuity upon which our modern conception of the artist is founded. I hope that the reader will recognize both what is lively in the earlier writings and what is obviously dead; if, in addition, an awareness of its historical origins helps the reader to criticize what is also dead in our own view of Bernini, the value of such a work will be vindicated.

Two, more specific factors which have guided my choice of articles should also be mentioned. First, all the articles are concerned primarily with Bernini's sculpture. A study of the critical reactions provoked by his works in architecture would read somewhat differently. In its most gross outlines, the reception received by the architecture is an inversion of that accorded to the sculpture. Classicist critics tended to look more favorably on the former than on the latter, while modern critics have tended to do the opposite. Second, I have tried to include material not readily available in English. Thus the contribution of Rudolf Wittkower, who has done so much to further our understanding of Bernini and the Baroque, is represented here by

the important collaborative work with Heinrich Brauer since his later work, written in English, is widely known.

In almost every instance the selections have been drawn from larger works that have had to be abbreviated. On occasion, the footnotes have been slightly abridged and translated. In all these instances I apologize to the authors for this necessity. I offer special apologies and thanks to Professors Hans Kauffmann and Irving Lavin. To Professor Kauffmann for having allowed me to reprint an article written a number of years ago even though his own studies of these problems has continued unabated. I urge my readers to compare his recent study of the *St. Longinus* in his *Giovanni Lorenzo Bernini. Die figürlichen Kompositionen* (1970), where the evidence of the preparatory drawing in Dusseldorf has been considered. And to Professor Lavin for allowing me to reprint only one part of his article on Bernini's death and to include his translation from Domenico Bernini in the separate section devoted to that author. For his permission to reprint excerpts in this book, I would also like to express my appreciation to Dr. Heinrich Brauer.

I am furthermore indebted, and extend my thanks, to Dr. Wolfgang Lotz of the Bibliotheca Hertziana and to the editors of Anton Schroll and Company, Collector's Editions, and *The Art Bulletin* for their permissions to include material in this book.

I also wish to thank all those who have helped me with the various problems I encountered in preparing this book. In particular, I am indebted to Lorna Cohen, who has smoothed out many of the rough spots in my English prose in her reading of the manuscript; and to Margaret Murata, who has contributed the verse translations and has given me the benefit of her expert knowledge with the other translations. To my colleague and wife, Linda Freeman Bauer, I owe more than thanks and appreciation for the critical skills and insight from which the book has benefited at every stage of its preparation. Finally, I thank Norma D'Isidoro for her expert and efficient typing of the manuscript.

INTRODUCTION

George C. Bauer

More perhaps than any other artist, Gian Lorenzo Bernini has been identified with his age. He was remarkably successful during his lifetime, and his works, which are among the most conspicuous left by Baroque Rome, have often been seen as the direct and unquestioned reflection of his era. In the eighteenth century, as the passage of time enervated and as a new critical attitude deflated the values of his world, Bernini became the obvious representative of what was taken to be pernicious and moribund in life as well as art. In a later period, when his reputation was being re-established, he still appeared, to his credit or disadvantage, as an artist whose works illustrate the values of the seventeenth century. Even today, when his purely personal and individual contribution to the creation of the Baroque style has been established beyond any doubt, this idea sometimes seems to threaten Bernini's achievement as an artist. The persistence of such a notion, however, is neither accidental nor arbitrary, for in Bernini, the seventeenth century recognized its ideal protagonist. In contemporary accounts of his life and works, reality is cut to the pattern of archetype, and his success applauded with such wholehearted enthusiasm that the image of the artist which emerges is almost that of a mythical hero.

Although apparent even in the casual comments recorded in the numerous guide books to Italy and Rome, the opinion of his contemporaries appears most clearly in the two biographies published shortly after his death. One of these was written by Filippo Baldinucci, the Florentine connoisseur and critic, for Queen Christina of Sweden, who saw to its publication in 1682. The second was written by the artist's son, Domenico Bernini, but not published until 1713. The

1

relationship between the two is an intimate one—so much so, in fact, that almost all modern scholars have accepted Baldinucci's account as the original and Domenico Bernini's as little more than a not very cleverly disguised plagiarism. Recently, however, Cesare D'Onofrio, by a careful examination of the two works, which ranges from the comparison of specific passages to the study of Baldinucci's working methods, has demonstrated that a manuscript by Domenico must have served as the source for both of the books.[1]

The life traced in Domenico's biography is compounded of clearly marked incidents and episodes which illuminate one facet or another of his father's genius. Here we meet a Bernini who, if not divine, is a child prodigy whose natural capacity suits him for the practice of any profession. Carving his first sculpture at the age of eight, by ten he is already the subject of prophecy and fame's noisy trumpet. He is an industrious and singleminded student of his art who enjoys the advantage of being gifted with preternatural ability. A series of astonishing works follow and he is recognized as the indispensable artist of the papal court. Being witty, intelligent, and devout, he is easily assimilated into the courtly hierarchy of Rome. Soon kings and popes are competing for his services, and grand projects rise under his direction. Triumph adds to triumph until, at the age of eighty-two, in the fullness of years, his life comes to an end.

Yet, if the progress and events of the biography are undeniably conventional, this is not simply the result of Domenico's desire to present a flattering picture of his father; for in the episode with Costanza, Bernini's mistress, Domenico does not hesitate to hold the artist culpable for his jealousy. Nor can one attribute the complimentary formulas entirely to the willful deceptions of the artist himself, who, in retelling his life, sought to embellish his fame; for, if evidence of this can be adduced, as D'Onofrio suggests,[2] most of what is recorded seems undoubtedly true. Instead, in an age of aulic pomp and ceremony, experience itself was subject to the formalism of convention: the witty mot, the apposite gesture, and the right demeanor were all valued as the proper means of social expression. Bernini, no less gifted in life than in art, was a master inventor of such norms in which his admirers saw reflected their own aspirations. The channeling of experience into a stylized mold cannot be better illustrated than by Domenico's account of the visit of Queen Christina

[1] See Cesare D'Onofrio, "Priorità della biografia del Dom. Bernini su quello del Baldinucci," *Palatino*, X (1966), pp. 201–8.

[2] See Cesare D'Onofrio, *Roma vista da Roma* (Rome, 1967), *passim*.

of Sweden to his father's studio. Highly flattering in and of itself, the visit was turned by Bernini and the queen into an occasion which personalized and reinvigorated an old convention without depriving it of its impersonal stylization. Bernini, surprised in the midst of his work by the arrival of the queen, appeared before her wearing his coarse working clothes, the symbol, as he explained to those who advised him to change into more suitable clothing, of the profession for which he was being honored by the queen. She, of course, instantly understood the artist's intention, and far from being offended by his crude appearance, wished to touch the garment with her own hands. In outline, this account repeats an older formula—that of the king or emperor who stoops to retrieve a fallen brush for an artist—used to praise, flatter, and enhance an artist's reputation; but here it has been consciously reinvented to fit a particular occasion. The story of Bernini's life is replete with such incidents, which, like those in a ritual, have been formed according to a pattern half real, half imaginary and ideal.

Through a combination of the overwhelming approbation received by the works of his hand and the stylized events of his life, Bernini's history was elevated beyond what was merely personal and temporal to become ideal and typical; because of this, it acquired a validity independent of the artist or his works. However later critics reacted to his art, they always had to come to terms with this ideal incarnation in which the artist always appears greater than any estimation of his art.

• • •

Domenico's biography, however, is not limited to a recitation of graceful seventeenth-century formulas. Within this framework, there is a great deal of strictly factual information about the artist's life—when he was born, to whom he was married, and so on—and about the artist himself—how he looked, what he thought and said. Although a modern historian would wish for more material of this kind, what is given is often so lively and fresh that we cannot help but be convinced that it is indeed the artist speaking or that it permits a genuine insight into his character. When Bernini went to Paris to prepare designs for Louis XIV's rebuilding of the Louvre, for example, Domenico reports not only that all Rome trembled for fear that the aged artist would be lost to them, but also that as he went through Italy "the cities were deserted, so to speak, from the desire of the people to see with their own eyes that man. . . , so that in jest he used

to say 'then the elephant traveled,' for the sight of which everyone comes running when it passes." [3]

Moreover, Domenico provides invaluable accounts of Bernini's training as an artist, of his methods of working, of the circumstances surrounding particular commissions, of the works themselves, and of their reception by the public. Along with those listed in Baldinucci's life of Bernini, the projects mentioned by Domenico form a basic catalogue of the artist's work—the necessary point of departure for any evaluation of an artist. Here, too, the range of Bernini's activity as an artist is described. Not only was he a sculptor and an architect, but a painter as well; to the normal run of draftsmanship he added a gift for caricature; and the comedies he wrote, designed, produced, directed, and acted were an exciting highlight of the Roman carnival season. Thus Domenico's biography, in both the variety and extent of the materials it offers, has been fundamental for all later Bernini scholarship.

• • •

We know today that not everyone in the seventeenth century was content to applaud the great man's success. Neither the practice nor the criticism of art in Rome at that time could be described as disinterested. Despite significant developments in the relationship of the artist to society, by and large the artist, the conditions under which art was produced, and the works themselves still occupied a fairly well accepted and widely recognized position in the social structure of the time. For the artist, powerful and wealthy patrons were the source of commissions, of position and rewards, and of fame. For the patron, artists were the ornament of majesty and great works their hostages from glory. The peculiar social and economic organization of Rome, dependent as it was almost exclusively on the papal court and on the subsequent revolutions and shifts of money and influence that attended the elevation of a new pontiff, created a high degree of instability. Throughout Domenico's biography, the deaths of the popes are treated as critical moments in the life of his father. Whether or not the new pope would look favorably on the artist meant the continuation or the end of his privileged position and its attendant rewards.

Under such circumstances the rivalry among artists for patronage was intense; and a good part of the contemporary criticism has a narrow partisan bias aimed at discomfiting a rival and, if lucky, at displacing him in the esteem of a patron who saw the works he had

[3] Domenico Bernini, *Vita del Cavalier Gio. Lorenzo Bernino* (Rome, 1613), p. 124.

hoped would be notable become notorious. The means used for this purpose were of the most varied kinds and ranged from clever phrasemaking to elaborate and learned treatises. Often the simplest means have proven the most enduring. Large numbers of anonymous jibes were secretly posted on the patient *Pasquino*, a hellenistic statue that gave its name to our own term for such lampoons—the pasquinade. Thus, whereas Domenico Bernini described his father's use of the bronze stripped from the Pantheon for Pope Urban VIII Barberini's baldachin in St. Peter's as a special dispensation of Divine Providence, *Pasquino* gave a more cynical and human interpretation: *Quod non fecerunt barbari, fecerunt Barbarini*—what the barbarians didn't do, the Barberini did.

At the other end of the scale is the diatribe written against Bernini's statue of the Emperor Constantine which stands at the foot of the Scala Regia, the entrance to the Vatican Palace designed by Bernini. It is a full-scale attack on the artist and his art couched in the language of the erudite virtuoso and abounding with allusions to ecclesiastical and classical learning, but no less biting or ruthless for all its elevated prose and humanistic imagery.

Bernini, who had great success in securing the favor of the popes and made himself the virtual artistic director of Rome, seems to have been a master of such Byzantine intrigue. Giovanni Battista Passeri, a painter and the author of a book on the lives of seventeenth-century artists, likened Bernini to the dragon in the garden of the Hesperides who, jealously guarding the apples of papal favor, "everywhere vomited poison and always sowed the way which led to the possession of high favors with the most stinging nettles." [4] Endowed as he was with the poise, easy confidence, and ready wit of the perfect courtier, the Cavalier fulfilled this role without difficulty. Referring to Borromini's radical reinterpretation of architecture, he remarked that it was better to be a poor Catholic than a good heretic; and in 1636 when he became embroiled in a controversy over the cracks which appeared in the dome of St. Peter's, he prepared a comedy for the next year's Carnival directed against those who attributed them to his incompetence. Then, in the following year, through the intervention of Cardinal Antonio Barberini, he succeeded in suppressing another comedy, by the students of the Collegio Capranica, which was intended to demonstrate his guilt.

If the artist in seventeenth-century Rome had to be constantly on

[4] Giovanni Battista Passeri, *Vite de' pittori, scultori ed architetti* (Rome, 1672), pp. 242–43.

guard against the political vagaries associated with personal or factional strife, he could at least find consolation in the fact that praise ran to the same extreme and was as hyperbolic in adulation as the censure was acrimonious in invective. Numerous poems and eulogies celebrating an artist and his work were composed with the common fulsomeness that still colors our evaluation of the period. Bernini, who even Passeri admitted maintained his superior position as a consequence of his merit, was frequently the subject of such accolades, and an astonishing eight volumes were published in praise of the Four Rivers Fountain alone.

• • •

In spite of the excess and exaggeration which inflated its contours, public criticism in the seventeenth century was supported by a fairly well articulated skeleton of critical values which were based on the work of art itself, rather than on the artist. To the vast majority of those who lived in his time, Bernini's art realized the ends dictated by the theory of art that the humanistic Renaissance had fashioned from ancient aesthetics—above all its theory of poetry. Those qualities in his art singled out for praise or blame rest upon the implicit assumption that, like poetry, the visual arts fulfill their highest purpose in the depiction of representative and noble human nature. Although neither ignored nor unappreciated in seventeenth-century evaluations, the sensuous appeal and value of his works were generally subordinated to an interest in their intellectual content, and no seventeenth-century critic can be expected to discuss his style in the way which has become routine for modern art historians. Instead Bernini was prized for his power of "invention," for his ability to translate the ostensible subject—portrait, tomb, fountain—into form in such a way that a meaningful literary theme or conceit was revealed. Like the formalization of experience, such a conceit was necessarily dependent on each individual case and the originality of the artist was identified with his striking and apt interpretations of his subjects. Thus Borboni comments approvingly on the ingenuity of Bernini's invention for the tomb of Urban VIII in which Death records the name of the pope in his book; and Domenico Bernini describes, among others, the invention underlying the uncompleted group of Truth unveiled by Time in which the artist protested his unjust disgrace and predicted his future triumph.

Borboni also reveals that Bernini's sculpture was valued for its capacity to stir the emotions of those who saw it. This concept of

expression was a fundamental part of the humanistic theory which held that art should be useful as well as pleasing and which maintained that by the depiction of the outward, physical movements which accompany human actions and passions, the artist could excite the inner feelings, and therefore influence the behavior of the beholder. Borboni remarks that on seeing the *Pluto and Proserpina* we are inspired to defend the helpless maiden; more explicitly, he states that even those mothers who resist are forced to caress their children on beholding the representation of Charity on the tomb of Urban VIII.

Logically and historically, the achievement of such an expression required a convincing imitation of nature. Domenico Bernini's account of the youthful and impetuous Gian Lorenzo laying his leg against a smoldering brazier so that he might more accurately and realistically portray the martyrdom of St. Lawrence both fulfills the demand for effective expression to be felt by the artist and guarantees the unflinching naturalism of his art. Similarly, in Borboni's description of the vivid, lifelike quality of the bust of Francesco d'Este, it is Bernini's ability to produce a realistic depiction of nature which is being praised; and this was made all the more admirable because it was done from a painted portrait of the Duke.

The idea of imitation, however, concealed within itself a contradictory notion. For in the depiction of representative human actions and passions—that is, of life not as it is, but as it ought to be—the artist could not simply hold a mirror up to nature: he had to retouch the image in order to exclude all that was merely temporal or accidental. Thus imitation as a critical concept was a two-edged sword that could sanction both descriptive naturalism and conscious idealization. The anonymous author of the diatribe on Bernini's *Constantine* takes the artist to task for both its unnatural and its too realistic representation.

Closely related to the ambiguities in the idea of imitation was the notion of decorum. This concept was the most susceptible to conflicting opinions and was ultimately to have the most far-reaching effects on the appreciation of Bernini's art. Originating in the sensible observation that to be convincing, the gesture, dress, and setting employed in a representation must conform rationally and empirically with the subject and with one another, the notion of decorum also came to be applied as a standard of decency and of moral or religious propriety. Almost all the complaints brought against Bernini's *Constantine* in the diatribe rest on one or another of these senses of decorum. In the eyes of the anonymous author, what Bernini had wrought was simply neither appropriate nor acceptable as an image of

the first Christian Emperor. One by one he recounts the artist's violations of what should be expected in such a representation and a good deal of humor arises from his lively, tongue-in-cheek attempts to rationalize them.

Of more moment historically than this irreverent broadside leveled at the *Constantine* is the brief sally the author directed at Bernini's *Ecstasy of St. Teresa*. By almost universal acclamation, it was one of Bernini's most highly regarded achievements; and a visit to see it in the church of Santa Maria della Vittoria was a highlight on the itinerary of any cultivated visitor to the Holy City. To its countless admirers, the sculpture was a brilliant and proper realization of the transport of Divine Love, but to the writer of the diatribe this most innocent of saints had been deceived by the sculptor. Instead of having shown her in the pure bliss of the seventh heaven, he accuses Bernini of having represented her in the heaven of Venus and subject to something less than spiritual passion. As the world to which the artist belonged waned in the course of the eighteenth century, this moralistic interpretation of decorum was to wax ever stronger.

The sculptor, however, would not have been so successful if the intellectual content predicated by the humanist theory of art had not been supported by the visual appeal of his work. Those who wrote about art in the seventeenth century naturally wrote in the style and followed the norms of literate expression, but they also expected their readers to see and experience the works directly. In discussing the Baldacchino, Domenico Bernini appeals to the testimony of sight; Borboni refuses to describe the Four Rivers Fountain in the Piazza Navona to avoid prejudicing anyone who may wish to see it; and one of the complaints made against the *Constantine* is that we don't know from where it should be viewed. Although in part recognizable as conventional formulas, these comments indicate an interest in the visual effects of Bernini's art at a time when adequate forms and vocabulary for its expression had not yet been developed.

The vivid naturalism of his sculptures clearly delighted his contemporaries and, as we have seen, elicited their praise. Equally appealing were the sensuous qualities of the materials themselves, of the splendid effects of bronze, gilding, and multi-colored marbles. And to these may be added an appreciation for the way in which Bernini organized the forms in order to eliminate or to take advantage of what was ostensibly an impediment. Like the unexpected conceit or, as in Bernini's comedies, the surprising inversion of aroused expectations, the overcoming of an apparent obstacle was widely regarded as the special province of true creativity. The pre-existing window incorpo-

rated into the Cathedra Petri or the exploitation of the real doorway in the conceit of the tomb of Alexander VII were, in his contemporaries' eyes, evidence of the artist's genius. From this point of view Bernini was ranked above his rivals not only for the novelty of his inventions, but for his skill at working the marble, which to his supporters and to many who came after seemed nothing short of miraculous. This attitude is well expressed in a short description, published in 1674, of the reactions of two admirers of the *Apollo and Daphne*:

> . . . but that which caused them to be extraordinarily amazed was the Apollo and Daphne, the statue sculpted by the Cavalier Lorenzo Bernini which, having contemplated it at length, they agreed was a perfect epitome of mastery. . . . And that which most astonished them (besides the exact design, grace, proportion, and the almost divine air of the heads) was seeing the ease of the execution and the chisel used in such a way that one could believe it had been cutting wax instead of marble. Not less of a spectacle to the two of them were the untrammeled hair, and the laurel leaves into which the nymph is being transformed. Both are estimable in themselves because, rather than being feigned and artificially stamped by the heavy hammer, they are separate, fine, and true; and they were as one in their admiration of it.[5]

It was therefore as the image of his age, illuminating and transforming the aspirations of those who believed him "born by Divine Inspiration, and for the glory of Rome, to bring light to that century," that Bernini saw his star rise over the seventeenth century. Yet the artist himself predicted that his star would fade, and indeed it would be some two hundred years after his death before the world would again confess with Borboni that every age has its genius. The seeds of this change had already been sown during Bernini's lifetime, and it was perhaps the vigor of their growth which inspired the artist's pessimistic reflection.

• • •

In 1664 the learned archeologist and student of art, Giovanni Pietro Bellori, delivered an academic lecture[6] in which he formulated into a coherent theory the idealistic and normative impulses inherent in Italian art. By insisting that the good artist neither freely invents nor slavishly copies nature, he affirmed the ideal conception of beauty that

[5] Luigi Scaramuccia, *Le finezze de pennelli italiani* (Pavia, 1674; reprint ed. Milan, 1965), p. 18.

[6] Later published as the introduction to his *Le vite de' pittori, scultori et architetti* (Rome, 1672).

was to prove so detrimental to Bernini's reputation. Bellori's systemization of this notion and his evident preference for Raphael and Annibale Carracci, for Domenichino and Guido Reni, seems closely related to the classicism practiced by a loosely-defined group of artists working in Rome, and it is this milieu which nurtured the germ of much of what followed. Although often inspired by the fierce competition described above, the tentative criticisms first directed against Bernini's sculpture and influence in the spirit of these artists were to become the critical platitudes of the later period. Orfeo Boselli, for example, one of the few pupils of Francois Duquesnoy, wrote an unpublished treatise entitled "Observations on Ancient Sculpture" [7] in which, with Bernini and his favorite painter Baciccio obviously in mind, he complains about the deterioration of art brought about because every commission for painting or sculpture fell into the hands of only one painter or one sculptor, both of whom he characterizes as insatiable politicians. He also objects to those moderns who criticize the drapery of the ancients as being too lean, but who, when they seek to fatten it up, end up with tripe-like pleats and with garments resembling boards. The author of the diatribe on the *Constantine* also betrays his classicist sympathies. He, too, complains about Bernini's "unnatural" draperies and condemns the statue for its lack of clear, contained contours.

But it was not until the mid-eighteenth century that Johann Joachim Winckelmann and Gotthold Ephraim Lessing, two of its chief exponents, provided the classicist viewpoint with the means for a sustained and consistent critique of Bernini's art. The sculptor's work is not directly the subject of either author's writings, but in the case of Winckelmann a polemical stance can be documented. In a letter of 4 June 1755,[8] he stated that one of the values of his recently published first work, the *Reflections on the Imitation of Greek Art in Painting and Sculpture* of 1755, was the refutation of Bernini. In the same letter Winckelmann reports that this slight essay of just over fifty pages had met with unbelievable approval; and when it came to the attention of Lessing, it inspired, at least in part, his *Laokoön* of 1766.

In the *Reflections* Winckelmann develops the ideas first set forth by Bellori, but, as its title indicates, with an important difference.

[7] See Michelangelo Piacentini, "Le 'Osservatione della scoltura antica' di Orfeo Boselli," *Bollettino del Reale Instituto di Archeologia e Storia dell'Arte*, IX (1940), pp. 5–35.

[8] Hans Diepolder and Walther Rehm, eds., *Johann Joachim Winckelmann: Briefe* (Berlin, 1952), I, pp. 175–77.

Whereas for Bellori and his contemporaries the ideal was empirical nature refined and purified, and ancient sculpture no more nor less than a cherished example of such achievement, for Winckelmann ancient art represented an ideal independent of and superior to any direct experience of nature. According to his view, the ideal beauty of ancient art was the product of Greek nature and Greek culture together; but although it was therefore temporal in its origin, once achieved, it became timeless. Being ideal, this beauty was unique and, no other solution being possible, it succeeds as the eternally valid standard for any epoch. For Winckelmann its characteristic features, both formally and expressively, were those of restraint. Greek art—known at this time almost exclusively through literary sources and Roman copies or Roman originals—was illuminated by a "noble simplicity" and "quiet grandeur." Modern works were to be judged by how well they followed the immutable laws found in ancient sculpture; without adherence to these laws, true beauty was impossible.

Formally, this demanded idealization instead of realism, intellectualism instead of emotionalism, clarity instead of ambiguity, integrity of parts instead of interconnection, and sobriety instead of richness. Applied to Bernini's sculpture, these criteria yielded a devastating critique. Although Winckelmann himself makes only scattered comments on Bernini, his hostility to the artist's style was absolute and readily apparent; his ideas spread quickly among those who thought and wrote about art, and they were not slow in pointing out to their readers how little Bernini adopted the ancient ideal. New criticisms reinforce earlier ones, and these are repeated over and over. The drapery is irrationally activated and flutters senselessly, as if stirred by a violent wind; furthermore it conceals rather than reveals the body and its movement. The figures themselves are too realistic in their detail and the portrayal of emotion and too unnatural in their artificial and affected poses. The individuality of the figure is subordinated to the effect of the whole and its contours are obscured. Noble restraint and timeless dignity are sacrificed for ostentatious pomp and display, for a brilliant effervescence which has no more substance than the momentary life of an exploding skyrocket.

What was, even in Winckelmann's time, a living, mutable tradition now became, through the classicist negation, the Baroque style, a completed cycle in the history of art. A close follower of Winckelmann, Francesco Milizia, some of whose opinions are included here as an example of fully-developed classicist criticism, joined just those artists who are still considered today the major figures of the

High Baroque style: "Borromini in architecture, Bernini in sculpture, Pietro da Cortona in painting, the Cavalier Marino in poetry are a plague on taste, a plague which has infected a great number of artists."[9] Milizia's harsh and strident refutation of Baroque art, delivered in a simple and unadorned syntax which can be contrasted with the often tortuous, involuted sentences of the seventeenth century, reveals another aspect of classicist criticism.

For Winckelmann and Milizia, Bernini's art was not only bad in a formal sense, but also in a moral sense. Bernini was no misguided naif, but a conscious corruptor of taste and morals. Like most other parts of eighteenth-century artistic theory, this attitude too can be traced back to an earlier period, but it was now given a more rigorous formulation. In the humanist tradition, art was intended to instruct as well as delight. It was therefore invested with a high moral purpose and a potential power which might be exercised for good or ill; the artist assumed a moral responsibility for what he created and the critic for guiding him into the proper paths. In the earlier period these responsibilities were normally satisfied by the representation of significant human action, by showing man not as he is, but as he ought to be; when necessary the idea of decorum could be evoked to control and chastise what was untrue, misleading, or vulgar.

At the end of the seventeenth century and in the course of the eighteenth, however, the idea of decorum came to play a more and more important role in art criticism; little by little it worked itself free from its original purpose of insuring a convincing illusion of reality and assumed the role of a moral arbiter, insuring that what was represented was not so much correct in terms of naturalism as it was "proper" in terms of morality.

In the hands of Bernini's critics, this moral interpretation of decorum served two purposes in denying his style. On the one hand it offered a way to repudiate works whose subjects, unlike those of, say, Rembrandt, were not considered vulgar nor mean in themselves; and on the other it offered a means for dealing with an artist whose works were distasteful, but whose genius, skill, and success had been placed beyond dispute by the universal assent of his contemporaries. The former is best understood in the example of the *St. Teresa*. As we have seen, the sexual connotations of its expression had already been criticized in the seventeenth century. Now they were taken as its dominant characteristic, and Bernini was condemned out of hand for his license in representing Divine Love in the guise of a boudoir

[9] Francesco Milizia, *Dizionario delle Belle Arti* (Bassano, 1798), p. 114.

voluptuousness. Such overt evidence of corruption on the part of the artist was well suited to the latter purpose of rationalizing his success.

Along with everything else classicist art theory adopted from earlier periods was the notion, already stated by Vasari in regard to the Middle Ages, of periods and styles in which art languishes and decays. For Winckelmann and his followers, the art of Bernini and its later developments represented just such a decline whose cause was to be found in the corruption of the artist himself. Willfully and vainly, they claimed, he scorned the true laws of beauty to pursue his own caprices. "His gifts," Milizia writes, "were brilliant vices." In these writings, the heroic image of the artist held by his contemporaries was recast to create a darker, almost demonic one. Bernini appears here as the insidiator of the innocent whom he dazzled with his brilliance. It was now possible, as it were, to give the devil his due. Endowed with all the advantages and none of the virtues, Bernini's genius could be admitted, while his success and influence were decried on every side.

The final link in the critical ring, which was built up over a hundred years to contain the force of Bernini's genius, was placed by Gotthold Ephraim Lessing. The humanist theory of art had been founded on the notion that painting and poetry were closely related, indeed in some ways almost identical. Depending on the innocent analogies drawn between the two arts in the literature of antiquity, Renaissance critics appropriated large parts of ancient literary theory to describe the nature and purpose of the visual arts. Within reason such an approach was often illuminating; but in the end, a serious confusion of the aims and means appropriate to the two arts developed, in which the idea that painting was a mute poem and poetry a speaking picture threatened to do violence to both arts. Shortly after the middle of the eighteenth century, Lessing set out to re-examine the whole issue. In his *Laokoön* of 1766, he attempted to establish the inviolate boundaries between the two arts which could not be transgressed without destroying their respective beauties. The result was the final means employed by the normative art theory of the eighteenth century for the negation of Bernini's art.

Beginning with Winckelmann's observation in the *Reflections* that Virgil's Laocoön howls in pain, whereas in the famous statue in the Vatican he only utters an anguished groan, Lessing proceeds to explain why such a difference is not only proper, but lawful. For the sculptor to have given Laocoön the vehement expression required by a scream, he writes, would have been wrong for two reasons. First, because insofar as expression approaches distortion, it encroaches upon and violates beauty, the eternal law of art; and second, because

the visual arts, unlike poetry, can represent only a single moment and often only a single view. This moment, therefore, must be chosen with extreme care so that it is the most potentially effective over a long period and repeated viewing. And it follows that such a moment can only be one in which the imagination is allowed to play some part. With an image of extreme passion, which a screaming Laocoön would present, there is nothing beyond it; our imagination is fettered to what we see represented and our emotion quickly exhausted. For the same reason, the moment chosen cannot be one which is completely momentary or transitory: the pleasing smile becomes a leering grin, the suffering scream an empty declamation.

Even a cursory survey of Bernini's works reveals what effect such a doctrine must have on the appreciation of them. From the tensed, highpitched instantaneity of the *Apollo and Daphne* to the hallucinatory, passionate anguish of the *St. Teresa* and beyond, there is scarcely a work by Bernini which does not openly contradict Lessing's notion of the true nature of sculpture. Nor was it long before his ideas became widespread. Offering, on the one hand, a timely differentiation of the arts, and on the other, ideal, inherent laws for visual representation rooted in the example of ancient sculpture, his work found an eager audience. In a selection included here from the travel book of John Moore, Lessing's ideas are applied to Bernini's *Apollo and Daphne* so faithfully that it could have been included as an illustration in the *Laokoön* itself. The statue group which in the seventeenth century had amazed and delighted its viewers for its sheer technical virtuosity and breathtaking naturalism now seemed artificial and, above all, void of any profound or serious content—of true beauty and truth as they appear in ancient sculpture.

The ideas of Winckelmann and Lessing provided the basis for the criticism of sculpture up to and into the twentieth century. This may be contrasted with what happened with respect to painting. Even in its early history, the criticism of painting had evolved a more flexible critical apparatus which recognized and incorporated formal features associated with the styles of different artists, such as Michelangelo's drawing, Correggio's grace, or Titian's color. Although not unaffected by the great interest in antiquity characteristic of classicism, it continued to develop in the following centuries. Sculpture, on the other hand, was now circumscribed by the single standard of antiquity and, concordantly, by the notion that the nature of sculpture, bound to a physical, material substance demanded such a standard.

• • •

Although now equipped to deal with the question of Bernini's art in well-defined critical terms should the occasion arise, most writers preferred the less subtle, but equally effective criticism of simply ignoring it. Such an attitude is in harmony with the moral conception of art. It can already be found in Raphael Mengs, the neo-classicist painter, who was Winckelmann's friend and collaborator and who wrote in an undated letter to the French sculptor, Falconet, that the art of Bernini deserved no attention.[10] A long line of critics, who systematically excluded any mention of the artist except when it was unavoidable, would have agreed with him. As a result, there was very little written on Bernini's art from the middle of the eighteenth century to the beginning of the twentieth; and what was written is often little more than an elegant or indignant variation of what had been said before.

Yet Bernini's works were not so easily put out of mind, simply because they could not easily be put out of sight. Until Lord Elgin's removal of the Parthenon marbles to the British Museum at the beginning of the nineteenth century, and even after, the path to antiquity lay South to Italy—to Rome, Pompei, and Herculaneum; and no visitor to the Eternal City could completely ignore the art of Bernini. St. Peter's, then as now, from the Ponte Sant'Angelo to the Cathedra Petri, is largely an experience created by Bernini's works; and the Villa Borghese, a necessary stop because of its collection of antiquities, also contained Bernini's early works—the *Aeneas, Anchises, and Ascanius,* the *David,* and the *Apollo and Daphne.* And, as if to confirm the fears of the classicists, there were those who, in spite of the prevailing dogma, found themselves charmed. Gabriel Francois Coyer wrote in 1776 about Bernini's early sculptural groups that:

> . . . all these pieces of modern sculpture have given me, or very nearly, an impression as lively as the marvels of antique sculpture. The enthusiasts of antiquity will pardon this error as the bad inclination of my senses.

And about the *St. Teresa* that:

> I must once more exclaim in admiration on a marvel by Bernini at *Santa Maria della Vittoria.* It is Saint Teresa in ecstasy, at the moment that a Cherubim at the flower of the age of men, beautiful of a beauty more than human, discharges an arrow of fire into her heart; one sees her fallen on her back, the breast expanded, the chest elevated, her breathing interrupted, all the nerves excited, the ecstasy marked in her eyes, in the perturbation of her face, of all her person, of her

[10] Uhde Bernays, ed., *Kunstlerbriefe über Kunst* (Dresden, 1928), p. 250.

clothing, which exposes a naked leg. The expression of the pen would not know how to respond to the expression of the chisel.[11]

His delight in the *St. Teresa* was then confirmed by an impressive following of his countrymen—Stendhal in 1829, Taine in 1865, and Zola in 1896.[12]

In Italy itself, Paolo Mazio, after arguing that Domenico Bernini's biography is both factually accurate and just in its estimation of his father's merit and achievement, goes on to say:

> And after all, coming to my point, what would help to aggrandize the virtue and exaggerate the genius of Gian Lorenzo? His works survive— the grand peristyle which crowns the basilica of St. Peter's like a ring of glory, the Confession and the Cathedra which are the most stupendous structures of bronze that have been made in modern times, the Navona fountain, the group of Apollo and Daphne, and a hundred others—and demonstrate with a voice as efficacious as veracious, the artistic power of Bernini.[13]

More easily imagined than proved in such a strong espousal of Bernini's art is the growing strength of Italian nationalism which could not afford to deny so dazzling a forebear. Still, it may be worth mentioning in this connection that in the same year, 1844, the journal which had published Mazio's article announced a project to honor one hundred outstanding Italians by striking commemorative medals, and that among the ten artists to be so honored was Gian Lorenzo Bernini.

However this may be, by the mid-nineteenth century, Italian critics were beginning to face a dilemma. One horn of the dilemma demanded a negative appraisal of the artist's works on the basis of the prevailing structure of critical values used to judge works of art. The other horn was more complex, but demanded a more positive evaluation of the artist in general. It included not only the often favorable impact of the works themselves, but a new notion of Bernini as a historical phenomenon stimulated by the development of history as an empirical discipline. In the hands of the great German historian, Ranke, as well as his contemporaries and his followers, a new conception of historical method had been created which sought to be rigorously empirical in its relationship to the past. The historian was to be impartial and scientific, his evidence tried and tested, and history itself truthful and objective. Such a history which sought, in Ranke's

[11] Gabriel Francois Coyer, *Voyage d'Italie* (Paris, 1776), pp. 9–10.

[12] See below in the selection from Walther Weibel, pp. 84–85, 91.

[13] Paolo Mazio, "Memorie inedite della vita di Gianlorenzo Bernini," *Il Saggiatore*, I, No. 2 (1844), p. 339.

phrase, to present things as they were *(wie es eigentlich gewesen)* tended to free the study of the past from the tyranny of present passions, and every period thus became equally worthy of impartial scrutiny. Although on the level of aesthetic appreciation such a notion could not affect the values used to judge the artist's works, on the strictly historical level, it could and did spur a new interest in the artist from a purely factual point of view. A trickle of articles began to appear which simply published some newly discovered factual knowledge on Bernini or his work. The most important of these was L. Lalanne's publication in 1885 of the diary kept by Paul Fréart, Sieur de Chantelou, during Bernini's visit to Paris in 1665. Filled with fascinating descriptions of Bernini's activities and opinions, it is an invaluable source for our understanding of the artist. This line of thought which recognizes Bernini's importance as a historical phenomenon, almost in spite of his art, culminated in 1900 with the publication of Fraschetti's monograph on the artist, which is an extensively detailed and documented account of his life and work. Confronted with this dilemma, some adjustment of its two terms was necessary which would do justice to them both.

The answer to this problem was proposed long before Fraschetti undertook his work. In 1853, Q. Leoni, in an article on the Baldacchino by Bernini in St. Peter's, makes the following observation:

> Whoever sets himself to consider coolly how many difficulties a work of such nature presents and what an arduous undertaking is the making of a monument, unique for its conceit and beauty, which is in perfect proportion and harmony with another monument boundless in its great vastness, will easily comprehend of what singular genius and what certain judgment Bernini had need; and certainly will weigh with great indulgence those defects which escaped the notice of the artist, and should be attributed more to those times, than to a depravity of his taste.[14]

By shifting the responsibility for what from the classicist point of view were considered defects in Bernini's works—Leoni describes himself as an "admirer of the good and classical style"—from the artist to his times, it was possible to affirm the artist's undeniable genius and historical importance without upsetting the general system of values used to judge a work of art. Similarly, an observer like George Hillard, who admired the virtuosity of Bernini's early works in the Villa Borghese yet rejected his later, more overtly "Baroque" ones in St.

[14] Q. Leoni, "Il Baldacchino del Bernini nella Basilica Vaticana," *L'Album, Giornale letterario e di Belle Arti*, XX, No. 35 (1853), p. 263.

Peter's, came to the same conclusion. Thus still another image of the artist emerged, and, like its predecessors, it reflects its age. In the seventeenth century Bernini was the cultural hero who shaped and affirmed society; in the eighteenth century he was the evil magician who used his gifts to corrupt and destroy; now in the nineteenth century he was endowed with the Romantic notion of ineffable genius in constant tension with a restrictive, unworthy age which prevented him from realizing the highest goals.

It is in this guise that, on the threshold of the twentieth century, Bernini reclaims his place in the affection of his countrymen. In 1898, for the three-hundredth anniversary of the artist's birth, commemorative celebrations and a major exhibition of his work were planned in Rome. On the anniversary of his birth a memorial plaque was affixed to the house in which it was believed he had lived; and on the afternoon of the same day a solemn convocation was held on the Capitol in the Palace of the Conservators.[15]

Two years later, in 1900, Stanislao Fraschetti published his monumental life of the artist. Painstakingly documented with hundreds and hundreds of notices from published and unpublished sources, it presented Bernini as a fully rounded, historical personage, and is without question the cornerstone of modern Bernini studies. For the first time the works mentioned by Domenico Bernini, Baldinucci, and others were given a documentary foundation which established their chronology, as well as their work histories. Thus it was now possible to follow both the development of individual works and that of the artist himself. Yet this signal advance in historical knowledge about the artist was contained in a critical framework that can be traced back through Milizia to Winckelmann and Lessing. For Fraschetti, Bernini's best works are the early ones which most nearly conform to the ideal of ancient sculpture, but which have been transformed by his genius: "In the equilibrium of this nobly blended union, he attained excellence; and, if the century had not deceived him in its sinister flame, as in the glare of a fire, he would have produced grand and much more marvelous things." [16] Fraschetti's monograph is good evidence that, in and of itself, history, no matter how finely wrought its net, cannot adequately contain aesthetic phenomena. The recognition of Bernini as an artist, therefore, must be sought in a different direction—one which, perhaps surprisingly, begins with Winckelmann.

[15] See Stanislao Fraschetti, "Corriere Romano," *L'Arte*, I (1898), pp. 467–68.
[16] Stanislao Fraschetti, *Il Bernini* (Milan, 1900), p. 328.

. . .

As conscious as Winckelmann's rejection of Bernini and the Baroque had been, it was only a minor part of his purpose. That purpose, of course, was the description and interpretation of the art of antiquity; and it is in his most influential work, the *History of Ancient Art*, that the idea of a history of art which sought to show its "origin, progress, change, and development" appears for the first time. By treating the art of the ancient world as the product of climatic and cultural conditions, he laid the basis for our modern conception of art history as a succession of styles, each with its own dynamics and expression. Thus in the course of time the external standard, imposed on later art by Winckelmann himself, began to give way to an internal standard in which the values are immanent in the particular style. Although no less subjective in the end, this notion of style provides criteria to judge a work of art which are not ideal and universal but individual, and responsive to the infinite variety of past events.

Encouraged by the work of Winckelmann, Herder and others of the Romantic era rehabilitated the long-despised Middle Ages. Herder also developed the notion that to understand the unique and constantly changing phenomena of the past the historian must rely on his intuition rather than on abstract principles or general laws. It was, however, in the work of the great Jacob Burckhardt that these ideas as an approach to cultural history were fully developed. His comment in the introduction to part one of his now classic *Civilization of the Renaissance in Italy* that, in other hands, his studies might have led not only to a different treatment, but to different conclusions as well, is at once a vindication of Herder's demand for empathy and a rejection of Ranke's ideal of an objectively verifiable past.

Burckhardt's relationship to Baroque art was a complex and ambiguous one. Like Winckelmann before him, he genuinely appreciated the merits of the Flemish painter, Peter Paul Rubens, but he could not accept Bernini. The reason for this is partly explained by his comments on sculpture in his *Cicerone* of 1855, a guide, as its subtitle explains, "for the enjoyment of art in Italy," but really a history of Italian art. For Burckhardt, sculpture was bound to its material substance and, consequently, subject to intrinsic and universal laws. Once again, and for reasons now familiar, Bernini's art was judged negatively; yet at the same time, the style of Baroque art was defined with new clarity and treated historically. Burckhardt organized the criticisms which had been directed at the Baroque to describe a consistent mode of expression which was the result of both the

individual (Bernini) and general conditions (history, sculpture itself).

According to Burckhardt, sculpture between roughly 1630 and 1780, as a consequence of various historical circumstances, adopted qualities commonly associated with painting and has two major characteristics: naturalism of representation and the expression of emotion at any price. The "man of destiny," as Burckhardt calls him, in this development was Gian Lorenzo Bernini. Because of both the sensitivity and the consistency of Burckhardt's explication of these ideas in the sculpture of Bernini and those who followed, the *Cicerone* provided later art historians with a formal description of the Baroque upon which more positive interpretations could be based.

In the work of Heinrich Wölfflin, Burckhardt's student, the notion of style was to become more and more independent of concrete cases and individual artists. Neither the artist himself nor what he represented was as important as a supposedly autonomous mode of seeing and representation. In Wölfflin's conception of art history, which explicitly rejected the individual creative act and its consequences, Burckhardt's description of seventeenth-century style was refined into an abstract, neutral entity stripped of its negative connotations. Set in opposition to that of the Renaissance, Baroque style as defined formally by Wölfflin became a contrary, but equally consistent and legitimate mode of visualization.

Walther Weibel, again starting from Burckhardt, took the opposite line by infusing Burckhardt's description of Bernini's style with a new content. For Burckhardt, as for Milizia and Hillard, the seventeenth century was largely an era of empty pomp and splendor, and its art aimed at or submitted to these goals. Weibel, in his *Jesuitism and Baroque Sculpture in Rome*, argued that Bernini's style was an expression of the cultural experience of the Catholic Reformation. Instead of interpreting the formal characteristics of the artist's sculpture as willful exaggerations and arbitrary theatrics, he saw them as meaningful elaborations of the religious climate of the period. For Weibel, the self-conscious forcefulness of Bernini's art, founded on its naturalism and heightened by its expression of emotion, was inspired by the desire—also recognizable in the Catholic literature and public sermons of the day—to create the strongest impression on the observer, and thereby to exert the greatest moral and religious influence. All those features which had repelled earlier critics were now reinterpreted in the light of a sincere religious expression and given a positive value. Thus to take one example, Bernini's drapery style, which had seemed so inexcusably capricious to his classicist critics, was explained by Weibel, as it is today, as an attempt to

heighten—through active, movemented surfaces—the emotional content of the figure. Although criticized, generalized, and refined in various ways, Weibel's analysis of the form and content of Bernini's sculpture as the legitimate expression of the aims and ideals current in seventeenth-century papal Rome has provided the intellectual assumption underlying subsequent studies of the artist.

• • •

As we have seen, new ways of thinking about the artist had sometimes been provoked in direct response to an occupation with the art itself; but by and large the motivation for such changes must be sought in collateral changes in the way people thought about other things. This is, of course, a quite natural state of affairs, and it continues in the twentieth century. But now new approaches to the artist reflect the general interests of modern art historical studies.

The classicist critique of Bernini's art had proved to be remarkably elastic and tenacious. Once fully established in the mid-eighteenth century, the criticisms of his art which it contained were as readily raised by the followers of Ruskin as by the followers of Winckelmann; both admirers of the gothic and admirers of antiquity were united by their common distaste for Bernini and the Baroque. In the meantime, however, the philosophical and methodological approaches to art which constitute modern art history were being developed. When Bernini again appeared as an artist worthy of serious attention, art history had become a recognized intellectual discipline whose object of study was a product of the past which is nevertheless directly experienced as meaningful and significant in the present. Thus Bernini's art was now approached as a subject of both historical and aesthetic interest, and the historical and critical methods employed in its study were generally those common to art history as a whole.

The documentary studies initiated so successfully by Fraschetti were carried on by Pollak, Golzio, Incisa della Rochetta, Battaglia, Faldi, and others, and still continue today. Closely related to these kinds of studies was the new, critical reading of earlier sources, such as Alois Riegl's important translation and commentary on Baldinucci's life of Bernini. Through these efforts and the simultaneous identification of previously unrecognized works by the artist, the extent and sequence of Bernini's career has become increasingly clearer, and Wittkower's exemplary monograph on the artist has now given it a more or less definitive shape.

By providing an accurate chronology of the works, such studies

have encouraged a more rigorous analysis of the artist's style. Up to the twentieth century, criticism had treated Bernini's style in an ideal way, as the more or less fixed and permanent expression of the artist, equally valid for all of his works. Now this idea of style was subjected to a greater differentiation and treated genetically; categories of works were examined; and relationships between his art and that of his contemporaries critically analyzed. The process of differentiation affected not only Bernini's career as a whole or certain parts of it, but individual works as well. Fraschetti had published documents which often allowed the execution of a commission to be followed step by step from inception to completion, but in general he had been content with only the historical value of this information. Its critical importance was established in 1931 when Heinrich Brauer and Rudolf Wittkower published their monumental study of Bernini's drawings in which the style and meaning of his art were explained in terms of its genesis. Through a sensitive and rigorous interpretation of the drawings that made use of documentary and published sources, the authors analyzed and illuminated each work discussed as the result of a developmental process comprising ideas, problems, and choices. The meaning of a particular sculpture was thus removed from the isolation of its final state because it contains within itself the resonance of its development. In these pages, the work of art becomes the physical shape and form of intangible ideas and values that have been ascertained in their changes and modifications, and Bernini appears as an artist possessed of a fully creative intelligence in the modern sense.

Both an interpretation of the preparatory process and Weibel's assertion that Bernini's art was the expression of the culture of which it was part suggest the need for investigations which would reveal what it was that the artist and his patrons intended to say—that is, for iconographic studies. The volume dealing with the seventeenth century in Emile Mâle's fundamental iconographic survey of Christian art appeared in 1932; and subsequently Battaglia, Hecksher, Hibbard and Jaffe, Panofsky, and Wittkower, among others, have enriched our understanding of this aspect of Bernini's art. In the hands of Hans Kauffmann, however, iconography has become the basis for a fundamentally new approach to the artist's works. In a series of articles, and most recently in his book on Bernini's figurative sculpture, Kauffmann has studied the sources of the artist's work with the same sensitivity and high critical standards that had characterized Brauer's and Wittkower's earlier treatment of the drawings. Since formal conventions often accrue specific meanings which become independent of a particular narrative context, Kauffmann's analysis of such conventions

in Bernini's sculpture is a telling guide to the artist's intended meaning which is based directly on its formal presentation. Through the interpretation of the formal traditions and conventions upon which it depends, the individual form acquires a new context which reveals new insights into the way form and content mutually condition each other in Bernini's creation of a work of art. Thus in Kauffmann's studies of Bernini, meaning and its presentation are seen as the single expression of the same act of artistic creation.

The final selection included in this anthology, Irving Lavin's important study of Bernini's composition of the *Blood of Christ*, is also concerned with formal traditions. The discussion, however, is not restricted to those conventions which pertain to the formal vocabulary of the work of art; it is extended to include the conventions which, as we have seen, frequently formed the framework for the artist's life. Through his investigation of Bernini's death, Lavin has created—by merging both biographical and formal conventions—a remarkably vivid picture of the social and psychological roots of one of Bernini's most personal, but paradoxically, most public works. As Lavin demonstrates, Bernini had this composition engraved so that he might "give it to everyone and send it across the world." Never, perhaps, was Bernini truer to what he himself had become than in this sentiment of his old age; for in its blending of individual aspirations and public concerns, we can recognize the historical image of the artist which he and his contemporaries had combined to create.

THE LIFE OF THE
CAVALIER GIAN LORENZO BERNINI

Domenico Bernini

In the city of Naples on the seventh of December in the year 1598, Gian Lorenzo Bernini was born to make two centuries celebrated by his life. He was instructed with excellent discipline in the first rudiments of literacy by his father Pietro, a native of Florence, and his mother Angelica Galante, who was born in Naples. But since his father was in Naples at the pleasure of the viceroy who wanted him to make some sculptures for the embellishment of the royal church of S. Martino, Gian Lorenzo, too, from the very beginning, also began to be so enchanted with this profession that he often abandoned his childish pastimes to spend entire hours gazing at the statues without stirring; and at the age of eight, to prove himself, he made a small marble head of a little angel. Such initial deeds did not fail to arouse the admiration of his father who then well understood that he should not imagine for him other expectations than great ones. Therefore perceiving in the boy a most noble notion of, and a capacity for, any profession whatsoever, he devoted himself to providing him with such things as most readily suited his inclination. . . .

But since the vivid example is usually the incentive and the guide of behavior, and because a coal nearby cooks more than the entire sun far away, it easily happened that Gian Lorenzo, seeing his father inclined to work in sculpture, also gave way to his own inclination for this occupation, and he declared his desire to learn its principles from

"The Life of the Cavalier Gian Lorenzo Bernini." From Domenico Bernini, *Vita del Cavalier Gio. Lorenzo Bernino* (Rome, 1713) (excerpts); trans. by George C. Bauer. The section on Bernini's death, trans. by Irving Lavin, from "Bernini's Death" by Irving Lavin, *The Art Bulletin*, LIV, No. 2 (1972), pp. 160–62. Reprinted by permission of the author and publisher. See below, pp. 111–26.

him. It is unbelievable how much more the father, his mind taken by the rare qualities of the son, then strove to instruct him; but he quickly perceived that the principles which others usually understand through study were in Gian Lorenzo innate, and it seemed that what others acquire with toil he had obtained as a gift of nature; for he immediately recognized in him a marvelous aptitude for the cognition of beauty and, moreover, an equal talent for realizing it in design. . . .

In such a theater of virtuosi Gian Lorenzo appeared for the first time at the age of ten; and since, by itself, virtue opens the way to distinctions and honors, it was not long before . . . Cardinal Scipione Borghese, having learned of the arrival in Rome of Pietro Bernini with his family, sent for him and commanded that on the following day he bring to the palace Gian Lorenzo whom fame had already represented in that court as superior in spirit to the age he presented. And the result was not less than the expectation; because at the reception given him by the Cardinal, he carried himself with such a mixture of vivacity and modesty, of submission and alertness, that he captivated the mind of the Cardinal, who immediately wanted to present him to the Pontiff. Gian Lorenzo was not at all discomfited to see himself admitted to the majesty of the Pope; instead, with bold face and firm step, as if the course of long years had accustomed his sight to the splendors of that Throne, he knelt to kiss the Pope's foot and devoutly requested his blessing. The Pontiff, venerable by nature in appearance, wished to try the courage of the boy by affecting terribleness, and, facing him, he commanded in grave tones that there, in his presence, he should draw a head. Gian Lorenzo picked up the pen with confidence and smoothed the paper over the little table of the Pope himself. Beginning to make the first line, he stopped, somewhat uncertain, and then, bowing his head modestly to the Pontiff, requested of him "what head he wished, if of a man or a woman, if young or old, and if one of these, with what expression he wished it, whether sad or cheerful, scornful or agreeable?" "If this is so," the Pope now added, "you know how to do everything." And he ordered him to make a head of St. Paul. With a few strokes of the pen and with an admirable boldness of hand he completed it with such mastery that the Pope was lost in wonder and only said to some of the Cardinals who were there by chance, "This child will be the Michelangelo of his age." He embraced him with the tenderness of affection, opened a casket which contained gold medals bearing his imprint, and indicated that he should take as many as he could. Gian Lorenzo demonstrated his appreciation for that honor, but also consenting to obey, he took twelve, which were only as many as he could take with his little hands.

Those medals are still preserved as a memento of the event in the house of his children. . . .

But Gian Lorenzo did not therefore allow his head to become swollen; and in him praise served only as the stimulus to work—because applause, which is wont to make others vainly satisfied with themselves, aroused in him the most burning desire to make himself more worthy of it by his deeds. Therefore realizing that Rome offered him a wonderful occasion to further his education through the diligent study of the precious relics of ancient sculpture, it is unbelievable with what assiduity he attended their school and with what profit, moreover, he understood their instruction. For a period of three years, he left each morning from S. Maria Maggiore, near which his father Pietro had built a commodious house, and went on foot to the Vatican Palace at St. Peter's; there, until sunset, he entertained himself, now with one, now with another of those wonderful statues which antiquity has handed down to us and which time has preserved for the benefit and dower of sculpture. . . .

Out of devotion to the Saint whose name he bore, he wanted to portray, in marble, the nude St. Lawrence being burned on the gridiron: and in order to adequately represent the effect that the fire should have on the flesh and the agony of martyrdom on the face of the saint, he placed himself with his bare leg and thigh against a lighted brazier. Experiencing in himself the martyrdom of the saint, he then drew with lapis the painful movements of his face from their reflection in a mirror, and observed the various effects on his own flesh as it was altered by the heat of the flames—a much more worthy act than that of the ancient, Scaevola, who placed his hand in the fire as a consequence of having erred, because our Gian Lorenzo burned his flesh out of a desire not to err. Pietro, his father, arrived home and saw his son in that act of martyrdom and, recognizing the reason for it, he wept tenderly, perceiving in him, still young and tender at the age of fifteen, so great a desire for virtue that to attain it, he portrayed in himself the torment of a true St. Lawrence, to sculpt a fictive one. . . .

But the execution of the statues destined for the Palace of the Villa [the Villa Borghese] were of greater concern in the mind of Gian Lorenzo. He considered the obligation he assumed in fulfilling the orders of the Pope for the decoration of one of the most famous villas of Europe. The villa is located outside the ancient Porta Collina, that is to say, Pinciana; it is completely surrounded by walls which enclose space for a most noble garden five miles around. At the center and one half rises a palace designed and built by the Fleming, Jan van Zanten,

and completely encrusted with ancient bas-reliefs. Inside there is almost a whole people of ancient statues, almost all intact, which were preserved for us from the fury of the barbarians by the same ruins of Rome. Of these, the *Seneca in the Bath*, the *Venus and Cupid* believed to be by Praxiteles, the *Gladiator* of Agasias, the sculptor of Ephesus, the *Hermaphrodite* rediscovered in the Gardens of Sallust near the Quirinal Hill during the papacy of Paul V, and the head in bas-relief of Alexander the Great hold first place among the principal ones; and it was there that he had to place his own. His emulation of such celebrated artists, the comparison of their works, and the expectation of everyone created in Bernini great apprehension for the undertaking. But his mind, lover of arduous and noble endeavors, did not doubt of success, and he resolved to make four statues, any one of which alone would have worthily occupied any ancient artist. One was the group of Aeneas, Anchises and Ascanius who flee from burning Troy with the Penates; another was the *David* who is in the act of delivering the blow from his sling against the giant Goliath; the third was the group of Daphne who flees from Apollo, her insidiator, and who is being delightfully transformed into laurel; and the last was that of Pluto abducting Proserpina, which represents an admirable contrast of tenderness and cruelty. And what, besides the symmetry of each of them, caused extraordinary amazement in the critics of that time was that he brought all four, each larger than life, to perfection in the period of only two years. When in their astonishment many questioned him about this, he used to reply "that when working he felt so ardent and so enamored of what he was doing that he did not work the marble but devoured it"; and as he later said in his extreme old age "in his youth he never struck a false blow." So much was he then superior in art. Indeed, it happened that, entering the villa one day with Cardinal Antonio Barberini forty years later and sighing at the sight of his works, he exclaimed, "Oh what little progress I have made in art, when as a youth I handled the marble in this way!" What perfection and mastery is contained in each of these four statues must rather be judged by the eye on seeing them, than described by the pen with the vain exaggeration of words. . . .

Meanwhile, at the end of January in the year 1621, Pope Paul V died; and it was not so much the memory of the dead Pope, which is always diminished by the novelty of his successors, as anticipation of the future government which caused great agitation in the court of Rome. Gian Lorenzo, who recognized the Pope as his first benefactor (the title by which he was later always wont to call him), wept for the common loss which was also his own; he was uncertain too of the

person to whom the future election might fall. But his spirits quickly brightened at the elevation to the Pontificate of Cardinal Alessandro Ludovisi. . . . Nor was it long before he [i.e., Pope Gregory XV] desired to honor him with the title of Cavalier and with the arms of Christ. This first demonstration by the Pope towards him and the honorable rank to which he was raised increased the Cavalier Bernini's reputation among the people and made him more eager to continue his studies, so that, as if he were only beginning, he showed himself so indefatigable and so alienated from every other amusement, even though licit, that he later used to say "he had not recognized during his first twelve years in Rome any other path than that which led to his usual study."

Gregory died . . . on the eighth of July, 1623. After slightly more than half a month, the Cardinals secluded in the Conclave easily recognized the merit of Cardinal Maffeo Barberini who, on the seventh of August, was unanimously elevated to the Pontificate. Then at the still youthful age of fifty-five, with a lofty spirit and a noble mind, he was thus that much more capable of illustrious and glorious deeds. On the same day as his creation, he summoned the Cavalier and said to him: "It is your great fortune, oh Cavalier, to see Cardinal Maffeo Barberini pope, but much greater is our own that the Cavalier Bernini lives during our Pontificate." And from that first day, he declared his wish to be treated by him with the same familiarity with which he had been treated by him in the state of Cardinal. . . .

But Urban, who esteemed him more than any other, did not want to lose a moment in appropriating the virtue of the Cavalier for the advantage of his papacy. Therefore, being a prince of grand and glorious ideas, he nurtured in his mind great thoughts and the most noble action. Consequently, in order to execute the many things he intended to do, and judging him apt and capable of receiving any excellent impression whatever, he ordered him, from the very beginning, to devote a part of his time to the cultivation of painting and architecture, eager that his faculty for these arts be equal in distinction to his other virtues. Bernini did not hesitate to approve the counsel and to follow the orders of his beneficent pontiff; nor for the former did he avail himself of any other master than the ancient buildings and for the latter than the modern paintings of Raphael, which, in his words, were like so many paid masters for whoever desired to apply himself to similar studies. For two full years, therefore, he applied himself to painting. And although, during his earlier studies, he had overcome all the difficulties presented by design, he then devoted himself to nothing but the manner of coloring;

and these, which we call his studies, were of such an exquisite manner, both in their coloring and their design, that they are the equal of the chief figures done by the most celebrated artists of his time.

. . . Two portraits of his mind and hand remain famous above all. One of those is preserved in the Casa Bernini and the other in a more worthy theater, that is, in the famous Hall of Portraits of the Grand Duke which contains works by the most distinguished painters, all by their own hands. In the Casa Bernini is to be seen the much praised portrait of Costanza, and in the Gallery of the Grand Duke, the bust, in marble, of the same woman. Both are of such fine discernment and so vivid a manner that, in the copies themselves, the Cavalier made appear how much he was enamored with the original lady. He was then inflamed with desire for this woman, because of whom, if he remained in part culpable, he nevertheless succeeded in being declared a great man and one excellent in art. Either jealous of her or losing his head for another reason (since love is blind), he imposed upon one of his servants, giving him I know not what affront, though for having been public and damnable, it followed that he ought to be penalized with no negligible punishment. The Pope, apprised of the deed, ordered that the servant be exiled, and through his Chamberlain, he sent to the Cavalier an absolution of his crime written on parchment in which appeared a eulogy of his virtue worthy of being transmitted to posterity, because in it he was absolved for no other motive than that he was excellent in art; nor was he called here by any other titles than those of "rare man, sublime genius, and born by Divine inspiration and for the glory of Rome, to bring light to that century."

Nor should one ignore that at that time, and later, he worked especially in that kind of design which is commonly called caricature. This was a singular consequence of his spirit; for in these drawings he deformed, in jest, the effigies of others—but in those parts where in some way nature had been wanting. And without destroying the resemblance, though one part is exaggerated and caricatured, he rendered them on paper most lifelike, and what in substance they were. This kind of invention was rarely practiced by other artists since it is not everyone's forte to draw beauty from the deformed and symmetry from the disproportionate. He made many of these, and for the most part he delighted in caricaturing princes and other great persons for the pleasure that they then received in seeing themselves and others, at once admiring the great ingenuity of the artist and amusing themselves with such entertainment. . . .

To return now to where we left off, the Pope imposed on the

Cavalier, as was said, the study of painting and architecture, with the intention of having him paint the great Benediction Loggia and erect some kind of great structure that would fill the space beneath the dome of St. Peter's. . . .

And since, in matters of architecture, the Cavalier instructed his disciples that it was necessary to first consider the material, then the invention, then the disposition of the parts, and finally to perfect them all with grace and delicacy, so for this great work he devoted enormous care to each of these. And firstly, concerning the material, it seemed to him that bronze was very fit and proper for the majesty of the temple, and for this reason he suggested its use to Urban. He was able to use the metal revetments that were still to be found in the ancient portico of the Church of the Rotonda [i.e., the Pantheon]. They had been especially protected by Divine Providence from the voracity of the Emperor Constans II who despoiled it of the bronze tiles with which it had been covered, but who was unable to carry off the revetments because, as we may prudently judge, Heaven preserved them for a better use in honor of the Prince of the Apostles. The invention was no less precious than the material. Beneath the vast space of the dome he wanted four enormous, but proportionate columns, with their bases and pedestals, to rise that were to support a great baldachin covering the altar called the Confession and that from the center of this baldachin the Cross be elevated in beautiful relief. His desire to ennoble the invention with a marvelous disposition of the parts seemed to present the greatest difficulty. He reflected that in so huge an expanse of space, the diligent application of proportions, which only poorly accorded with the whole of the temple, would have been of no avail. Therefore, it being necessary to leave behind the rules of art, and frightened of losing himself without a guide, he only reluctantly agreed to it. However, he harmonized the two contrary demands so well that, in proportioning it, he knew how to break the rules without violating them; indeed, he found in himself the measure which in vain one seeks in the rules. . . . Equal was the perfection of grace and beauty that he gave it because, considered either in the parts or the whole, it is singular in the one and unique in the other, so that excluding all others, the testimony of vision alone is sufficient to affirm this truth. . . .

The Cavalier was then approaching thirty-seven years when he brought to perfection the works cited. The Pope wanted to employ him in another work, not less time-consuming, than honorable in its success; and this was to have him paint with his own hand the great Benediction Loggia. But a strange illness interrupted the fine plan and

also had the worse effect of completely debilitating the Cavalier. His untiring activity, his execution of what others together did not do—and all difficult, and particularly his continuous work in marble—at which he was so intent that he seemed instead ecstatic and to be inspiriting the stones with his eyes to make them lively, were in him a great cause of harm that forced him to bed with the most acute fever and mortal sickness. . . .

At the same time, then, that the Cavalier found some relief from the long illness which afflicted him, but before his strength allowed him to work with his hands and impatient with his idleness, he worked with his mind; and since nature seems oppressed until gladdened by something agreeable, he framed the idea of some comedies as much more honest, as they were rare. These, then, on a suitable occasion he related to Cardinal Antonio Barberini from whom he had not only full approval, but the more efficacious stimulus of being obliged to have them recited at some time; and he was provided with the proper occasion to greatly excite his interest in the work when it appeared that, happy in his progeny, some manifestation of cheerfulness was suitable for him. Therefore, the Cavalier, either persuaded or compelled, consented to it. It is not our intention, nor the value of the work to describe them; it will suffice merely to point out some particulars, letting these argue the whole. The beauty, then, and the wonder of them consisted, in the larger and better part, in satirical and witty mots, and in the invention of appearances. The first ones were so forthright, full of spirit, and founded on the truth that many virtuosi attributed some to Plautus, others to Terence, and still others to different authors, none of whom the Cavalier had ever read, for all were created by the force of his ingenuity alone. And it is worthy of a good deal of consideration that, with the theater refilled each night by the most respectable nobility of Rome, both ecclesiastic and secular, those stung by his mots not only were not offended, but reflecting on their honesty conjoined with the truth, almost gloried in being appropriate subjects for Bernini's acute and witty sayings, so that they then passed by word of mouth across all of Rome. And many times that same evening they reached the ear of the Pope who, on seeing him the next day, wanted, with express signs of pleasure, to hear them again. Not only did he expend his labor in composing them, but he also took no little trouble to make certain that those who were to play in them—for the most part people of his household and not accustomed to the stage—acted their parts naturally and with spirit; in doing this he was the master of everyone and everyone then behaved as if they were venerable professors of the art. Where he had to mix the work of

the mind with that of the hand, that is to say in the invention and in the stage-effects, it was not so much rare, as unique. In the celebrated comedy of the *Flooding of the Tiber*, he made a great quantity of real water appear from the distance which—when it most seemed to suit the action, by breaking some dikes that the artifice of Bernini had weakened to this end—poured onto the stage and rushed down towards the auditorium. The spectators took that appearance for a true inundation, and each one judging what was art an accident, so frightened themselves that some jumped up to flee, while others sought to make themselves superior to the danger by climbing on the benches; and everything else was proceeding with the same confusion when suddenly, with the opening of a sluice gate, all that great abundance of water was swallowed up with no more damage to the audience than that of fear.

In another, named *The Fair*, he represented on the stage a Carnival float with an escort carrying torches of tar and tow. One of those who carried the torches and whose part it was to make the trick rubbed and then re-rubbed his torch against the scene, in the way one usually does against the sides of walls, as if he wanted to spread the flame. Some of the spectators and, moreover, some of those on the stage shouted loudly for him to stop, for fear that he would ignite the set. His action and the voices of the others awakened in the people some apprehension, which was scarcely conceived before it degenerated into fear: because they saw the set, and with it a good part of the stage, kindled by artful and innocent flames which, spreading little by little, created a universal conflagration of it all. The terror of the spectators was such that someone would have perished in the precipitate escape from the imminent danger. But at the height of the confusion and of the fire, the scene was changed with extraordinary orderliness, and from an apparent conflagration became a most delightful garden. In the audience the astonishment at this sudden novelty was greater than the terror created by the fire, so that everyone, being stupefied, excused his fear by praising the deception. . . .

But with the change in government, one saw in Rome changes beyond those that were customary, and among these, changes of fortune. The memory of Urban was held odious by some, who attributed the length of the pontificate to the defect of the Prince—distasteful to many for the most recent memory of the calamities which disturbed the end of his government; but to those who understood most and best, he had been glorious for many years and unfortunate for few because they knew how to separate the actions of

the sovereign from the malevolence and the demands of the times. Consequently, as is the custom at courts, everyone spoke of him, not as he should have, but goaded by his passions; but the commotion which stirred the conclave for the election of the new Pontiff was greater. The Cardinals who were there were almost all creatures of Urban, and they would have been easily disposed in favor of the Barberini: had not their competition for the same dignity and the equality of their state chilled in some of them the memory of the benefit they had received. The Barberini were truly not in accord with the election of Cardinal Giovanni Battista Pamphili and for some time held him excluded from the Throne; but the effort and persuasions of Cardinal Giacomo Panzirolo, supporter of one and friend of the others, contrived to get their consent, and Pamphili was elevated to the Papacy with the name of Innocent X. Therefore it easily happened that, for whatever reason (the investigation of which lies outside the purpose of our work), the Pope inflicted on the Barberini those frequent and grave misfortunes which are too well-known to need description, and from Innocent's wrath against them was born an aversion to the friends and dependents of their house. The Cavalier Bernini was considered among the first of these, so that initially he was either disliked or little appreciated by that Pontiff; and since from the unexpected novelty of hostile encounters not even the innocent can escape, it easily happened that the Cavalier also remained exposed to the blows of that storm which for many years disturbed the court of Rome and Italy. . . .

Only the Cavalier, who was the subject of all the discussions, kept silent; and although he received new and vigorous encouragement from the King of France and the Cardinals who dwelt there to enter the service of that Monarch, he always refused, saying that "Rome sometimes sees dimly, but never loses her sight"—by which he meant to infer that it was a city in which virtue is sometimes thwarted by envy, but is never suppressed. And during all of those four years, which briefly gave scope to his rivals, he bore that fate, not with continual dissimulation, nor with useless laments—which are wont neither to offend, nor defend—but by finding in his virtue the consolation and remedy for those misfortunes. For in that same period when he seemed abandoned by fortune, he revealed to Rome the most beautiful works that he had ever made, authenticating by his deeds the valor which his adversaries discredited with their words. He was also convinced that just as falseness is usually invigorated by celerity, by waiting and with time the truth of his good faith would reappear with even greater beauty. And this same sentiment which to him was a

consolation, he displayed to us in a wonderful group in which he represented Time unveiling Truth. He invented a most beautiful woman, in marble and larger than life, elegantly seated on a rocky base and being disrobed by Time who, aged and winged, flies over her. She was to appear nude with the sun in her hand and with the comely eyes of her joyful face modestly turned towards him, almost as if she recognizes him as her benefactor and thanks him. At his death the Cavalier wished to leave this memorial to his children in perpetual *fidei commissum*, almost as if he took more pleasure in bequeathing to them his truth than his riches. . . . Of this group only the Truth was completed; and although he had procured a large and beautiful marble for the Time, yet, whether dissuaded from the work by the ire of that same Time who, inconstant by nature, refused to be eternalized by the hand of Bernini, or for some other serious occupation, it remained excavated in vain, a useless stone. . . .

At that time not only did he himself discover to the world Truth through Time, but with equal tenderness, if with greater devotion, he sculpted the so widely acclaimed statue of Santa Teresa, on the occasion described below. In the same year in which occurred the death of Urban, Cardinal Federigo Cornaro had renounced the patriarchate of his native Venice, an office he had filled as a rare example of virtue for twelve years, and returned to Rome, where, in the constant exercise of works, alike pious and glorious, he lived a mirror of innocence to the world. He had a special veneration for Santa Teresa, and since he was already decrepit and devoted himself to nothing more than preparing for the first and last grand voyage of death, he resolved to build in honor of the saint a magnificent chapel in the church of the Discalced Carmelites, the Madonna della Vittoria, and therein to make his tomb. He therefore gave the commission to the Cavalier who made for him a beautiful and noble design which surpassed anything he had ever done. The cardinal wanted him to execute the statue of the saint with his own hand and benignantly requested it of him. The Cavalier obliged him, and, in the opinion of all, no marble made by hands was worked with greater tenderness and design than this one. He represented the saint at the moment of sweetest ecstasy and swooning, transported beyond herself and abandoned within, and hovering near her, an angel who sweetly wounds her heart with the golden arrow of Divine Love. Bernini said that "this was the least bad work he had done," but his modesty was readily repudiated by the universal and public voice of Rome, which held that "in that group the Cavalier had surpassed himself and vanquished art with a rare object of wonder." Thus one of his sons,

who was the eldest, admiring this most worthy labor, composed the following madrigal in praise of it.

A swoon so sweet
Should have eternal guise;
But since suffering does not rise
To the Heavenly Portal
Bernini in this stone made it immortal.

But now at last it is time for Time to unveil Truth; and since all that which between the Pope and the Barberini had been at the incitation of anger, with their concord then became a bond of love, so the valor of Bernini again arose in Rome, as much more applauded as it had been gainsaid. At the time, therefore, when, without ever being untrue to himself, he clearly demonstrated that his virtue was not subject to the vagaries of fortune, the Pope thought to place in the middle of the Circus Agonalis, presently called Navona, the Egyptian obelisk brought to Rome by the Emperor Caracalla. . . . The obelisk lay buried for a long time among its own ruins, from which, as was said, Innocent, with imposing resolution, decided to raise it as the crowning touch of a most noble fountain in the middle of the Piazza Navona. Therefore, he ordered several designs from the foremost architects of Rome; but to Bernini no order was given. Borromini made his, and each of the others, inspired by emulation, exhausted himself at the work. The Pope reviewed them all: some of them he praised, but not one did he choose.

Nicolo Ludovisi, Prince of Piombino, had recently married Donna Costanza Pamphili, the niece of the Pope, and . . . attributing the aversion of the Pope more to the liabilities of those times than to any fault of the Cavalier, he made up his mind, for the good of Rome, to promote him in every way. But his knowledge of the tenacious and steadfast nature of the Pope made him doubtful of a favorable outcome. However, making up in ingenuity what he lacked in strength, he sent for Bernini and, as if for an entirely different purpose than to show to the Pope, but, as he said, for his own enjoyment, he secretly asked him to make a design for the Navona fountain. The Cavalier could not deny to so praiseworthy a Prince a gratification which he believed to be private and which should not otherwise be made public. Therefore he made it and along with a model sent it to him. The Prince, who was eagerly awaiting it, received it with as much pleasure since the idea of it seemed beautiful and the design grand; indeed, he did not hesitate a moment to seek an occasion so that, even if only in passing, Innocent might see it. Nor did he wait long for

success, because expecting the Pope to dine in the palace of his cousin, Donna Olimpia, in Piazza Navona after the usual Cavalcade on the day of the Blessed Annunciation, he deliberately placed the model on a little table in a room through which the Pope had to pass after the meal. He was certain that on seeing it the Pope would at least demand to know by whom it had been done. But a good deal more happened than he designed because the Pope saw it, and in seeing it, after half an hour of almost enraptured admiration of the invention, the nobility, and the breadth of the mass, he turned to the Cardinal, his nephew, and to Donna Olimpia, his cousin, and in the presence of the entire Secret Camera burst out in these words: "This design cannot be by any other than Bernini, and this is a trick of Prince Ludovisi so that in spite of those who do not wish it, we will be forced to make use of Bernini, because whoever would not have his things executed must not see them." And the same day he summoned Bernini with demonstrations of affection and esteem; in a dignified manner, almost excusing himself, he adduced reasons and various considerations for which he had not until then made use of him; and he gave him the commission to make the fountain according to his own model. . . .

The sun had not yet set on that happy day which saw the creation of a new Pontiff when the Cavalier was summoned by the Pope [Alexander VII] and treated by him with demonstrations at once appropriate to his new dignity and to their old reciprocal affection. . . .

While, therefore, the Cavalier attended with fortunate results to the abovementioned works [i.e., the Colonnade and Scala Regia of St. Peter's], Queen Christina of Sweden arrived in Rome mantled in a new and beautiful splendor. Having abjured her heresy and abdicated her throne, she came as much worthy of respect, as rich in herself alone, to subjugate herself at the feet of the Pope. . . . The Cavalier had received new orders from Alexander to complete the colossus of the Emperor Constantine on horseback which he had begun at the time of Innocent, and he was already completely absorbed in this great work again. The Queen knew of this and one day, when the Cavalier least expected the honor of the visit, she came with a numerous entourage to see him in his house. He, being just then at work, received her wearing that same garment which is suitable to his profession. And though he had time to remove it and redress himself, he replied to those who advised this that he "had no clothing more decorous to receive a Queen who wishes to visit a virtuoso than that coarse and rough one which was characteristic of the virtue that had rendered him such to the world." This, being penetrated by the

sublime intellect of that grand lady, not only raised her opinion of him, but as a mark, moreover, of her esteem, she wished to touch it with her own hands. . . .

• • •

But by now near death and at the decrepit age of eighty, the Cavalier wished to illustrate his life and bring to a close his practice of the profession he had conducted so well till then, by creating a work with which a man would be happy to end his days. This was the image of our Savior in half figure, but larger than life-size, with the right hand slightly raised in the act of blessing. In it he summarized and condensed all his art; and although the weakness of his wrist did not correspond to the boldness of the idea, yet he succeeded in proving what he used to say, that "an artist excellent in design should not fear any want of vivacity or tenderness on reaching the age of decrepitude, because ability in design is so effective that it alone can make up for the defect of the spirits, which languish in old age." He destined this work for the very meritorious Queen of Sweden who, being unable to compensate its value, chose rather to refuse it than descend from her royal beneficence. But she was constrained to accept it two years later, when the Cavalier left it to her as a legacy. . . .

Before beginning our narration it is well to turn back the discourse somewhat, and demonstrate how singular the goodness of life was in the Cavalier Bernini, and with what union of Christian maxims he rendered notable the many beautiful gifts of his soul. He was a man of elevated spirit who always aspired to the great, not resting even at the great if he did not reach the greatest; this same nature carried him to such a sublimity of ideas in matters of devotion that, not content with the ordinary routes, he applied himself to those which are, so to speak, the shortcut to reach heaven. Whence he said that "in rendering account of his operations he would have to deal with a Lord who, infinite and superlative in his attributes, would not be concerned with half-pennies, as they say"; and he explained his thought by adding that "the goodness of God being infinite, and infinite the merit of the precious Blood of his Son, it was an offense to these attributes to doubt Forgiveness." To this effect he had copied for his devotion, in engraving and in paint, a marvelous design which shows Jesus Christ on the Cross with a Sea of Blood beneath, spilling torrents of it from his Most Holy Wounds; and here one sees the Most Blessed Virgin in the act of offering it to the Eternal Father, who appears above with open arms all softened by so piteous a spectacle.

And he said, "in this Sea his sins are drowned, which cannot be found by Divine Justice except amongst the Blood of Jesus Christ, in the tints of which they will either have changed color or by its merits obtained mercy." This trust was so alive in him that he called the Most Holy Humanity of Christ "Sinners' Clothing," whence he was the more confident not to be struck by divine retribution which, having first to penetrate the garment before wounding him, would have pardoned his sin rather than tear its innocence. He was wont for many, many years before his death often to discourse at length with learned and singular priests; he became so inflamed with these ideas and the subtlety of his thought ascended so high, they were amazed how a man who was not even a scholar could often not only penetrate the loftiest mysteries, but also propose questions and provide answers concerning them, as if he had spent his life in the Schools. Father Giovanni Paolo Oliva, General of the Company of Jesus, said that "discourse with the Cavalier on spiritual matters was a professional challenge, like going to a thesis defense." Nor did he nurture these noble thoughts in his soul without fruit, but he continually practiced virtue with solid works. For the space of forty years he frequented every Friday the devotion of the good death in the Church of the Gesù, where he often received Holy Communion at least once a week. For the same long space of time, each day after finishing his labors he visited that Church, where the Holy Sacrament was exposed, and left copious alms for the poor. Besides giving many dowries to poor unmarried girls during the year, he always contributed one on Assumption Day, and obligated his children to six more in his will. To gain merit by avoiding gratitude he even distributed copious alms through one of his servants, with the obligation not to reveal the benefactor. Although the practice of philanthropy was, so to speak, born and raised with him, yet in the last years of his life he took it so much to heart that, not considering himself sufficiently able to find the poor, he gave charge, and funds, to many religious to pass on the aid. And because he loved secrecy in such works, we may judge that he made many more of them than we have notice of. From some notices he kept in a volume of household finances we learn that, having three months before his death placed two thousand scudi in a prayer-stool, only two hundred were later found there; he ordered his children also to use these in a pious work, with clear indication that what remained was to make a similar exit. In a letter written from Paris he orders his son, the Monsignore, to double the amount of alms he had left instructions to give "because God is a Lord who will not be won over with courtesy." Often during the year he took his family to some hospital, where he wanted his small

children to follow his example in comforting the sick, presenting them with various confections he kept ready for the purpose. It was an amazing thing for a man employed in so many important occupations devoutly to hear Mass every morning, to visit the Holy Sacrament every day, to recite every evening on his knees the Crown and Office of the Madonna, and the seven Penitential Psalms, a custom he constantly maintained until his death. When he then saw himself approaching death he thought of and discussed nothing else than this passing; not with bitterness and horror, as is usual with the aged, but with incomparable constancy of spirit and using his memory in preparation for doing it well. To this end he had continuous conferences with Father Francesco Marchese, priest of the Oratorio of San Filippo Neri in the Chiesa Nuova at Rome, son of his sister Beatrice Bernini, a person venerable for the goodness of his life and noteworthy for his doctrine, of whom the Cavalier availed himself to assist at his death. And he said, "that step was difficult for everyone because everyone took it for the first time"; hence he often imagined himself to die, in order by this exercise to habituate and dispose himself to the real struggle. In this state he wanted Father Marchese to suggest to him all those acts usually proposed to the moribund, and doing them he arrived, as if in preparation, at that great point. Assuming also that, as is usual, words would fail him at the extremity of life, and he would suffer the anguish of one who cannot make himself understood, they worked out a special way in which he could be understood without speaking. With such precautions, with his soul completely reinforced, he finally reached the proof.

We have already said how debilitated and strained he was left from undertaking the restoration of the Palazzo della Cancelleria. Whence he finally fell ill with a slow fever, to which was added at the end an attack of apoplexy that took his life. Through the whole course of the illness, which lasted fifteen days, he wanted a sort of altar set up at the foot of his bed, on which he had displayed the picture of the Blood of Jesus Christ. What were the colloquies he held now with Father Marchese, now with other religious who stood by, concerning the efficacy of the most precious Blood and the confidence he had in it, can rather be conjectured than reported. For none of those present could help bursting into tears on hearing with what firmness of sentiments he then spoke, of whom neither the burden of age and sickness, nor powerful enemies, had been able to obfuscate that clarity of intellect which always maintained itself equal and great in him to the last breath of his life. Realizing that he could no longer move his right arm because of the aforementioned attack of apoplexy, he said,

"it is only right that even before death that arm rest a little which worked so much in life." To Cardinal Azzolino, who honored him with several visits in those days, he said one evening that "he should implore in his name Her Majesty the Queen to do an act of love of God for him, because he believed that that great Lady had a special language with God to be well understood, while God had used with her a language which she alone was capable of understanding." The Cardinal did his bidding, and received from the Queen the following note.

> I beg you to tell the Cavalier Bernini for me that I promise to use all my powers to do what he desires of me, on condition that he promises to pray God for me and for you, to concede us the grace of His perfect love, so that one day we may all be together with the joy of love, and enjoy God forever. And tell him that I have already served him to the best of my ability, and that I will continue.

Meanwhile his house was a continuous flux and reflux of the most conspicuous personages of Rome; they came or sent word, with sentiment no less distinguished from the common convention, than was distinct and particular in each of them his esteem and regret to lose so great a man. Finally speech failed him, and because he felt exceedingly pressed by the catarrh, he made a sign to the Cavalier Mattia de Rossi and to Giovanni Battista Contini, who, together with Giulio Cartari and all his pupils stayed always by his bed, as if amazed that they could not recall a method of drawing the catarrh from his breast; and with his left hand he strained to represent to them an instrument designed to lift exceptional weights. As he had agreed with Father Marchese before taking ill on the method of making himself understood without speaking, it astonished everyone how well he made himself understood with only the movement of his left hand and eyes—a clear sign of that great vivacity of spirits, which did not yield even though life withdrew. Two hours before passing he gave the benediction to all his children, of whom, as has been said, he left four boys and five girls. Finally, having received the blessing of the Pope, who sent it through one of his chamberlains, early on the twenty-eighth day of November of the year 1680, the eighty-second of his life, he expired. The great man died as he had lived leaving it doubtful whether his life was more admirable in deeds or his death more commendable in devotion.

In his testament he left the Pope a most beautiful picture by Giovanni Battista Gaulli representing the Savior, his last work in marble; to the Queen, the *Savior* itself by his hand; to Cardinal Altieri,

the portrait of Clement X; to Cardinal Azzolino that of Innocent X; and to Cardinal Giacomo Rospigliosi a picture also by his hand, having nothing else at home in marble other than the *Truth*, which he left in perpetuity to his descendants.

Mourning for the loss of this man was universal in the city of Rome, which recognized its majesty greatly enhanced by his indefatigable labors; and as was his life so also was his death the subject of many ingenious compositions at the Academies. The following day, when the Pope sent a gift to the Queen, she asked the chamberlain, "What was being said concerning the legacy of the Cavalier Bernini?" And having received the reply, "About four hundred thousand scudi," she added, "I would be ashamed if he had served me and left so little."

His body was exposed with pomp in the Basilica of Santa Maria Maggiore, with a funeral, distribution of wax, and charities to the poor; attendance was so great that the burial was postponed till the following day. He had already prepared the tomb for himself and his family in that church, and he was placed in it in a lead box, with an inscription giving his name and the day of his death.

OF SOME ARTISTS EXCELLENT IN WORKING STATUARY: BERNINI

Gian Andrea Borboni

. . . But should those venerable Aristarchs still not yield, I shall place before their eyes one who, having reached the pinnacle of his career in full vigor, will easily succeed in making them see clearly the reflections of the splendor of Michelangelo in his most marvelous works. And to speak the truth, who can imagine Proserpina abducted by Pluto, who does not see it more vividly sculpted by the chisel of Bernini, than described by the pen of Claudian?[1] Is there another such Cerberus who the more he terrifies, the more he delights? One sees in Pluto just that majesty which Tasso sought in another such figure:

> The fearful majesty in his fierce aspect
> Increases terror, and renders him more proud.[2]

And, nevertheless, amidst that dense gloom of fierceness, there glitters some spark of the fire which inflames his breast for the fair beauty. To see, on the other hand, in what a profound ocean of grief, of terror, and of dismay Proserpina reveals her heart to be overwhelmed, moves one to pity; to behold her, so beautiful a maiden, although fictitious, in the arms of a god so dark, so cruel, so fuliginous inspires the unreasoning desire to kill him, did not the artifice of Bernini protect

"Of Some Artists Excellent in Working Statuary: Bernini." Trans. by George C. Bauer from Gian Andrea Borboni, *Delle Statue* (Rome: Iacomo Fei d'And. F., 1661), pp. 81–85.

[1] A Latin writer known to have lived in Rome and Milan during the years A.D. 395–404. One of his preserved works is the *Rape of Proserpina*, an unfinished mythological epic.

[2] From Tarquato Tasso, *Gerusalemme Liberato*, Canto IV, ottavo 7, 1–2, where it describes Pluto/Satan.

him with an impregnable shield. What shall we say of his Daphne who in flight with her arms upraised, her fingers already sprouting into fronds, and her body being bound by the bark of the tree, makes those who see her much more immobile in their amazement? O here, then, will the fame of the artist remain crowned until this so noble laurel turns to green. In the shadow of so fortunate a tree the labors of his mind will always be prized by glory, just as they will protect him from the thunderbolts of slander; indeed, so that the artist might more worthily bear a similar crown, I am certain it would be placed on his head by Apollo, to whom it falls to bestow the laurels, if that sculpted god of the Muses beside Daphne had life, which is all he lacks. It seems he portrayed him from the discourse of Apuleius as, from another's account impressed on his imagination, it is said that Raphael portrayed the Savior: *coma intonsus et genis gratus; corpus totum gratissimum, membra nitida, lingua fatidica.*[3] But he who desires to see the intrepid courage of that innocent stripling David, should see him sculpted by the renowned artist and he will recognize in that statue a soul animated by Heaven and a body, though unarmed, all strength and fitness to hurl the stone at Goliath. No one should expect that I want to describe the rocky mass of the Circus Agonalis[4] where one sees the wonders dreamed by Necromancers, who make copious founts of water rise over solitary mountains. Besides I don't want to prejudice that just desire, of whomever it may be, to see a marvel of our time; but I would invite the poets, more than all the others, to go there to refreshen their minds, for I should believe to have shown them the true fountain of the Muses. In fact, it would be a task without end for whoever wished to recount all the works which have come from the expert hand of Bernini to embellish the universe. Nonetheless, not to mention the tomb of Urban VIII would be too culpable a neglect. I omit the ingenuity of the invention with which Death, seated on a sepulcher, also enrolls in his ranks the pontiffs, among whom is Urban; and I omit the fineness of the materials, as well as the nobility and magnificence of the rest of that stupendous work, and restrict myself to a statue of Charity which one may admire there. Whoever sees it will always confess that in representing her, the sculptor has surpassed himself; she moves all the mothers who see her, even though they resist, to love tenderly and to caress their sons.

[3] Borboni cites *Museo Gualdi super Imagin. Salvat.* The quote is from Apuleius, *Florida*, I, 9–10: "his flowing hair unshorn, his cheeks blooming. . .his body most pleasing, his limbs dazzling, his tongue prophetic."

[4] I.e., the Four Rivers Fountain in the Piazza Navona, Rome.

Cornelia, the great mother of the Gracchi, said that *Filij sunt Delitiae et ornamenta parentum;*[5] if there is anyone who doubts her, let him go to the celebrated statue of Charity where he will be forced to admit it on seeing the face of that smiling mother turned to a child with such tenderness of affection that it arouses in those who see her a similitude of Divine Clemency, which under just a similitude of like features comes to us from the evangelic prophet in those words: *ad ubera portabimini et super genua blandientur vobis.*[6] In sum, to show clearly to the world the most affectionate feelings and unlimited charity of Urban's grand soul and express them vividly, nothing more is required than a statue without comparison. No more is needed to understand with what reason such a remarkable sculptor has been cherished, favored, and honored by the Supreme Pontiffs—Urban himself, Innocent the Tenth, and Alexander the Seventh for whom, one can say, he is the Lysippus. If, then, there was someone who wanted to see the chisels of so great a man employed for other Princes, many such works could be produced for him; but to satisfy such a request, I am content that one alone among the other distinguished works of the so celebrated sculptor serve for them all. This is the marble bust portrait of his Highness, made for the Most Serene Duke of Modena, Francesco d'Este. What amazes one is that it was not portrayed from life, but from another, painted portrait. Nevertheless, it is rendered so lifelike that when seen by that Prince he seemed—I was almost on the point of saying did not his sagacity prevent it—like a new Narcissus punctiliously admiring his features in the brilliance of the statue, and taking pleasure in himself or being smitten by his statue, he began to reason with it like a new Pygmalion. I shall say no more: the reward given its creator guarantees the excellence of the work. Whoever wishes to know if the trite proverb, *raritas facit pretium,* is true, attend. One thousand doublons were given to Bernini by a most liberal generosity—worthy of the boundless spirit of that grand Prince and of the magnificence of the Este who, proportionate to the merit, are accustomed not only to reward largely, but to oblige the virtue of the illustrious men of all professions to live indebted to their ancestors and nestle beneath the most pure and spacious wings of their innocent eagles.[7] Of these eagles the sweetest of the Castalian Swans[8] seemed to

[5] "Sons are the delight and jewels of their parents."

[6] Borboni cites *Isaiah*, 66. The quote is from verse 12: "then shall ye suck, ye shall be borne upon her sides, and be dandled upon her knees."

[7] The eagle is an armorial device of the Este family.

[8] I.e., poets. Castalia is the spring on Mount Parnassus which is sacred to the Muses.

be the disciples and by them, in rivalry with the wings of Fame, were borne aloft and splendidly protected by that Most Serene House which was ever the Parnassus of the Muses. Now I need say no more to those Aristarchean laudators of antiquity, having made them see that nature at all times produces some remarkable man, like that plant praised by the Roman poet which, no matter how many times brought to death by the sword, nevertheless always sprouts new shoots:

> *uno avuleso, non deficit alter*
> *Aurens, et simili frondescit virga metallo.*[9]

[9] Borboni cites the *Aeneid*, VI. The lines from Virgil (143–44) are part of the passage which in Dryden's translation (206–16) reads:

> In the neighboring grove
> There stands a tree: the queen of Stygian Jove
> Claims it her own; thick woods and gloomy night
> Conceal the happy plant from human sight.
> One bough it bears; but, wondrous to behold,
> The ductile rind, and leaves, of radiant gold:
> This from the vulgar branches must be torn,
> And to fair Proserpine the present borne,
> Ere leave be given to tempt the nether skies:
> The first thus rent, a second will arise,
> And the same metal the same room supplies.

CONSTANTINE BROUGHT
TO THE PILLORY

Anonymous

At last, on the first Sunday of Advent, the good—but not the best—Constantine[1] arrived to take his station—but without plenary indulgences—at the stair and *ad limina* of St. Peter's and to hear on the Vatican Hill, as in the Valley of Jehoshaphat, the Gospel and the sermon of Judgment. . . . Nor shall it be *parturient montes*,[2] so long as from those of the Chigi, after so many centuries, has come a topic for all the satires, a monster stained with more spots than a leopard and more blemishes than the Cavalier Gonnella.[3] Who would ever have dreamed—not even for a chimera, let alone for a Pegasus generated from the stony head of Medusa—that for a great Emperor and the greatest benefactor of the Church such a statue should be erected? And then by an Alexander, greatest and best? An equestrian statue of low and half-relief, it is imbedded in the wall like an embryo of the first horse once roughed-out of stone by the trident of Neptune; or to describe it better, like a beastly centaur, half-horse and half-man,

"Constantine Brought to the Pillory." From "Il Costantino messo alla Berlina ò Bernina su la Porta di San Pietro," (Rome, MS. Bibl. Vat. 4331) (excerpts); trans. by George C. Bauer. Excerpts first published by G. Previtali in *Paragone*, XIII, No. 145 (1962), 55–58.

[1] I.e., Bernini's equestrian statue of the Emperor Constantine the Great, which was placed on the main landing of the Scala Regia, the ceremonial entrance to the Vatican Palace.

[2] From Horace, *Ars poetica*, 139: "Mountains will labor, a laughable mouse is born!" The coat of arms of Pope Alexander VII Chigi, for whom the statue was completed, contains six mountains and a star quartered with an oak tree. In the original there is an intended play on the word "topic" and the Italian word for mouse, *"topo."*

[3] A buffoon.

bisected lengthwise with one half supported by the air and the other by iron driven into the wall; and as if it were the ass of Balaam pressing his master's leg so tightly to the wall, it would take not only the knotty staff of Balaam, but the eloquent tongue of the animal, and the flaming sword of the angel to detach it and give it in the round.

Was it then a poor block of Carrara marble or the Vatican piazza as the site that denied to the perfect and complete statue (today incaved within the confines of a niche) the freedom to caracole in the open? And is it for this reason that we must take on faith what's missing and the Emperor's other leg, and that he is supported below without a miracle from St. Peter who gave legs to a cripple?

That such things were done by the ancients and moderns in numerous works of several historical subjects, as one sees on the triumphal arches and columns of Rome, is no justification, rather it deserves praise as the result of necessity alone. But that by instinct of choice it should appear in a single statue made for a first and singular Christian Caesar is nothing but the mendacity of the stone or of the design. Yet Algardi, who may be the true Stasicrates[4] of his Alexander, in his relief of St. Leo, also detached as much as possible—almost completely—the two principal figures. Such were not only the ancient works, which were greater in number than plants refreshening an immense forest, so that the Seven Hills embraced more statues than people, but also the modern ones raised to the Popes and heroes in St. Peter's and on the Capitol. . . . It falls only to the lot of the most worthy and well-deserving Emperor to sustain himself, like St. Paul, the first hermit, with the half-loaf of a miserable stone although Bernini knows how to fulfill completely the desires of that other, false solitary, the satyr Pan in the desert: *dice ut lapides isti Panes fiant*[5] and how from every stone, though no touchstone, to extract with the art of his mercury a philosopher's stone and by a secret alchemy to transform this same horse into the ass of Apuleius.[6]

The statue also stands condemned for the great error that one does not know from where it should be seen: if from the great portal which is the entrance to the palace, it can scarcely be seen buried in that niche as if lurking in ambush; or if from the Portico of St. Peter's,

[4] A favored artist of Alexander the Great; see Plutarch, *Lives, Alexander*, LXXII, 3–4.

[5] From the Gospel of *Matthew*, IV, 3: "Command that these stones shall be made bread."

[6] I.e., the "Golden Ass," as the *Transformations of Lucius Apuleius* is popularly known. One of several allusions in the diatribe to Bernini's supposed corruption and profiteering.

from where it is not discovered except by betrayal or flight, then it is seen from the side, of course not from the front; and one understands less what purpose is served by that great Pavillion, although seeded with so many stars, knotted with a gigantic cloth of honor and with that paludament trailing on the ground which lacks a Caesar; from this, as if from a stall, the halterless horse seems to escape and bound for the Campagna, spurred on by the erect Cavalier to launch itself on the air; nor does one see the Cross to which the Emperor directs his eyes although he has his arms open in ecstasy in the figure of a St. Francis receiving the stigmata. . . . To excuse it by saying Constantine alone saw the Cross proves to be either absolutely false, since it was visible to all who were not blind, or frivolous, since if such were the case, then one could neither paint nor sculpt the solitary visions of numerous saints. In our case out of envy of revealing the Cross to others, it is made invisible to Constantine himself. The best reason for this will be that the son does not have with him his holy mother Helena who also discovered the Cross in the sky, or that in the House of Herod, the enemy of the Messiah, the star which guided the Kings vanished.

Nothing could be done with that unbroken and unbridled horse without catching it, if not by the tail, then by the mane, and thereby running the risk of breaking one's neck like Curtius or Maxentius, or of being dragged like Crispus, the father of Hippolytus, although from the time of Bellerophon, its inventor, the bridle was always used by men and in statues, as one may singularly see in that of the Capitol where the reins tightened by the rider are missing from his hand, but certainly not the halter at the head of the horse. It is otherwise with our poor Emperor who, clinging like the boys on the Barbary horses (although they use the bit) to the mane with his hands and to the belly with his knees, finds himself in great confusion, not only over how to mount the horse, but also how to direct it without reins. But since the left hand of the Emperor accompanies the right in asking alms of Heaven, it falls to the lot of the horse not to have a bit in its mouth on the first day of Advent, so that it does not even break its fast on Sunday— although the whole horse seems a triumph of marzipan and meringue.

I also chose to believe that the horse is missing all its teeth for its smile upon seeing that the satyr's beard of its master (who does not lack horns on his head) has thirty-one hairs for the defect of the barber. . . . May God forgive he who has cut it, because today one would not see a mature Constantine represented as half-man, half-horse, as if half-shaved and half-hairy, and not without risk of being at

the mercy of Dionysius of Syracuse[7] with the face of Apollo and Asculpius. There are not lacking those, however, who excuse it by saying were he smooth-shaven, he would not be safe from Luigi, Bernini's brother. . . .

In fine, leaving to the anatomists of Santo Spirito and the Horse Tamers of the Quirinal Hill the censure of the other parts, I am thus content with a cursory and rough observation of what even the boys of Santa Croce understand, that in that statue the first rudiments and elements of art stand in need of correction, let alone the barbarisms and solecisms of the first rank. Nevertheless, as Zeuxis composed the flower of his Cnidian Venus from the graces of the beautiful, he pretends from the furies of many horses to have distilled the quintessence of his own in the Vatican. But so that I don't appear completely deaf, dumb, and blind—like that demon when with prophetic vaticination one can say *loquetur lapis de pariete*[8]—I shall at least say with some of those sculptors who, in spite of whoever sees only his influence, are certainly not the pupils of the ignorant master, but the Phidiases, Lysippuses, and Praxiteleses of our century and who are accustomed to give in their marbles no less soul to the men, than spirit to the beasts, that in both these respects there are here so many errors that they cannot be corrected, like the verses of that poet in Martial, except with a single cut from head to toe. I say, then, to give precedence to the beast, that this one, like a horse with four white stockings that can neither be bartered nor sold, has all its quarters false—in a way, nevertheless, that is as much more suited for a horse than is its master for a Cavalier. And *in primis*, that were it placed with four feet on the ground and extended, the horse would be so long that in two steps it would occupy the Longara and reach to Portolongone. It is astonishing that, having made his Longinus a cripple for the brevity of his legs, he should do the same to a horse for the length of its body, so that it might bound and arrive more quickly in Constantinople, and also into Heaven . . . and it could well bear all the burden since stood up, it would look like a camel, either to get into Heaven more easily than the rich, or into Paradise with the chariot of Elijah, without the quadriga of horses. Moreover, since it displays nothing of the truth and is completely ideal, the horse would make a good Pegasus for the poets who, rising on abstract ideas and

[7] The tyrant of Syracuse who for fear of assassination was barbered by one of his officers with a burning coal; see Plutarch, *Lives, Dion*, IX, 3.

[8] Perhaps based on *Habakkuk*, II, 11: "For the stone shall cry out of the wall, and the beam out of the timber shall answer it."

impossible contingencies, base themselves on falsehoods and fables and drink the honey whose effects on the mind are more lunatical than Apollonian. Thus this horse, without any symmetry or harmony whatsoever in its members or in its bearing, so that it would discountenance a sybaritic dance, were it put to the battering ram in war, would seem one of those Spanish horses, the Aquilino of Tasso, generated by the wind.

To the length of its legs is joined a largeness beyond measure, as if it were a Frisland horse for a troop of cuirassiers, although the cuirass of the Emperor is that of a light cavalry man, with a certain knottiness and sticking of the pleats which would not be found on one in whom the spirit and the arm were enough to smooth and press them. What more? That the horse has an emaciated belly for want of feed which, as usual, it has been cheated of by the groom; and because, as is done with the *Chinea Napolitana*,[9] it has been condemned to fast so that it should not dirty even the atrium of St. Peter's. As if misfortune had not already attached it to a house in which for the constipation of the father, the children die emaciated! This ascetic horse has on its belly certain veins which are so gross and so swollen that it runs not a little risk of dropsy and of being condemned, not to strike fountains on Parnassus like Pegasus, but to carry all the aqueducts on the Seven Hills that water them without tax.

That alone which has been denied to the belly abounds in and aggrandizes the tail. So out of proportion and immense is that bundle that it would require all the train-bearers returning from chapel to lift it, and not all the armies of Sertorius[10] would be enough to pluck it hair by hair, although to feed them would be a task beyond all the fishermen in the world, let alone the Apostles. Having before it the imaginary sign of the Cross (even if it isn't there) as a new and happy horoscope for its master, it leaves behind the great tail which is like the comet that usually threatens the fall of crowned heads.

Consider the thin neck, like that of a crane . . . and that the head, although it comes from another than so great Minerva's, is wretched like that of the ostrich which is accustomed to gobble up stones and nails. . . . Is it perhaps because of the sword of St. Peter that the right ear seems afraid, so that to flee the blow it is reversed

[9] The white horse presented annually to the popes by the city of Naples as a pledge of fealty.

[10] Plutarch, *Lives, Sertorius*, XVI, 3–5, relates how the Roman general, Sertorius, to demonstrate the efficacy of doing something slowly, one step at a time, had a weak soldier remove the tail of a strong horse, hair by hair—a task which could not be accomplished by a strong soldier yanking on the tail of an old and decrepit horse.

from the norm, and that the two ears, like sails twisted crosswise and following the motion of the body itself that was made from the side, seem like ships sailing close to the wind? The badly designed mane of the horse causes no envy in the curled and wavy tail; either because the groom has not combed it well and only wrapped it like a fashionable wig, or because today fortune is more easily taken by the shoulders than by the forelock.

Although worthy of a great volume this is the horse in compendium. It is so lacking in contour that it seems thrown together, but with the stones either thrown over his shoulder by Deucalion or those that from the time of Solomon throw themselves at the feet of the god Neptune no less than the mendicant fathers. . . . To be quit of this miserable horse: if the horse of Caesar, who was later killed by Brutus, had feet in the form of human fingers, that of his pious successor, Constantine, has been equally murdered, along with its master, by the hand of the brutal sculptor.

Here we are with it in view, without losing sight of how easy it is to recognize the Emperor on the vast mass of his animal, like one of those dwarfs who in jest get up on camels or elephants with apes or parrots—unless, because the forelock of the horse on the Capitol seems to be a little owl, on this horse the Cavalier is intended to be the owl. Now of ours one says not less charitably that with the violent movement or spring of the horse, almost as if more possessed than spirited, the Emperor ought to have a little more, if not movement, than heightened animation and vivacity. But he is as immobile as if he were nailed to the spot, staring in amazement at the sky where, for all of the day of Advent and the trumpet of the Last Judgment, the cross has not yet appeared. It is as if Bernini rendered in the same moment the horse ascending into Heaven from the Mount of Olives and Constantine onto the Cross on Calvary.

One also observes, and with reason, that the Emperor to harmonize with his horse has a miserable head and not what would be demanded both by decorum and the majesty of an Emperor according to the proverb, *facies digna Imperio*, as well as the truth and nature of our own conception of him. On the strength of histories and medals one knows that he was endowed with a not ordinary beauty—the worthy father of a Crispus who was born to inflame with his own not less the love than the hate of his stepmother[11]—and much closer to

[11] Constantine's execution of his son, a great scandal for a Christian Emperor, was explained by analogy with the tragedy of Hippolytus and Phaedra. Crispus spurned the illicit affection of his stepmother, Fausta, whose passion, turned to hatred, caused his ruin.

juvenescence, in which joviality flowers and Jove reigns. Nevertheless, in spite of nature and of art, one recognizes here a face and an air more those of a baron of the Campo dei Fiore than of an Emperor of the Campidoglio, and more of a stable boy or horse breaker than of an Alexander or Darius. . . . Nor would they be far from the truth who say that the whole face and head of Constantine has been taken in one piece from the *Longinus* in St. Peter's and from the *Habakkuk* in the Chapel in S. Maria del Popolo; that is to say, that onto the trunk of an Emperor is grafted the very same head of a centurion and a shepherd prophet, as was once done by Caligula who, desiring that all of the Roman people have only one neck, deprived the most majestic and venerable statues of their brains. Nevertheless it is also to be noted that the first, the head of Longinus, was pillaged from the Borghese Centaur so that by an occult destiny, after it had flown through the air—and by a hair—to the bust of Habakkuk, it has fallen on this flying centaur which is therefore almost the pirate of its own original thief. Nor do those lack who affirm that this head, like that of Proteus, has been changed and is very diverse from the first one which already appeared at the window—like one of those women who, placed in the piazza and under our eyes, turn out to be very different from the scenic prospect which they presented on the balcony.

One does not know what crime was committed by the right leg and thigh which is missing the buttocks . . . and have been treacherously assaulted in that stall with several blows while on the horse itself, which instead of rising to Heaven, would merit for this excess, though not its own, to be hurled into Hell to burn with the horses of Phaeton and Pluto. After having been served like a friend in the right thigh (which is the only one visible, like that of a crane on the seashore, while the other hides beneath the veil of Timanthes[12]) the leg appears clearly more gross than necessary because of some inflammations caused by the lack of stirrups, as formerly happened to Titus by the swelling of his legs from the continuous exercise of mounting.

Passing from this to the arms and hands: although accustomed to wield scepters and swords—certainly not spindles and distaffs which spin very thinly—and although kings, more so than Artaxerxes,[13] usually have both hands fairly long, these are so curled and contracted, that they appear to suffer from gout; but with predatory claws they

[12] An ancient painter, the contemporary of Zeuxis, who in his sacrifice of Iphigenia showed varying intensities of grief, which culminated in the father whose face was hidden by a veil; see Pliny, *Natural History*, XXXV, 74.

[13] Artaxerxes II, son of Xerxes and King of the Persians, was called the Longhanded because his right hand was longer than his left; see Plutarch, *Lives, Artaxerxes*, I.

conform with the Imperial eagle turned to a golden sun he cannot see. However, he does not resemble the eagle in his neck, which being stiff, long, and thin can rival instead that of the crane or ostrich on a par with his Courser or Barbary that conveys him more by flight than at a gallop. Everything else which covers him marches to the same tune, because the mantle is certainly not an Imperial one, but so mean and scanty that much more remained on the back of St. Martin when, from his horse with a blow of his sword, he divided his in half to share it with that poor man who protected himself from the cold with no more than his skin. To such an extent was it made haphazardly and without art that the tailor either had lost the size when cutting it on the bench, or trimmed it too closely around the edges in order to give the relics to those devoted to him. . . .

Truly out of charity would I advise the Cavalier Bernini to avoid forever as an unfortunate arena the church of St. Peter's where on the rocks of both architecture and sculpture he has always been ship-wrecked. He can well remember and content himself with that cupola, bound in iron so that it does not split itself—more for the smile, than for anger at the *Longinus* who, with both legs withered, extends his right arm to the bloodletting without reaching the major artery of the bell tower,[14] which even on the ground resounds in wrath, and screams for vengeance more loudly than the blood of Abel; with that Cathedra unloaded like an insupportable burden on the shoulders of those Greek porters and resting by two ribbons on the fingers of those two Latin ones; and with the *probatica piscina*[15] of the colonnade within which, it itself remains incurable for all the centuries and will never have anyone who, with his hand or foot, wants to raise it. I leave aside his Costanza[16] transformed into a Charity with so many (I don't know whether they are sons or fathers) at her breast that she should rather be Justice, her companion, of whom it is proper that she give of herself to everyone. Nor shall it be strange that one virtue is exchanged for another and a nursing sheep for the Roman wolf by one who, in forming his *St. Teresa* in the church of the Vittoria, dragged that most pure Virgin not only into the Third Heaven, but into the dirt, to make a Venus not only prostrate but prostituted. . . .

[14] Under Urban VIII, Bernini had designed and begun to build towers flanking the facade of St. Peter's on the giant foundations left by Carlo Maderno. After work on the south tower was begun, cracks appeared in the structure below. In 1641 work was halted and, after Urban's death, in 1646 the tower was dismantled.

[15] The pool of Bethesda in Jerusalem at which Christ cured a cripple; see *John*, V, 2–9.

[16] I.e., Costanza Bonarelli, Bernini's mistress at one time; see above, p. 39. The Charity referred to is the allegorical figure on the tomb of Urban VIII.

DICTIONARY OF THE FINE ARTS: BERNINI

Francesco Milizia

Sculpture demands form and character, that is, the correctness of the design and an expression proper to the subject.

Sculpture cannot be colored. Colored statues are not for artists, but for artisans, and for the most common crowd. By giving to the marble the appearance of soft flesh and firm tendons, the artist ought to create an illusion, not to the extent that a product of his art is taken for nature itself, but to show its likeness to ideal nature.

If sculpture cannot make use of color, neither can it flutter with painterly draperies. The reason is clear. If the principal object of the sculptor is design, then his object is the nude. And if he cannot always work with the nude, he uses as little drapery as he can, so that the draperies should be like those used by the good Greek artists who covered their statues so delicately that the beautiful forms always appeared. For that reason they draped them in natural and fine folds with fabrics that seem wet. Sometimes, as in the Zeno, in the Flora of the Campidoglio, and in the Marius of the Villa Negroni, they used large, sweeping drapery. On the other hand, the modern sculptors, to make their sculpture painterly, have handled the draperies in a way not even proper for painters, and the draperies which result are rocky, crumpled, and monstrous. Bernini, especially, indulges in this.

· · ·

The son of a sculptor, Bernini was brought to Rome as a child and was numbered among the child prodigies. The head of a Faun,

"Dictionary of the Fine Arts: Bernini." From Francesco Milizia, s.v. "Bernini" and "Sculpture," *Dizionario delle belle arti del disegno* (Bassano, 1787). Excerpts; rearranged and trans. by George C. Bauer.

several heads and busts of Cardinals and Popes, a *St. Lawrence*, the group of Aeneas and Anchises, the *David*, and the *Apollo with Daphne* were all works of his youth. His ardor and his work brought him patrons and rewards, and the rewards incited him to new efforts. He was taken by compositions which are rich and of great magnificence. There are the Cathedra and the Confession in the Vatican, the *Longinus*, and the Tombs of Urban VIII and of Alexander VII, the *Constantine*, and the angels of the Ponte Sant' Angelo, about one of which was said:

> She laughs, she sings, she dances
> and yet she is missing a shoulder.

His best work is the *St. Bibiana*; but the *St. Teresa* in the Vittoria swoons in an ecstasy, not of Divine Love, but of very worldly voluptuousness. The catalogue of his statues is still longer, as is that of his works in architecture. He lived many years and was always hard working. He also painted in his leisure hours. No artist has been more famous than he. Louis XIV wanted him in France, and he went there like a man who thought to honor France. Besides five *Louis d'or* a day for the sojourn of eight months, he received a gift of 5000 *scudi* and an annual pension of 2000, with another of 500 for his son: journeys lavishly rewarded. The result of this expedition was a design for the facade of the Louvre, a design brilliant for its eccentricities and unexecuted. Bernini made many busts in France and, back in Rome, he executed an equestrian statue for the king to express his gratitude. But this statue had no other merit than to be colossal, and in France it was afterwards transformed into a Marcus Curtius.

• • •

Bernini's mind was lively, quick, and abundant. In his sculptures one observes an ease of conception and execution, and a lack of prudence and purity. His gifts are brilliant vices. He was the first to introduce license and errors under the pretext of grace: flesh too soft and without true beauty; not expression, but exaggeration and affected attitudes; a fine execution, but tortured and mean; ingenious ideas, new motifs, and projects large, rich, bold, and original.

• • •

As a sculptor, Bernini sought solely to dazzle the eye and to this end he gave himself up to the fantastic, sacrificed correctness for brilliance, and distorted every form. He is most mannered in the

draperies, and as prodigal in their use as the Greeks were restrained. Bernini is the antipode of Michelangelo: the latter instructs and, with his austerity, repels; Bernini pleases with his seductions, entices and entices into errors. As an architect he was resourceful and licentious: his agreeable license has opened the way to the Borrominesque deliriums. From his infancy and throughout the course of his very long life, Bernini was surrounded by the masterpieces of antiquity existing in Rome. He saw them every day, at every hour. Yet he renounced them so completely, it is as if he had never seen them. He renounced that beautiful simplicity; indeed he trampled upon it, and instead embraced affectation. With his abundant talent, he impetuously scorned the laws established by the sage, ancient artists to devote himself entirely to his caprices. His caprices pleased and in the seventeenth century he wielded the scepter in two arts, that of sculpture and that of architecture. To the extent that his fame was great, so was he harmful to the arts. He corrupted them and his authority caused their ruin. To abandon simplicity is to abandon beauty.

• • •

This artist was one of the most favored by nature and by fortune; he was admired and imitated and meanwhile is not worth imitation. He pursued a mistaken path especially in sculpture. But how does one so talented go astray? During the two centuries which had preceded him, the renascent arts had passed through all the stages of weakness, of growth, and of improvement. The artists had secured for themselves all honor for following the rules and the ancient models. Bernini, therefore, to become illustrious, made himself original. He thought to achieve glory with exaggeration, with extravagance, and with ostentation. His pomp prevailed; it seduced the eyes of many who have naught but eyes. He was praised and flattered by those who call themselves great but are really small; finally he had to be imitated by many people who flee the fatigue of thinking. Nothing is easier than irregularity; therefore it was courted and promoted by a long series of followers.

THE VILLA BORGHESE:
BERNINI

John Moore

. . .Of the villas, the Pineiana, which belongs to the Borghese family, is the most remarkable. I shall confine myself to a few cursory remarks on some of the most esteemed curiosities it contains. The *Hermaphrodite*, of which you have seen so many prints and models, is accounted by many, one of the finest pieces of sculpture in the world. The mattress, upon which this fine figure reclines, is the work of the Cavalier Bernini, and nothing can be more admirably executed. Some critics say, he has performed his task *too well*, because the admiration of the spectator is divided between the statue and the mattress. This, however, ought not to be imputed as a fault to that great artist; since he condescended to make it at all, it was his business to make it as perfect as possible.

I have heard of an artist at Versailles, in a different line, who attempted something of the same nature; he had exerted all his abilities in making a periwig for a celebrated preacher, who was to preach on a particular occasion before the court; and he imagined he had succeeded to a miracle. "I'll be hanged," said he to one of his companions, "if his Majesty, or any man of taste, will pay much attention to the *sermon* today."

In this Villa, there are also some highly esteemed pieces by Bernini. Aeneas carrying his father; David slinging the stone at Goliath; and Apollo pursuing Daphne: the last is generally reckoned Bernini's masterpiece; for my part, I have so bad a taste as to prefer the second. The figure of David is nervous, with great anatomical justness, and a strong expression of keenness and exertion to hit his

"The Villa Borghese: Bernini." Excerpted from John Moore, *A View of Society and Manners in Italy* (London: W. Strahan & T. Cadell, 1781), pp. 491–500.

mark, and kill his enemy; but the countenance of David wants dignity. An antique artist, perhaps, could not have given more ardour, but he would have given more nobleness to the features of David. Some may say, that as he was but a shepherd, it was proper he should have the look of a clown; but it ought to be remembered, that David was a very extraordinary man; and if the artist who formed the Belvedere Apollo, or if Agasias the Ephesian, had treated the same subject, I imagine they would have rendered their work more interesting, by blending the noble air of an hero with the simple appearance of a shepherd. The figures of Apollo and Daphne err in a different manner. The face and figure of Apollo are deficient in simplicity; the noble simplicity of the best antique statues: he runs with affected graces, and his astonishment at the beginning transformation of his mistress is not, in my opinion, naturally expressed, but seems rather the exaggerated astonishment of an actor. The form and shape of Daphne are delicately executed; but in her face, beauty is, in some degree, sacrificed to the expression of terror; her features are too much distorted by fear. An antique artist would have made her less afraid, that she might have been more beautiful. In expressing terror, pain, and other impressions, there is a point where the beauty of the finest countenance ends, and deformity begins. I am indebted to Mr. Lock for this observation. In some conversations I had with him at Cologne, on the subject of Sculpture, that gentleman remarked, that it was in the willful and temperate exertion of her powers, in this noblest province of the art, *expression*, that ancient sculpture so much excelled the modern. She knew its limits, and had ascertained them with precision. As far as expression would go hand in hand with grace and beauty, in subjects intended to excite sympathy, she indulged her chisel; but where agony threatened to induce distortion, and obliterated beauty, she wisely set bounds to imitation, remembering, that though it may be moral to pity ugliness in distress, it is more natural to pity beauty in the same situation; and that her business was not to give the strongest representation of nature, but the representation which would interest us most. That ingenious gentleman, I remember, observed at the same time, that the Greek artists have been accused of having sacrificed character too much to technical proportion. He continued to observe, that what is usually called character in a face, is probably excess in some of its parts, and particularly of those which are under the influence of the mind, the leading passion of which marks some feature for its own. A perfectly symmetrical face bears no mark of the influence of either the passions or the understanding, and reminds you of Prometheus's clay without his fire. On the other hand, the moderns,

by sacrificing too liberally those technical proportions, which, when religiously observed, produce beauty, to expression, have generally lost the very point which they contended for. They seemed to think, that when a passion was to be expressed, it could not be expressed too strongly; and that sympathy always followed in an exact proportion with the strength of the passion, and the force of its expression. But passions, in their extreme, instead of producing sympathy, generally excite feelings diametrically opposite. A vehement and clamorous demand of pity is received with neglect, and sometimes with disgust; whilst a patient and silent acquiescence under the pressure of mental affliction, or severe bodily pain, finds every heart upon an union with its sufferings. The ancients knew to what extent expression may be carried, with good effect. The author of the famous Laocoön, in the Vatican, knew where to stop, and if the figure had been alone, it would have been perfect; there is exquisite anguish in the countenance, but it is borne in silence, and without distortion of features. Puget thought he could go beyond the author of the Laocoön; he gave voice to his Milo; he made him roaring with pain, and lost the sympathy of the spectator. . . .

BERNINI'S ART

George Stillman Hillard

The huge, uncouth structure, reared over the high altar, awakens, both from its ugliness and inappropriateness, a double effusion of iconoclastic zeal. It is a baldachino, or canopy, of bronze, ninety-three feet high, and resting on four twisted columns of the same material; the whole elaborately ornamented and richly gilded. It is difficult to imagine on what ground, or for what purpose, this costly fabric was placed here. It has neither beauty nor grandeur; and resembles nothing so much as a colossal four-post bedstead without the curtains. Its size is so immense, that it cannot be avoided, either by the eye or the mind. It is a pursuing and intrusive presence. Stand where we may—look where we will—it thrusts itself upon the attention. We wish it anywhere but where it is—under the dome, rearing its tawdry commonplace into that majestic space, and scrawling upon the air its feeble and affected lines of spiral.

The bronze, of which this baldachino is constructed is said to have been taken by Urban VIII from the Pantheon, a fact which gives a fresh coating to the dislike, which the mere sight of it awakens. . . .

St. Peter's is a world of art; but the specimens, with a few exceptions, are by no means of the first class. The period at which the building was so far completed as to admit of interior decorations, was the Alexandrian age of art. Bernini was to Michael Angelo what Lycophron was to Homer. The monuments to deceased popes erected here are all of them costly, and many magnificent. Some separate figures and portions of them are of great excellence, but few soar to the dignity, simplicity, and feeling of high monumental art. Most of

"Bernini's Art" by George Stillman Hillard. Excerpted from George Stillman Hillard, *Six Months in Italy* (Boston: Ticknor, Reed, and Fields, 1853).

them are framed upon a uniform model. They are pyramidal in their general outline: the statue of the deceased pope, kneeling, sitting, or standing, being the central and crowning figure. Below, is a sarcophagus, ornamented with bas-reliefs, flanked or supported by statues, in which all the resources of allegory are exhausted. Prudence, Justice, Charity, and Religion, lean, sprawl, or recline; and all endeavor, with more or less of ill-success, to do what marble never can do. . . .

In the monument to Urban VIII which is in the tribune, the genius of Bernini is seen in its most favorable aspect. The figure of the pope is in bronze, and full of expression; and the statues of Prudence and Justice, which are in marble, are fine specimens of cleverness and skill. They are not beautiful, still less, sublime. They want repose and dignity, but they are full of animation and spirit. They are somewhat exaggerated and redundant in their forms, like the pictures of Rubens; but they have the same vital energy.

In the same tribune—as if to give us the extreme points to which the genius of Bernini could rise and fall—is the most glaring offence against good taste in all St. Peter's; a fabric of bronze, in which is enclosed the identical chair in which St. Peter and his immediate successors officiated; that is we are told to believe so. Four fathers of the church hold up the bronze covering with their hands, but, in their attitude and position, they resemble dancing-masters rather than saints and theologians. Above, there is a pictorial representation of the Holy Ghost, a confused hubbub of clouds, gilding, rays, and cherubs; the whole design from top to bottom being nothing less than detestable.

● ● ●

In one of the upper rooms [of the Villa Borghese, today in a lower room] is a very remarkable marble group by Bernini, of Apollo and Daphne. It represents the moment when the flying nymph is seized by the god, and is already beginning to be transformed into a laurel. The upraised hands are terminated by twigs and leaves instead of fingers. The feet are rooted in the ground, and the whole of the lower part of the form is barked about and enveloped in foliage in a manner wonderful to look at and difficult to describe. The face, thrown back, breathes the repose of death. Apollo, a light, graceful figure, is in eager pursuit, with arms outstretched, and drapery flying back from the rapidity of his movement.

In mere technical dexterity and mechanical skill, this group excels anything of the kind I have ever seen. It is a miracle of manipulation. It is such a work as would, beforehand, have been

pronounced an absolute impossibility; and, as it is, we look at it with a sort of incredulous wonder as if there must be some trick about it, and that it could not be what it purports to be. The manner in which the flesh passes away into foliage is something quite indescribable, and remains a mystery after careful examination. Such a work would have been esteemed very remarkable if cut out of pine wood, but, wrought as it is in marble, it appears rather the result of magic than of mortal tools and fingers.

In the same apartment are two other works of Bernini, David with a sling, and Aeneas carrying Anchises, both of considerable merit. These, and the Apollo and Daphne, were all executed by him between his fifteenth and eighteenth year; an instance of precocity in sculpture quite without parallel, and at least equal to that of Chatterton in poetry. These statues show the natural vigor of his genius, as many of his later works give proof of the false direction which it took under the influence of bad taste and corrupting patronage. Had the path in which his powers moved been as true as their moving impulse was strong, he would have surpassed every name in modern sculpture, except that of Michael Angelo. When we turn from these works of the Villa Borghese to the clumsy fountain in the Piazza Navona, the bronze covering of the chair of St. Peter's, and the vile statue of Sta. Theresa in the Church of Sta. Maria della Vittoria, it is difficult to imagine that they all proceeded from the same mind; still less, that the works done in the green tree should so far surpass those done in the dry.

THE CICERONE: BERNINI

Jacob Burckhardt

By about the year 1630, the vitality of the sculptural style that began with Andrea Sansovino had been completely exhausted. Sculpture had sought to shape in a truly sculptural sense; from time to time the better sculptors had individually struggled out of the moribund manners of the Roman School of painting towards an increasingly pure and true principle of representation; and the proper basis of Sculpture, the self-contained representation of the human figure according to fixed laws of equilibrium and contrast, seemed assured. But in the last half century (about 1580–1630) this art had still not attained a pure and convincing character. Partly there is too much turbidity in it (the above-mentioned Roman manners, the old and the new naturalistic influences, the seductive audacity of Michelangelo, the lack of principles for the drapery), partly it lacks artists of effective individuality—of genuine, fresh powers, since at that time all the best artists turned to Painting. Why did they do this? Because generally only in Painting could the artistic genius of the time express itself fully.

For several decades Painting now had a new style, while Sculpture worked in an old one. Finally, Sculpture resolved to follow Painting (of which it is otherwise the predecessor) and to make that means of interpretation wholly its own. Even in the fifteenth century, the relief is an appendage of Painting; freestanding sculpture, through the greatest efforts of the masters of the Golden Age, had been preserved for a while from this fate—now it succumbed too. What the spirit of this Painting was, which henceforth also lives in Sculpture,

"The Cicerone: Bernini." Excerpted and trans. by George C. Bauer from Jacob Burckhardt, *Der Cicerone: Eine Anleitung zum Genuss der Kunstwerke Italiens* (Basel: Schweighauser'sche Verlags-buchhandlung, 1855), pp. 690–703.

will be described below in its place. In Painting we can admit its grandeur and its justification. In Sculpture the most important principles of the genre are lost because of it, and it no longer produces a noble, that is to say, ideal work that does not contain a grievous contradiction. Not without sorrow do we see vast means and individual, very great talents employed in *the* Sculpture, which during the following century and a half (1630–1780) held sway over Italy and from there prevailed over the whole world. Its victory was quick and irresistible, as everywhere in the history of art when something resolute overcomes what is irresolute.

But we may still not pass over Sculpture here. Its subjective powers—in contrast to the previous period—were uncommonly great, its activity of a kind that has left more monuments in Italy than the entire sum of everything earlier, antiquity excepted. It has, moreover, a very decided decorative value in relationship to architecture and to the organization of great ensembles, and, finally, it produced some things of such excellence, that one grants some indulgence to the rest as well.

As is well known, the man of destiny was *Lorenzo Bernini* of Naples (1598–1680) who as architect and sculptor, as the favorite of Urban VIII and many succeeding popes enjoyed a princely position, and who in his later years was without question esteemed as the greatest artist of his age. He then also overshadows all those who follow to such an extent that it is superfluous to investigate the nuances of their styles more closely. . . .

The compelling force which carried Sculpture along with it, was the prevailing style of Painting which, triumphant from about 1580, had succeeded the mannerism of the period from 1530 on. This style reveals two major characteristics, which permeate it and condition one another: (1) *the naturalism of the forms and of the conception of events,* which were given a more noble stamp by the Bolognese School, a more common one by the Neapolitan; and (2) the use of *emotion* at any price. In order to be forceful the painters proceed in a naturalistic way and, on the other hand, they are pleased with only the most real manner of expression possible in respect to the emotion. This actuality, because it at the same time was so *effective,* Sculpture now adopted for itself. The relationship of Sculpture to the antique was henceforth no closer than, for example, that we find in Guido and Guercino—the borrowing of a few isolated motifs. Bernini personally perceived the merit of the antique quite well and recognized, for example, in the mutilated Pasquino, the Golden Age of Grecian art;

only as an artist did he advance in a completely different direction.

It stands to reason that he and his school solved those tasks best in which naturalism is justified (albeit not unconditionally). To this category belongs the *portrait*. Already in the preceding period of a true and half-false idealism, the bust had been, in general, good—indeed, sometimes the best work done in this art; and now this relationship persisted in a splendid way. The tombs of Rome, Naples, Florence, and Venice contain many hundreds of very excellent busts of this kind, which stand as worthy parallels to the painted portraits from Van Dyck to Rigaud. In them character is not idealized, but rendered in a freer, more grandiose manner, as can only be done by a Sculpture entrusted with the greatest ideal tasks. . . .

The so-called *character heads* follow entirely the manner of the painters of that time and, indeed, not of the better ones. *Bernini* himself is much closer to Pietro da Cortona than, say, Guercino; his masculine figures are part of that common-heroic expression which first became predominant in Painting from the epoch of complete vacuity (1650). In his *Constantine* (below, on the Scala Regia in the Vatican) one has the mean average of what he considered the dignified type of man and horse; in his *Pluto* (Villa Ludovisi [now Villa Borghese]), the form of the head is the Cortonesque tendency carried to excess.

Also his handling of the *human figure in general* is rightly to be condemned, even irrespective of the pose. To youthful and ideal bodies he added a soft fat that makes any real structure invisible and through a shiny polish becomes completely repugnant. The way in which Pluto's fingers press into the flesh of Proserpina is calculated for any other effect than an artistic one. His youthful work, *Apollo and Daphne* (Villa Borghese, upper [now lower] hall), is at least more tolerable, in spite of its lack of character, because it is not yet opulent. Later artists, to please the taste of their patrons, refined this tendency in every way.

To heroic and character figures Bernini gave an ostentatious *musculature*, which threatens to rival that in Michelangelo's figures, yet for all that, does not create an expression of true elastic strength, but looks like the inflated bags of a bellows. This again is due, in part, to the unfortunate polishing (*Pluto*, Villa Ludovisi [now Villa Borghese]). In the statues of the large River Gods (central fountain, Piazza Navona), which he himself did not execute, the much more favorable impression obviously depends on a plainer handling of the surfaces of the nudes. And where the task was truly suited to him, as for example, the *Triton* of the Piazza Barberini, in which that loathsome pretension

to elegance was dropped, Bernini satisfies completely. On the whole, he has perhaps created nothing better than this half-burlesque decorative figure, which with the shell and stem forms such a splendid and animated whole. As so often in modern Italian art just those means work superbly in the naturalistic and comic sphere which, in the ideal one, corrupt everything. . . .

The *drapery* is altogether a truly deplorable side of this style. How Bernini, in Rome, in the presence daily of the most beautiful draped statues of antiquity, went so astray remains a riddle. Of course, figures in togas and Muses could not serve him as models in any case, because he dealt with nothing but *movemented,* emotionally charged motifs which in Antiquity are represented almost exclusively by nude figures; but also given his task, he would have been obliged to stylize the drapery differently. He composes it, that is, entirely according to painterly principles and completely relinquishes its noble, sculptural value in the elucidation of bodily motifs.

In portrait statues, where emotion is omitted and *official dress* demanded a decided characterization of the material, this style displays excellent examples. From the time of Bernini's papal statues (monuments of Urban VIII and Alexander VII in St. Peter's) Sculpture endeavored with real pride to represent in their contrasts the heavy brittle purple of the embroidered pallium, the finely folded alb, the glossy fabric of the sleeves and tunic, etc. Of the statues of Pope Urban VIII the one on his tomb (in the choir of St. Peter's) is noteworthy for the special delicacy of individual parts of this kind—filigreed cuffs and borders, etc.; that in the great hall of the Conservator's Palace, on the other hand, is remarkable for the bold calculation of the effect from the distance. At times the Cardinal's dress was also treated well and with merit (Lateran, Cappella Corsini). When not damaged by ancient (and then badly ideal) costumes and violent movement, as for example in most equestrian monuments, princes, soldiers, and statesmen are, at least on the average, better than angels and saints. . . .

Ideal dress, however, engulfs the body in its far-flying masses and fluttering ends which, as the eye is well aware, must weigh a hundred-weight. The polish which Bernini and many of his followers thought necessary to distinguish the ideal garment, particularly that of a celestial being, completely destroys the drapery, which assumes the appearance of having been—if the comparison is permitted—carved with a spoon in almond jelly. Clay figures are therefore more tolerable than marble ones.

Now then, what was the *emotion* for the sake of which Bernini so willfully sacrificed the eternal laws of draping? It will be treated in detail in the discussion of Painting, for now Sculpture is under the tutelage of this art. Suffice it to say that at this stage a false dramatic life arises in Sculpture, that the art is no longer content with the representation of mere *existence* and desires an *action* at any price; only in this way did Sculpture believe itself to be of consequence. The less the violent action is motivated by a deep, inner necessity, the more willfully it is explicated in the drapery. But if this went so far, then it was generally no longer possible to preserve the sculptural composition. The insight, so hardwon, into the formal conditions under which alone a statue can be beautiful, that consciousness of the architectonic laws which alone protects and inspires this substance-bound genre— this was lost for one and one-half centuries.

Now even for individual statues (to say nothing of groups) some kind of *moment* is assumed that will explain their movement. Sometimes there were independent subjects, which were chosen for no other reason. Of this kind is Bernini's slinging *David* (Villa Borghese), which expresses the greatest outer tension of a universal youthful nature. But what moment was proper for the innumerable statues in churches, for all the angels and saints who came to stand on balustrades, in niches on facades or next to altars, and so on? The problem was no easy one! Bernini, for example, was responsible, directly or indirectly, for the 162 saints who stand on the Colonnade of St. Peter's; and similar, albeit less extensive series were not rarely put into execution for the decoration of architecture.

Here too Sculpture faithfully followed Painting and adopted from it the *ecstatically intensified expression of feelings* symbolized through gestures. Such an expression is, in and of itself, a perfectly appropriate subject for representation and may be given with the greatest beauty and purity; but if it becomes the rule and almost threatens to constitute the only content and standard, then it is more dangerous for sculpture than for painting, which through color and surroundings can introduce much more variation and new motivation and can ever anew deceive the eye.

With a kind of resolute despair Sculpture goes to its daily work. It exerts every effort to find accessory ideas: it gives the saint a putto with whom he can make conversation; it lets the Apostle furiously turn the pages of the book held before him (the series of Apostles by Monnot, Le Gros, and others in the pier niches of the Lateran); Mocchi's *St. Veronica* (St. Peter's) rushes headlong with the sudarium; Bernini's angels on the Ponte Sant'Angelo coquet quite lovingly with

the instruments of the Passion (the one with the superscription an autographic work by Bernini); and similar instances. In general, however, there are and remain just a few motifs which, only disguised, are very frequently repeated. For example, an inspired ascending, as from a dream, is recognizable (Bernini's statues in S. M. del Popolo, Chigi Chapel; in the Cappella del Voto of the Cathedral of Siena); as well as a fervent confession and affirmation (Bernini's *Longinus* in St. Peter's; also several of the founders of religious orders in the pier niches of St. Peter's; among these the *St. Ignatius Loyola* by *Giuseppe Rusconi* is distinguished by a more profound expression and a more thorough execution; most unforgivably bad is the *Blessed Alessandro Sauli* by Puget in S. M. di Carignano in Genoa, among others). . . .

Therefore nothing but yearning devotion and passivity translated into the momentary and the dramatic by fair means or by force—this is the content of the individual ecclesiastical statue. Bernini willingly gave such statues a further interest, meant to be piquant, by means of an all *too large structure* relative to the smallness of the niche (the above-mentioned statues in the Cathedral of Siena); the equalization of the two, of the statue and the niche, lies in the bent, strangely coiled postures and the like. To this forced momenteneity, this imaginary drama also belongs, quite consistently, the creation of the *attributes* in the same proportion to their actual size as are the figures. The Early Middle Ages had given to St. Lawrence only a little gridiron, had placed in the hand of Catherine only a little wheel. Now nothing more is known of such a suggestive, symbolic manner of representation; since it is a question of a situation in whose actuality the viewer is to believe, Lawrence must now receive a man-sized gridiron, Catherine a wagon wheel. . . .

From the structure of single figures we proceed to the *groups*, several of which have already been mentioned in passing. An epoch of art, which placed so great a value on the momentary and the dramatic and which in every art aimed at pomp and splendor, had to have a decided preference for great marble groups. But since, in comparison to the expression of actuality and the moment, it was indifferent to the higher, linear laws, as a rule, unsuccessful works had to appear.

In *secular groups* the theme of mythological abductions in particular is treated. Already in his early group of Apollo and Daphne, Bernini represented the exaggerated momenteneity, which made that age happy; the *Pluto* also belongs to this category. In time such subjects passed into the hands of stone-cutters of garden sculpture and then, on occasion, prove to be so amusing that one completely forgets

their impropriety. In the seventeenth and eighteenth centuries one seeks in vain for anything approaching the sculptural seriousness of Giovanni Bologna's *Rape of the Sabines.*

The groups for fountains have already been mentioned to some extent. In the one on the Piazza Navona Bernini strived for the expression of elementary natural forces in Michelangelo's sense, but instead of a merely powerful existence, even here he cannot suppress his *pathos*—a disadvantage which cannot be made up for by the simple, capable handling. Here one learns to appreciate Giovanni Bologna's fountain in the Boboli Gardens, which expresses in sculptural forms a strong architectonic sense and needs no irrational element like the natural crag arranged with great artifice in Bernini's work.

In the same way one must know the *sumptuous tombs* of this period and the way their groups are structured in order to fully appreciate Michelangelo's tombs in the Sacristy of S. Lorenzo. Bernini himself began the new series with the Tomb of Urban VIII in the choir of St. Peter's and he finished with that of Alexander VII (over a doorway, to the side from the left transept); the type of the former then continues to govern the sepulchers of Leo XI (by Algardi), Innocent XI (by Monnot), Gregory XIII (executed long after his death, only in 1733, by Camillo Rusconi; the best of this series), and Benedict XIV (by Pietro Bracci); to which are still to be added that of Benedict XIII in the Minerva (also by Bracci) and that of Clement XII in the Lateran (Cap. Corsini).

In general the best or most tolerable of the statues are naturally the *portrait statues* of the popes enthroned, standing, or kneeling above the sarcophagus—especially those by Bernini himself. As for the rest, however, the niche in which the sarcophagus stands is treated as a kind of stage upon which something must take place. Gugliemo della Porta had still permitted his *Justice* and *Prudence* to lie quietly on the sarcophagus of Paul III, although they are no longer so unconcerned with the viewer as are Michelangelo's *Day, Night,* and *Dusk.* But from the time of Bernini, the two female allegories must perform a *dramatic scene;* their position, therefore, is no longer on the sarcophagus, but to both sides of it, where, either standing or sitting (and then starting up), they can give free rein to their emotion. The content of this emotion is supposed to be, for the most part, sorrow and despair, admiration, and adoring ecstasy for the deceased, which each sculptor then sought to vary in his own way. Ecclesiastical decency now demanded the complete draping of the figures, so the most studied drapery motifs of that time are to be found on these tombs in St. Peter's. Bravura in

treating nudes was made up for by the adjoined putti. Moreover, Bernini—if I am not mistaken, for the first time since the Middle Ages—creates the hideous allegory of death in the form of a skeleton; on the tomb of Urban VIII it writes the end of the epitaph on a marble placard; on the monument of Alexander VII it raises the colossal drapery of yellow and brown flecked marble, beneath which is a door. Unfortunately just this "idea" found those eager to parrot it. . . .

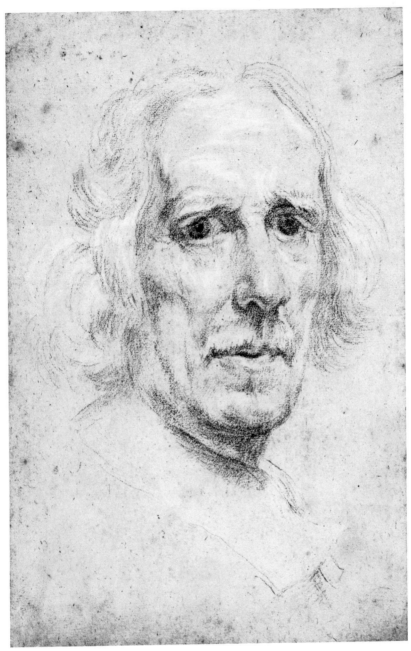

Fig. 1
BERNINI:
Self-Portrait (ca. 1665)
Windsor, Royal Library
(Reproduced by Gracious Permission of
Her Majesty Queen Elizabeth II)

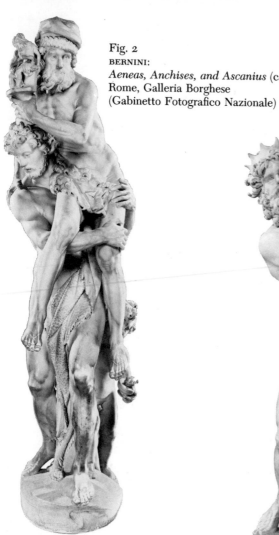

Fig. 2
BERNINI:
Aeneas, Anchises, and Ascanius (ca. 1619)
Rome, Galleria Borghese
(Gabinetto Fotografico Nazionale)

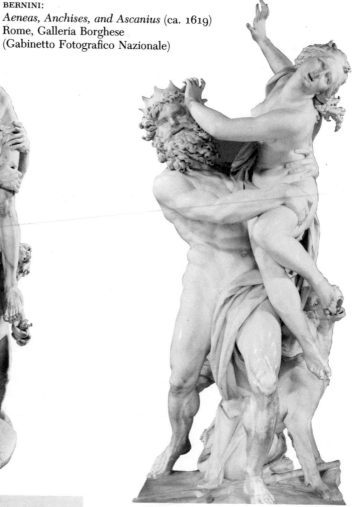

Fig. 3
BERNINI:
Pluto and Proserpina (1621–25)
Rome, Galleria Borghese
(Gabinetto Fotografico Nazionale)

Fig. 4
BERNINI:
Drawing for *Pluto and Proserpina*
Leipzig, Stadtsbibliothek
(From Brauer and Wittkower)

Fig. 5
BERNINI:
Detail of Fig. 3
(Gabinetto Fotografico Nazionale)

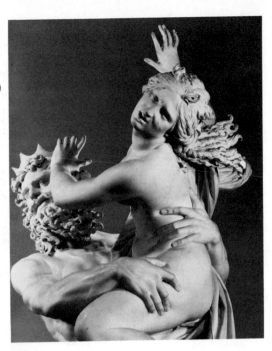

Fig. 5
BERNINI:
Detail of Fig. 3
(Gabinetto Fotografico Nazionale)

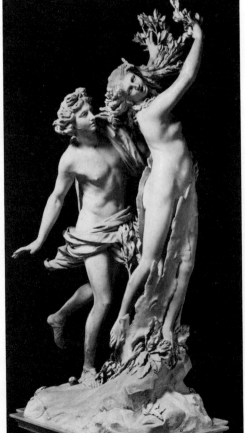

Fig. 6
BERNINI:
Apollo and Daphne (1622–25)
Rome, Galleria Borghese (Alinari)

Fig. 7
BERNINI:
Detail of Fig. 6
(Gabinetto Fotografico Nazionale)

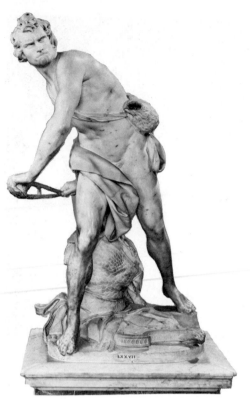

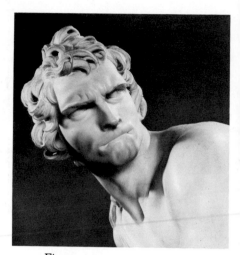

Fig. 9
BERNINI:
Detail of Fig. 8
(Gabinetto Fotografico Nazionale)

Fig. 8
BERNINI:
David (1623–24)
Rome, Galleria Borghese
(Gabinetto Fotografico Nazionale)

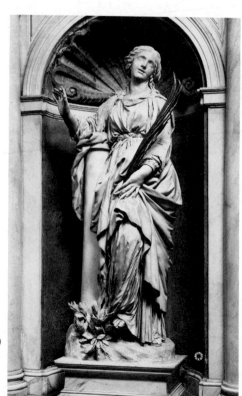

Fig. 10
BERNINI:
St. Bibiana (1624–26)
Rome, S. Bibiana (Anderson)

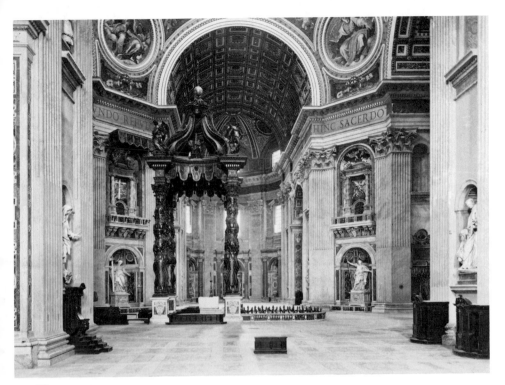

Fig. 11
Crossing of St. Peter's
Rome, St. Peter's (Alinari)

Fig. 12
BERNINI:
Baldacchino (1624–33)
Rome. St. Peter's (Alinari)

Fig. 13
BERNINI:
St. Longinus (1629–36)
Rome, St. Peter's (Anderson)

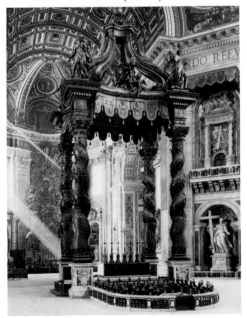

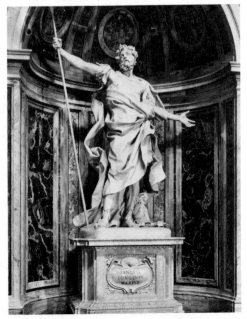

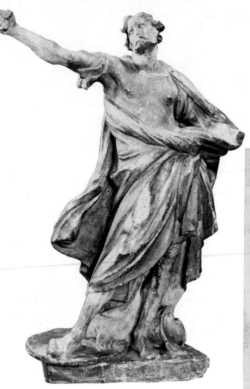

Fig. 14
BERNINI:
Bozzetto for the *St. Longinus*
Cambridge, Fogg Art Museum
(Courtesy of the Fogg Art Museum,
Harvard University; Purchase—
Alpheus Hyatt and Friends of the
Fogg Art Museum Funds)

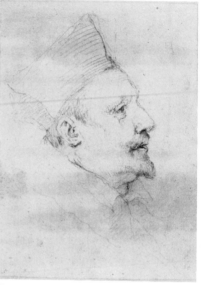

Fig. 16
BERNINI:
Detail of the *Bust of Cardinal
Scipione Borghese* (1632)
Rome, Galleria Borghese
(Gabinetto Fotografico Nazionale)

Fig. 15
BERNINI:
Portrait of Cardinal Scipione Borghese
New York, The Pierpont Morgan Library
(Library photo)

Fig. 17
BERNINI:
Caricature, *"Cardinal Scipione Borghese"*
Rome, Biblioteca Vaticana
(From Brauer and Wittkower)

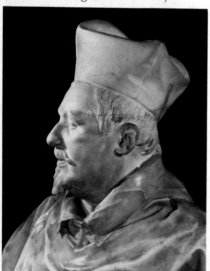

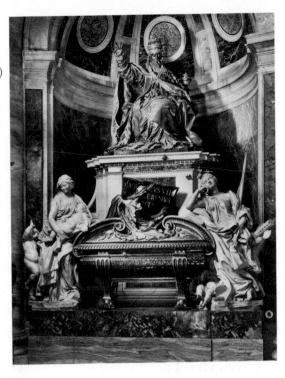

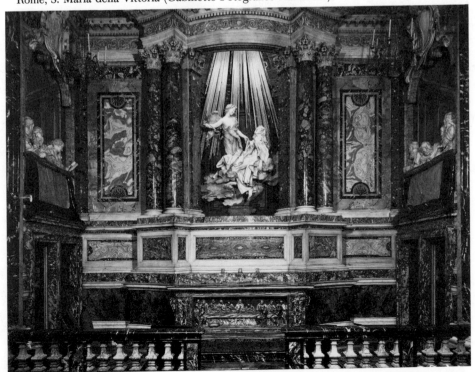

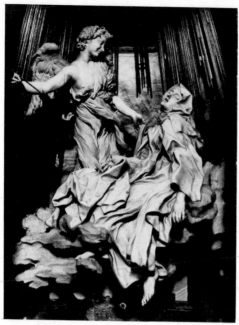

Fig. 20
BERNINI:
Detail of Fig. 19
The Ecstasy of St. Theresa (Anderson)

Fig. 21
BERNINI:
Detail of Fig. 20 (Alinari)

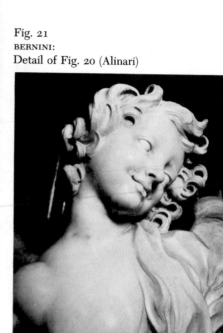

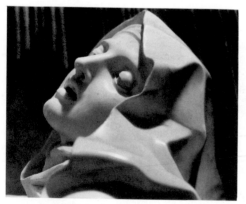

Fig. 22
BERNINI:
Detail of Fig. 20
(Gabinetto Fotografico Nazionale)

Fig. 23
BERNINI:
Truth (Verità) (1646–52)
Rome, Galleria Borghese (Anderson)

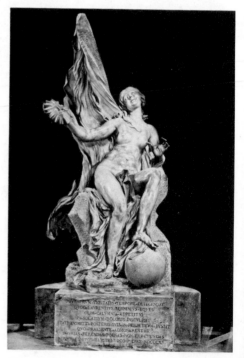

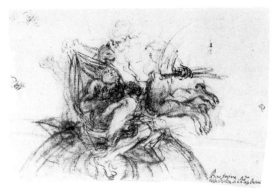

Fig. 24
BERNINI:
Drawing for the *Truth*
Leipzig, Stadtsbibliothek
(From Brauer and Wittkower)

Fig. 25
BERNINI:
Drawing for the *Truth*
Leipzig, Stadtsbibliothek
(From Brauer and Wittkower)

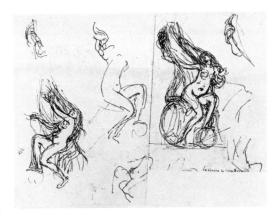

Fig. 26
BERNINI:
Fountain of the Four Rivers (1648–51)
Rome, Piazza Navona
(Gabinetto Fotografico Nazionale)

Fig. 27
BERNINI:
Detail of Fig. 26
(Gabinetto Fotografico Nazionale)

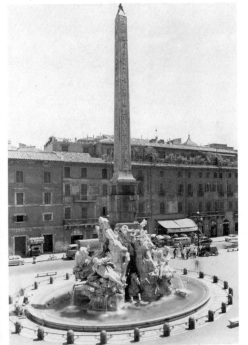

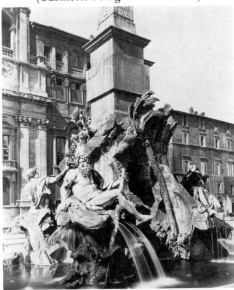

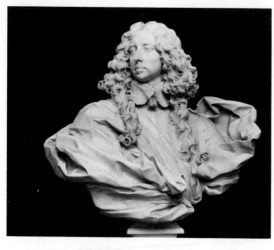

Fig. 28
BERNINI:
Bust of Francesco d'Este (1650–51)
Modena, Galleria Estense
(Gabinetto Fotografico Nazionale)

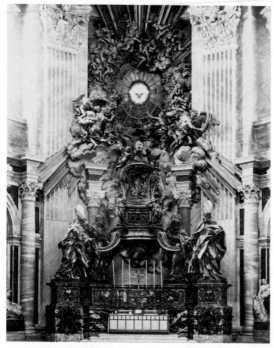

Fig. 29
BERNINI:
Cathedra Petri (1657–66)
Rome, St. Peter's (Alinari)

Fig. 30
BERNINI:
Detail of Fig. 29 (Anderson)

Fig. 31
BERNINI:
Constantine (1654–70)
Vatican, Scala Regia (Alinari)

Fig. 32
BERNINI:
Bozzetto for the equestrian portrait
of Louis XIV
Rome, Galleria Borghese
(Gabinetto Fotografico Nazionale)

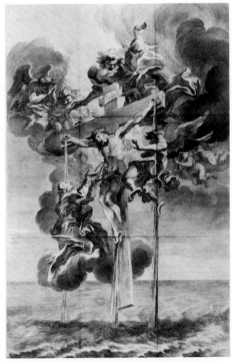

Fig. 33
BERNINI:
The *Sangue di Cristo*, engraving
(Photo: Irving Lavin)

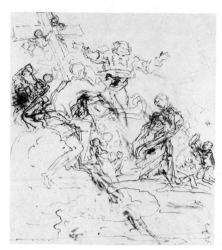

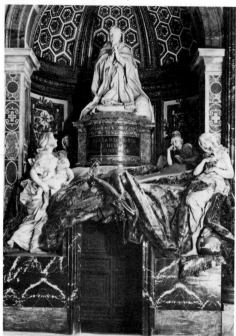

Fig. 35
BERNINI:
Tomb of Alexander VII (1671–78)
Rome, St. Peter's (Alinari)

Fig. 34
BERNINI:
The *Intercession of Christ and the Virgin*, drawing
Leipzig, Museum der bildenden
Künste, Graphische Sammlung
(From Brauer and Wittkower)

Fig. 36
BERNINI:
The *Blessed Ludovica Albertoni* (1674)
Rome, S. Francesco a Ripa
(Gabinetto Fotografico Nazionale)

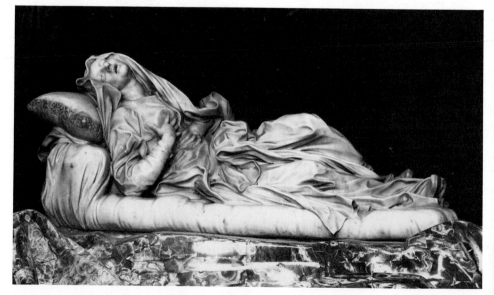

THE TOMB OF ALEXANDER VII

Stanislao Fraschetti

Documents in the Este archives reveal that in the tribune of S. Maria Maggiore planned by Bernini, Clement IX intended to have the artist build, besides his own tomb, that of Alexander VII as well.[1] In imitation of those by Sixtus V and Paul V, two great chapels were to be built in the lateral arms of the tribune, and in them were to be placed two magnificent sepulchers. But because of the death of Clement IX . . . the grand works were not executed.

Cardinal Chigi, however, wanted at all costs to see the monument to his great relative executed, and sought the advice of the master, who approved of the idea; but no longer able to carry out the work in the Liberian Basilica, he at once decided to erect it in St. Peter's.

In December of 1671 a huge model of the tomb made of wood and clay was prepared; it was finished in August of 1672,[2] and Bernini

"The Tomb of Alexander VII." Trans. by George C. Bauer from Stanislao Fraschetti, *Il Bernini* (Milan: U. Hoepli, 1900), pp. 384ff.

[1] "Most Serene Prince. Also, the pope has decided he wants to construct, opposite his own, a sepulcher for Alexander the Seventh, both to be built in the collateral parts of the above mentioned new tribune of Santa Maria Maggiore in imitation of the chapels built by Sixtus and Paul the Fifth. And to Your Highness I humbly bend my knee. Rome, 12 October 1669." (Archivio di Stato in Modena. *Avviso* dated 12 October 1669.)

[2] "Be it pleasing to Your Lordship to pay to Master Gio., sculptor, forty-five *scudi* that, with the other 125 already given, make the sum of 170 which are for the final and complete payment for all the sculpture and large models that the same did for making the tomb of Pope Alexander VII, of beloved memory. That is, for having made the model of the statue which represents Charity, in height fifteen *palmi*; and besides, another similar one which represents Truth; and two others, less than half-figures, which represent Justice and Prudence. And besides, for having made the model of the Death, twelve *palmi* high. And besides, for having made the model of

was paid with an order dated the seventh of the following October.[3] Based on the *bozzetti* made by the master, work was begun on large models for the statues.[4] Early in 1672 the sculptor Lazzaro Morelli, one of the artists who worked on the Ponte Sant'Angelo, made the model for the shroud of colored marble *[diaspro di Sicilia]* which was to adorn the monument.[5] This shroud was then executed by the same artist and his comrade, Pietro Balestra.

The work continued from 1672 until 1678. In the latter year the remains of Alexander VII were taken from the provisionary tomb in St. Peter's in which they had been deposited and placed with solemn pomp in the highly ornate monument.[6]

The sumptuous and strange structure, animated by the praying figure of the pontiff and by the four semi-nude allegories, appears within a grandiose niche, like those in the piers beneath the dome, all strewn with gold and colored marbles. The curtain of colored marble rises in broken waves like a stormy sea; it is lifted by a golden skeleton that, sneering horribly in the opening of the door, seems truly to express in its cruel symbolism:

Abandon all hope, you who enter.

The half-dressed women sink softly into the very rich shroud and on the pedestal of serpentine marble the white image of the pontiff, solemn in an ample pluvial, prays with folded hands.

the cloth that represents the shroud.—at Home, 25 August 1672.—GIO. LORENZO BERNINIJ." '(Archivio privato Chigi, Mandati.)

[3] Idem. *Mandato* [an order to pay] of Cardinal Chigi.

[4] Idem. "Be it pleasing to Your Lordship to pay to Master Gio., sculptor, twenty-five *scudi* on account for the large models that the aforesaid is making in conformity to the small ones made by me for the tomb of Alexander VII, of Blessed Memory, in St. Peter's.—at Home, 22 December 1671.—Your Servant, GIO. LORENZO BERNINIJ."

[5] Idem. "Be it pleasing to Your Lordship to pay to Mr. Lazzaro Morelli, sculptor, ten and one-half *scudi* which are the entire payment for having made a model of clay of the shroud for the tomb of Pope Alexander VII in St. Peter's; and having taken this to the travertine quarry in Tivoli and going himself to cut it, for the purpose of lightening it, so it could be carried to Rome.—at Home, 11 May 1672.—Your Servant, GIO. LORENZO BERNINIJ."

[6] "Work done by Master Antonio Turlone, stone mason, in removing the coffin of Pope Alexander the Seventh, of Blessed Memory, by order of the Cav. Bernini, as above.

"For having opened the wall where the said coffin was immured, working at night with men to the number of 12, part to open, and part to carry away the refuse and the rubble from the church of St. Peter's; and for having, during the day, transported the coffin into the Choir of the Canons who assisted in the ceremonies; and then transporting the coffin in front of the tomb of the pope; and then the next night from the said place placing it in the tomb and working it up, etc.—2 July 1678—Signed: GIO. LORENZO BERNINIJ and MATTIA DE ROSSI." (Archivio privato Chigi, Mandati.)

In this sepulcher, more than in any other, is manifest that mania for the ostentatious and vain luxury which the splendid lords of the seventeenth century loved and demanded even in the tomb. The accumulation of marble, of stucco, of bronze, of gold strangely mixed together with the conjunction of frank nudity and the horrible skeleton feigned in bronze, expresses, in fact, a strangely artificial sentiment, not in keeping with the solemnity of the sepulcher. Here is, finally, the triumph of the Baroque in all of its originality and also in its gaucherie: in this work the artist who was perfect in the *Daphne*, pure in the S. *Bibiana*, profound in the S. *Teresa*, feeling himself invaded by the fever of old age, becomes frivolous and unrecognizably audacious. Art for him no longer has rules or aesthetic perfection, but, in a fantastic accumulation of bizarre and disparate forms, it strives, torments itself to achieve effects never seen before, which more than soothing the eye with their harmony and stimulating thought, are to disturb with strange and coarse contrasts. The Cavalier Marino had proclaimed:

> The marvelous is the poet's aim;
> Who cannot astonish, should hide his shame!

And the artist, like the poet, intended the same end. In the particular case this applies to the conceit; as for the execution one cannot speak of the art of Bernini, because from the style of the individual parts and from the documents in the Chigi Archives, it is evident that the artist worked only on the head of the pope.

This beautiful statue is the only harmonious part of the monument upon which the eye rests quietly; it rises above the great pedestal on which one reads in letters of gold the words:

ALEXANDER CHISIUS PONT. MAX.

The face appears carefully studied in the minute wrinkles, and in the Van Dyck beard and mustache, which recall the appearance of a medieval condottiere. The hair is neatly parted on the high forehead and appears subtly worked around the very fine ears. The wrinkled hands, rendered with an exquisite touch, are joined in prayer in an attitude full of simplicity. The ample pluvial, embroidered with arabesques, falls in large, broken folds and is open in front to reveal the richly embroidered silk vestment and sleeves, which are cut with rare delicacy. The pope kneels on a pillow decorated with gold brocade beside which one sees the gem-studded tiara. The rough

cutting of the statue was begun in 1675 by the stone mason Tommaso Santi[7] and by the sculptor Michele Maglia,[8] the lace on the surplice was carved by the sculptor Giulio Cartari, a capable pupil of Bernini's who had the good fortune to accompany him to Paris,[9] and the carver Domenico Basciadonne executed the embroidery on the pluvial and stole, and the gems on the tiara.[10] Without any doubt, our artist executed the head of the beautiful statue, a fact one can also infer from the lack of orders to pay for the work on this part.

The statue of Truth was represented completely nude, like the one from the famous unfinished group, and certainly, together with the other one on the monument of Paul III, was ill at ease in the *Basilica Maxima*; and it is for that reason that the austere pontiff, Innocent XI, ordered Bernini to cover her with a bronze chemise painted white. The nude, allegorical figure has a coarse face, animated by large, doll-like eyes and surrounded by thick cord-like bundles of hair. She lays her shapely arms on her full breast—now poorly protected by the rough chemise—and one of her feet is placed on a globe constellated with gold. The large model in clay for this figure was executed by the sculptor Giuseppe Mazzoli;[11] the marble was blocked out by the stone mason Tommaso Santi;[12] and the handsome woman was carved, first

[7] "Be it pleasing to Your Lordship to pay to Master Tommaso Santi, stone cutter, ten *scudi* which are for roughing out the statue of Pope Alexander VII which is for St. Peter's.—at Home, 24 July 1675—GIO. LORENZO BERNINIJ." (Archivio privato Chigi.)

[8] Idem. "Be it pleasing to Your Lordship to pay to Mr. Michele Maglia, sculptor, twenty-five *scudi* which are for working on the statue of Pope Alexander VII which is being made to be placed in St. Peter's.—at Home, 24 July 1675.—GIO. LORENZO BERNINIJ."

[9] Idem. "Be it pleasing to Your Lordship to pay to Mr. Giulio Cartari, sculptor, twenty-four *scudi* which are for having worked on the cutwork and lace of the surplice of the statue of the pope.—at Home, 23 June 1677.—GIO. LORENZO BERNINIJ."

[10] "Be it pleasing to Your Lordship to pay to Master Domenico Basciadonne, carver, forty-five *scudi* which are for having worked on the embroidery of the pluvial and stole of the statue of the pope; and for having cut the jewels on the crown of the said statue which is located in St. Peter's.—at Home, 29 May 1677.—GIO. LORENZO BERNINIJ." (Archivio privato Chigi.)

[11] Idem. "Be it pleasing to Your Lordship to pay to Mr. Giuseppe Mazzoli, sculptor, twenty *scudi* on account for the work in clay that the said is doing for the statue of Truth that is on the tomb of Pope Alexander VII, of Blessed Memory.—at Home, 1 Nov. 1672.—Your Servant, GIO. LORENZO BERNINIJ."

[12] Idem. *Mandato* of 2 September 1673.

by Lazzaro Morelli,[13] and then by Giulio Cartari.[14] The clay model for the drapery with which the statue was covered was executed by the sculptor Filippo Carcani[15] and was then cast by the noted founder Girolamo Lucenti.[16] As one can see, the documents in the Chigi Archives prove the inaccuracy of the assertions of Titi, Canellieri, and others who attribute this statue to the great sculptor, and add that "although truth is wont to please but little, this one pleased too much."

The allegory of Charity is an enormous baroque statue, abounding in opulent flesh and drapery so rich, so disorderly, and so vulgar, that it almost seems possessed by a frenzy of fecundity. She contrasts in particular with the serene and solemn aspect of the pontiff: she has a prominent nose, long, tousled hair which seems like skeins of string, and a neck almost sausage-like; the heavy, flaccid putto she carries in her arms appears smothered in fat. The drapery heaves on her breasts as in the angels of Bernini, and the modeling of the fine gown reveals her legs in a confused way. This strange, disheveled woman was

[13] Idem. "Most illustrious Lord. Be it pleasing to Your Lordship to pay to Mr. Lazzaro Morelli, sculptor, thirty *scudi* in money; they are for working on the statue of marble which represents the Truth; which statue is being made for the tomb of Pope Alexander VII.—at Home, the first of Nov. 1673.—Yours, GIO. LORENZO BERNINIJ."

[14] Idem. "Most Illustrious Lord. Be it pleasing to Your Lordship to pay to Giulio Cartari, sculptor, thirty-five *scudi;* they are for working on the statue of Truth that is being made for the sepulcher of Pope Alexander VII, of Happy Memory, in St. Peter's.—at Home, 29 March 1675.—Your Devoted Servant, GIO. LORENZO BERNINIJ."

[15] "Evaluation of work done for the purpose of sculpture in the service of the Most Eminent and Reverend Lord Card. Chigi in aiding to make the model of clay of the drapery that has been made to cover the figure of Truth on the tomb of Pope Alexander VII, of Blessed Memory, in the church of St. Peter's; bill made by Filippo Carcani, sculptor.

"For having aided in making the said drapery of clay for the said figure as ordered the Cav. Bernini.—For having given both the color and tint of marble with white and varnish, etc.—on the 22nd Dec. 1678.—GIO. LORENZO BERNINIJ."

[16] Idem. "Bill of work done by order of the Most Illustrious Sir, Gio. Lorenzo Bernini, in the service of the Most Eminent and Reverend Lord Card. Chigi in making or casting the drapery of metal to cover the figure of Truth on the tomb of Pope Alexander VII, of Blessed Memory, in the church of St. Peter's, all done by Girolamo Lucenti, founder, at his own expense, excepting the metal.—For having formed the model, which was of clay on the marble figure, for having formed the wax with cast plaster, and for having then cast it all in metal at my own expense, excepting the cost of the metal, as above, and not including in the said bill the cleaning of the wax and the putting together of them, which were paid in part, etc.—(signed) GIO. LORENZO BERNINIJ."

executed by the sculptor Giuseppe Mazzoli[17] from a block roughed out by Tommaso Santi.[18]

The allegory of Prudence which, like that of Justice, appears in half-length behind the pall of colored marble, was executed by Giulio Cartari.[19] She, too, is disheveled. She turns her head to the left, admiring herself in the mirror, and her pose is full of affectation—similar to that found in the *Truth*, which, as was said, was also sculpted by Cartari. *Justice*, finally, has her curly head covered by a helmet; she supports her stern face on her right hand in an attitude of meditation and holds an inverted balance in her left. This figure—perhaps begun by Paolo Bernini—was finished by the sculptor Pietro Balestra.[20]

The gilded and tragic keeper of the gate who, concealed in the dusky doorway and carrying a winged hourglass aloft like a trophy, almost makes one tremble, was executed in wax by Morelli,[21] cast in bronze by Lucenti,[22] and gilded by the sword maker Carlo Mattei.[23]

The original and bizarre work, in which artificiality truly triumphs in the violent conceit and in the unnatural, swollen details of the human forms, was entirely completed towards the end of 1678.

The grand and ostentatious monument which cannot, certainly, be accepted as the manifestation of a healthy and composed art, is nevertheless admirable for the elegant line of the composition, for the harmonious decorative organization, and for the movement of the figures which, if disordered and confused, is movement. . . .

[17] "Be it pleasing to Your Lordship to pay to Mr. Giuseppe Mazzoli, sculptor, thirty *scudi* in money; they are for working on the statue of Charity that goes on the tomb of Pope Alexander VII.—at Home, 17 Nov. 1673.—GIO. LORENZO BERNINIJ." (Archivio privato Chigi.)

[18] Idem. *Mandato* of 11 February 1673.

[19] Idem. "Be it pleasing to Your Lordship to pay to Mr. Giulio Cartari, sculptor, thirty *scudi* for working on the statue of Prudence that goes on the tomb of Pope Alexander in St. Peter's.—at Home, 23 Jan. 1676.—GIO. LORENZO BERNINIJ."

[20] Idem. "Very Illustrious Lord. Be it pleasing to Your Lordship to pay to Pietro Balestra, sculptor, twenty-one *scudi*, that is, eighteen *scudi* for working and polishing the statues of Justice and Prudence, and three *scudi* to give to Mr. Michelangelo Maltese, painter, for having designed and colored two times the map of the world of the statue of Truth that is on the tomb of Pope Alexander in St. Peter's. I bend my knee.—at Home, 22 January 1678.—Your Servant, GIO. LORENZO BERNINIJ."

[21] Idem. "Be it pleasing to Your Lordship to pay to Mr. Lazzaro Morelli, sculptor, twenty-five *scudi* in money; they are for having worked in fitting the wax of the Death over the drapery and cleaning it to be able to cast it in metal.—at Home, 23 May 1676.—His Servant, GIO. LORENZO BERNINIJ."

[22] Idem. "Be it pleasing to Your Lordship to pay to Sir Lucenti twenty-five *scudi* in money; they are on account for the statue of Death that the said is casting of bronze for the tomb of Pope Alexander VII that goes in St. Peter's.—at Home, 23 July 1677.—GIO. LORENZO BERNINIJ."

[23] Idem. *Mandato* of 15 December 1677.

THE REPRESENTATION OF ECSTASY

Walther Weibel

An art founded on religious assumptions, which uses the representation of emotion as one of its chief means, must necessarily arrive at a rendering of the highest, most intense form of religious emotion—that of ecstasy.

The subject already appears in earlier art. Perugino, the sweet, Umbrian dreamer, "really made an occupation" out of the expression of emotion, which always speaks from his innumerable pictures with the same fluency. The great masters, however, have dealt with it more sparingly. Raphael painted only one transfigured Christ and only one Cecilia; and Titian painted the Assumption of the Virgin only once.[1] Correggio, on the other hand, used the expression of rapture with great mastery. Michelangelo represented the prophets and sibyls of the Sistine Chapel in a state which, in varying nuances, comes close to that of ecstasy. He was most successful where a deep absorption (Jeremiah), a slightly restrained activity, or a dream-like, prophetic look (Delphica) is shown; but Ezekiel and Jonah, who in their violent movement threaten to burst the frame, are rhetorical figures. They convince us very well that a fire burns in their speech, but not that the entire body and soul are consumed by burning passion.

Sodoma went a step further (1525) in the *Ecstasy of St. Catherine of Siena* (Siena, San Domenico). The saint has been unable to bear the sight of Christ; she has fallen into a faint and is supported by two sisters of her Order. This physiological conception of the event was

"The Representation of Ecstasy." From Walther Weibel, *Jesuitismus und Barockskulptur in Rom* (Strassburg: J.H.E. Heitz [Heitz & Mundel], 1909), Chap. V, pp. 82–94. (Excerpts, with slight abridgment and translation of the footnotes); trans. by Marianne Armstrong and George C. Bauer.

[1] Cf. Jacob Burckhardt, *Der Cicerone*. 7th ed., Leipzig 1898, p. 910.

soon generalized. "In the representation of ecstasy no higher moment was known than that of falling into a swoon." [2] The artists seem to have been aware that ecstasy did not only depend on a superficial excitation of the psyche, but they did not yet recognize the actual bodily processes and conditions which lead to this most extreme depth of religious emotion or occur as a consequence of it.

Bernini, too, in the beginning did not go beyond what had been done earlier. His *St. Bibiana* (1626), however, has raised her eyes to Heaven as tenderly as the Madonnas of Guido Reni; but nothing convinces us that it is not an empty declamation with which the saint only wishes to allude to the instruments of her martyrdom. In the relief of the *Stigmatization of St. Francis of Assisi* (Rome, S. Pietro in Montorio, ca. 1636) done by Bernini's student, Francesco Baratta, after drawings by the master, the saint, who is borne by two angels, has become unconscious after having received the stigmata. Further progress in the permeation of the entire body by a powerful emotion that erupts from a psychic agitation is suggested by the statue of St. Longinus (St. Peter's, 1638). It is the largest single figure by the master and a completely autographic work. The saint flourishes with wild rapture the miraculous lance that pierced the side of Christ. Venturi has even compared him to a dancing satyr from a bacchanal—if instead of the lance, he swung the thyrsus and did not hide his body beneath his robe.[3] The comparison is not a happy one. Longinus is conscious of his rapture; unlike the ancient satyrs, he is no naive child of nature. The figure is certainly heroic, but the limbs are so elastic, so purely muscular, that even for this the comparison with bacchanalian figures must be rejected. At most it holds true because the movement of the figure grips the whole body as does the rapture of a drunken faun. Any thought of a rhetorical pose ends here. In this man there truly lives a fiery demon and we believe him if he throws back his head and fixes his ecstatic eyes on Heaven.

The consummate solution of the task, however, was reserved for another work. In 1644 Bernini received a commission to furnish a statue of St. Teresa of Jesus, founder of the Reformed Order of the Barefoot Carmelites, for the church of S. Maria della Vittoria which was built by his protector Cardinal Scipione Borghese in memory of the Catholic victory at the Battle of White Mountain.

This work by Bernini must be dealt with at length because it is the master's most controversial. He himself declared it to be his best

[2] Ibid., p. 912.
[3] Adolfo Venturi, "Bernini." Article in *Pan*, V, 1899, pp. 57ff.

work,[4] and the criticism of his contemporaries justified him. Modern research, on the other hand, has expressed its opinion against it with especial vehemence, even with contempt. Burckhardt declared, "Here one certainly forgets all questions of style because of the scandalous degradation of the supernatural."[5] But while professional art historians have expressed themselves against this creation so harshly, some of the greatest thinkers of France have recently paid homage to the genius of Bernini: Stendhal, Taine, Zola. A work which arouses an admiration full of respect on one hand and, on the other, contemptuous hate, must at least bear the strong imprint of a personality.

Bernini's task was a large one. It meant creating the type for the representation of a great new saint who at that time was venerated in the widest circles. Teresa was so esteemed that, when they were to be canonized together, she was almost given priority over Ignatius of Loyola. Only with effort did the Jesuits succeed in having the name of the founder of the Society mentioned before that of the Spanish nun.[6]

In accordance with the importance of the task, the artist eagerly made every effort to create a work that would make the deepest impression on the mind of the believer. The group, completely autographic, was finished in three years, and Bernini also ensured, through the decoration of the Cornaro Chapel where it was to be placed, that it would be in harmony with its surroundings.

But, according to the principles of his style, in order to achieve a "painterly" effect, the artist had to make every effort to choose from the life of the saint what was "rich in emotion and movemented." It could not have been difficult for him to find these moments in the writings of the saint—which were certainly known in Rome at that time—and in the acts of the Congregation of the Rite.

How conscientiously Bernini undertook this task is shown by a passage from the autobiography of the saint. She writes:

> I did see an angel not far from me toward my left hand, in corporal form. . . . He was not great but little, very beautiful, his face so

[4] Filippo Baldinucci, *Vita del Cavaliere Gio. Lorenzo Bernino*. Milan 1812, p. 59.

[5] *Cicerone*, p. 191.

[6] Joh. Jos. Ign. von Döllinger and Fr. Heinrich Reusch, *Die Selbstbiographie des Kardinals Bellarmin, lateinisch und deutsch, mit geschichtlichen Erläuterungen.* Bonn 1887, p. 322 note. The canonization took place on February 16, 1622 and the names of those to be canonized were recited in the following order: Isidor, Ignatius Loyola, Francis Xavier, Teresa, Filippo Neri. The dispute over the order on this occasion is very characteristic for the ceremonial spirit of this epoch. For this see Leopold von Ranke, *Die römischen Päpste, ihre Kirche und ihr Staat im 16. und 17. Jahrhundert.* 3 vols. Berlin 1834, Vol. III, pp. 63f.

glorious, that he seemed to be one of the higher angels, which seem to be all enflamed, perhaps they are those which are called Seraphim. . . . I did see in his hand a long dart of gold, and at the end of the iron head it seemed to have a little fire, this he seemed to pass through my heart sometimes, and that it pierced to my entrails, which me thought he drew from me, when he pulled it out again, and he left me wholly enflamed in great love of God. . . .[7]

The passage was certainly known to the artist; in his work the angel is also on Teresa's left and how much the rest of the work corresponds to this vision may be shown by the splendid description of Taine:

> We returned to Santa Maria della Vittoria in order to see the St. *Theresa* of Bernini. She is adorable. In a swoon of ecstatic happiness lies the saint, with pendant hands, naked feet, and half-closed eyes, fallen in transports of blissful love. Her features are emaciated, but how noble! This is the true, high-born woman, "wasted by fire and tears," awaiting her beloved. Even to the folds of the drapery, even to the languor of her drooping hands, even to the sigh that dies on her half-closed lips, nothing is there in or about this form that does not express the voluptuous ardour and divine enthusiasm of transport. Words cannot render the sentiment of this affecting rapturous attitude. Fallen backward in a swoon, her whole being dissolves; the moment of agony has come, and she gasps; this is her last sigh, the emotion is too powerful. Meanwhile an angel arrives, a graceful, amiable young page of fourteen, in a light tunic open in front below the breast, and as pretty a page as could be dispatched to render an over-fond vassal happy. A semi-complacent, half-mischievous smile dimples the fresh glowing cheeks; the golden dart he holds indicates the exquisite, and at the same time terrible shock he is about to inflict on the lovely impassioned form before him. Nobody has ever executed a tenderer and more seductive romance. This Bernini, who in St. Peter's seemed to me so ridiculous, here conforms to the modern standard of sculpture, wholly based on expression; and to complete the effect he has arranged the light in a way to throw over the pale delicate countenance an illumination seeming to be that of an inward flame, as if, through the transfigured palpitating marble, one saw the spirit glowing like a lamp, flooded with rapture and felicity.[8]

[7] *Obras de la Gloriosa Madre Santa Teresa de Jesus, Fundadora de la Reforma de la Orden de Nuestra Señora del Carmen, de la primera Observancia.* New Printing. Brussels 1740. Vol. I, *Autobiografia,* Chap. 29, p. 138. [English translation from *The Lyf of the Mother, Teresa of Jesus,* trans. by W. M. of the S. J. (Antwerp, 1611), p. 232.]

[8] Hippolyte Taine, *Reise in Italien.* Vol. 1. Trans. by Ernst Hardt. Leipzig 1904, p. 260. [English translation from Taine, *Italy,* trans. by J. Durand (New York, 1871), p. 255.]

The words of Taine show clearly that he perceived the love of the angel as an earthly one. This is the main reproach directed against the work today. We already find it in Stendhal who in the 1820's wrote his *Promenades in Rome*. He relates:

> St. Teresa is represented in the ecstasy of divine love; here is the most ardent and the most natural expression. An angel who holds in his hand an arrow seems to uncover her breast to pierce her to the heart; he looks at her with a tranquil and smiling mien. What divine art! What voluptuousness? Our good monk believing that we did not understand it, explained this group to us: "E un gran peccato," he finished saying, that these statues can easily present the idea of a profane love.
>
> We have pardoned the Cavalier Bernini all the evil he has done to the arts. Has the Greek chisel produced anything of the equal to this head of St. Teresa? Bernini has known how to translate in this statue the most passionate writings of the young Spanish woman.[9]

This reproach of profanation, which in the accounts of Taine and Stendhal rings out over all the praise and which in Burckhardt forms the basis of the condemnation, would weigh heavily if the reports on the life of the saint and her own writings did not reveal why Bernini represented the subject in a way which has shocked many for the overt equation of the supernatural occurrence of a vision with a worldly scene of love. However, the principle of naturalism in the conception of events had to lead to this representation. Only by means of the physiological process accompanying the psychic one was it possible to illustrate sensibly the state of the saint during the vision.

From her youth the saint suffered from a severe illness, the nature of which can no longer be exactly determined. Because of the unusual frequency of visions and ecstasies one first thinks of a condition related to hysteria. A Jesuit, Father Hahn, maintained recently that the diabolical visions of the saint were the result of her hysterical inclination. Father Hahn, however, met with lively opposition, and his paper was placed on the Index.[10] The reporting officer of

[9] De Stendhal, *Promenades dans Rome*. Paris, ed. Calman-Lévy, Vol. I, p. 275. M. Valéry (Vol. IV, p. 109) comments similarly at about the same time. His work (*Voyages historiques et Littéraires en Italie pendant les années 1826, 1827 et 1828*. Paris 1833. 5 vols.) had then a signficance similar to that of the guide books of today.

[10] Cf. G. Hahn (S.J.), *Die Probleme der Hysterie und die Offenbarungen der heiligen Therese*. Trans. by Paul Prina. Leipzig 1906. When the book had already been placed on the Index and the French edition had been recalled, the work of a fellow member of the Order, Père Louis de San, *Etude pathologique-théologique sur Sainte Thérèse*. Louvain and Paris 1886, directed against his thesis was published. On Hysteria or Epilepsy cf. Hahn, p. 111, note 2.

the Congregation of the Rite, who had studied the Acts of the Canonization, held that the disease was epilepsy.

For the appraisal of the artistic ideal of the group, this dispute is only significant insofar as it definitely proves that in the visions and ecstasies of the saints bodily states occur which modern science would designate as pathological. Therefore, if Bernini, for instance, had made "clinical studies" of hysterical or epileptic seizures, as he appears to have done, then from the viewpoint of naturalism, once it was admitted, that would be completely justified. That he succeeded in its representation is demonstrated by the common judgment. Burckhardt, too, speaks of a "hysterical swoon" although a hysterical crisis is something other than a swoon.[11]

But even if the pathological condition of the saint, which by Teresa's own account got worse during the critical moments of visions and ecstasies, had been unknown to the artist or its nature unclear to him, the writings still suffice to account for his interpretation. That these were known to him is shown by the scrupulously exact conformity of his work with the passage from the autobiography cited above.

From her youth the saint had lived in total chastity; she was so completely inexperienced and naive in regard to sexual matters that this was especially mentioned by the investigators of the papal commission for her canonization.[12] It is all the more surprising then that her religious writings are animated by a fervent tone of love which is only rarely found in the literature of profane love. The joys of metaphysical love are described in passionate expressions; Teresa sings verses on the "divine union of love," and calls Jesus her lover; in a commentary on the Song of Songs she exceeds even the sensual, languorous breath of this poetical work. All the love of which her womanly heart was capable is concentrated in a metaphysical or sublime way upon God, but the expression which she gave to her feelings was scarcely different from that of a worldly passion.[13]

Her abnormal disposition, which was mentioned above, may have contributed to this effusiveness. Nevertheless, the whole current of the

[11] On the appearance of the hysterical crisis, that is, of its third period *(attitudes passionelles)* cf. ibid., p. 30.

[12] De San, op. cit., p. 25, note 2.

[13] The saint celebrates the love of God in the following way:

> *A questa divina union*
> *Del amor con que yo vivo,*
> *Haze à Dios ser mi cautivo,*
> *Y libre mi corazon:*
> *Mas causa en mi tal passion*
> *Ver à Dios mi prisionero,*
> *Que muero porque no muero.*

time was conducive to this mythic-erotic ideal. In Italy, however, the high point of this development occurred only several decades after the death of the saint (1564); but in spite of the very great influence which Spain undoubtedly exercised in the spiritual life of Italy in the second half of the Cinquecento and later, it cannot be accepted that the whole tendency developed from the writing of the Spanish nun alone. The parallel current in literature can be much more readily traced back to the erotic-romantic element in Ariosto's poetry. It culminated in the *Adonis* of the Cav. Marino, which an Italian researcher calls "the true epic poem of the Seicento, a poem of sentimental voluptuousness hidden beneath the hypocritical veil of allegory." [14] Nor did religious literature remain outside of this current. Perhaps we are dealing with the influence of Teresa's writings when the General of the Society of Jesus, Aquaviva (1581–1615) did not permit the printing of a commentary on the Song of Songs, because its expression, which hovers on the borders of sensual and spiritual love, appeared objectionable to him.[15] Even in the case of popular writings and sermons, a tone was chosen which today we would feel was objectionable. Father Orchi, for example, gave a sermon in Milan which was generally approved and which had a title that is impossible to translate: *"Le bevande amatorie date a bevere alla sposa dal suo servitore, per farla adulterare,"* by which he meant the carnal desires which seek to divert the soul from God.[16]

Such a widespread dissemination of these erotic allegories, through which the literati sought to exercise the greatest effect on their public, could not help but have repercussions on the formation of the plastic arts.[17] But this influence is found at its maximum in the group of St. Teresa.

(This divine union of love, with which I live, makes God my prisoner and frees my heart; but to see God in my captivity, creates in me such suffering, that I die, because I do not die.) *Obras*, op. cit., Vol. II, p. 361. Also in her prose writings, entirely leaving out her commentary on the Song of Songs, Teresa has chosen expressions that lie on the boundary of divine and profane love. For example, *"Gozan sin entender como gozan: está el alma abrassandose en amor, y no entiende como ama: conoce que goza de lo que ama, y no sabe, como lo goza: bien entiende que no es gozo que alcanza el entendimiento a dessearle."* (One enjoys without understanding how one enjoys: the soul is consuming itself in love and does not understand how it loves: it recognizes that it enjoys this that it loves and knows not how it enjoys: it understands well that it is not a pleasure that the understanding strives to reach.) *Obras*, Vol. I, *Camino de perfeccion*, Chap. XXV, p. 291.

[14] Ernesto Masi, "La reazione Cattolica" in *La vita italiana nel Seicento*. Milan, p. 63.

[15] Cf. Ranke, op. cit., II, p. 289.

[16] Nencioni. "Il Barocchismo" in *La vita italiana nel Seicento*, p. 270.

[17] Heinrich Wölfflin (*Renaissance und Barock. Eine Untersuchung über Wesen und*

Once Bernini had accepted the physiological basis of ecstasy, he had to let the whole body take part in the emotion that, because of the divine vision, originated in the soul of Teresa. Had he included in his artistic calculation only those parts which are generally used for the elucidation of the psychic processes—the physiognomy and the hands, then the result would have been a merely rhetorical pathos.

The saint lies on clouds, her upper body drawn back; the arms fall down wearily; the legs drawn somewhat into the body. The whole pose is such that one immediately obtains an impression of convulsions, of spasmodic movement not accompanied by the intellect. The wonderful head, whose beauty so enraptured Stendhal, is bent back on the neck as if from the painful thrust of a dagger. The eyes are half closed under leaden, fallen lids and rolled back almost completely so that the iris is only visible as a faint shadow on the upper edge of the white of the orb. The depression around the whole eye further strengthens the impression that a serious crisis shakes this frail woman. The nostrils seem to quiver; the mouth is convulsively opened, not in a scream, but barely in a deep moan. The lids, the nostrils, and the mouth are sharply undercut to create an effect of strong shadows.

The hands, the wonderful hands of Bernini, are worked out with the same care down to the smallest indentation of the little veins and the slightest projection of the cartilage and the folds in the skin. The inner agitation also burns in them; the fingers of the left hand, hanging down, are slightly bent, while in the cramped movement of the right hand the whole tremulousness of the soul is expressed.

Even the feet feel the inner ferment. One hangs free, the other is supported by the clouds; but in both, the toes are arched in such a way that we imagine we can trace the painful voluptuousness which thrills her to the uttermost extremity.

There is certainly no doubt, therefore, about the sensual (physiological) conception of the event on the part of Bernini. His contemporaries, who well knew everything associated with the erotic, must have realized this. Nevertheless the *St. Teresa* met with universal approbation even in church circles. One of Bernini's sons, who devoted himself

Entstehung des Barockstils in Italien, Munich 1888 [2nd ed. 1907], p. 73) rightly points out how much the heavenly-erotic works of the Baroque are related to the earthly-erotic works of the present *(Tristan und Isolde)*: "One will not fail to recognize how much our time is indeed related to the Italian Baroque—at least in individual phenomena. They are the same passions with which Richard Wagner worked. *'Ertrinken—versinken—unbewusst—höchste Lust!'* His artistry thus completely coincides with the Baroque expression of form. . . ." Nietzsche also points to the relationship of Richard Wagner and the great masters of the Baroque.

to a religious career and succeeded to a prelature, even lauded his father's work at a later time—something he would certainly not have been able to do had the group somehow caused offense because of its conception.[18] The reproach of lasciviousness was, therefore, first made by later generations; but this invalidates it, since we can only judge the intentions of the artist with the eyes of his own time.

[18] The poem [trans. above, p. 36], published by Baldinucci, op. cit., p. 59, reads:

> *Un sì dolce languire*
> *Esser dovea immortale;*
> *Ma perchè duol non sale*
> *Al cospetto divino,*
> *In questo sasso lo eternò il Bernino.*

From a volume of poems of that time, which describes famous paintings and statues, I quote one of the four poems on the Teresa group: *D. Theresiae Statua. Bernini in Corneliorum Sacello apud Discalceatos. Epigr. XLIII.*

> *Dum tota fervet intimis medullis*
> *Teresa, crescit et coruscus ignis,*
> *Amore flante Numinis; severam*
> *Ad alteram vocatur hinc palaestram.*
> *Intaminatum vulnera pectus.*
> *Nam visus Aliger, Deo jubente,*
> *Comisque blandusque, et serenus ore,*
> *Ferox sed armis, et manu trisulcum*
> *Vibrante telum, cuspide exacuta*
> *Haurire venas Virginis, sinumque.*
> *Vulnus, dolorem, languidumque pectus*
> *Testatur ipsum marmor, arte fictum.*
> *Quis credat? Infractumque frigidumque,*
> *Durumque saxum, tela ceu beata*
> *Perfert almae Virginis: frequenter*
> *Anhelat, aestuatque, conciditque.*
> *Doletque, languet, et mori videtur.*

[Of the Statue of Teresa by Bernini in the Chapel of the Cornaro in the Church of the Discalced: While Teresa glows within her heart,/Arises Love, the fiery Godhead/Giving forth; to the solemn palaestra/From here are called for her our prayers./Her breast is undefiled by wounds./But the angel, sent by God, in visage/Serene, loving and gracious, yet spirited/And armed, has quivering in hand the threefold/Spear that is sharpened to quickly pass through/The veins and bosom of the virgin./To the wound, the pain, the ennervated breast/Bears witness the marble with dissembling art./Who would believe it? Shafts as if blessed/Are borne to the soul of the virgin by broken/And cold, hard and obdurate stone./Often she gasps, and heaves, and swoons./And she suffers, languishes, and seems to die. Trans. by Margaret Murata.] (Silos, Joannes Michael, Bituntinus, *Pinacotheca sive Romana Pictura et Sculptura, Libri Duo, in quibus excellentes quaedam qua profanae, qua sacra, quae Romae extant, Picturae, ac Statuae, Epigrammatis exornantur.* Rome 1678, p. 189.)

The chisel of the artist was employed with special love on the Seraph, the gentle boy with the teasing smile. Here the marble has become truly malleable; the delicate flesh, the curling locks, and the soft feathers of the wings have no equal. The somewhat mischievous and ambiguous smile is the only thing for which we might today reproach the artist with a trace of justification, did not an eternal breath of ideality lay over the whole work.

For the naturalism of the representation has its limits. Not only in the formation of the clouds which look instead like barren rocks and are certainly not modeled after "the smoke of burning cornhusks," [19] but also in the drapery which is thoroughly ideal. Nowhere is the principle of Bernini's drapery of greater consequence or more magnificently carried out than in this group, in which the strongest emotion is represented. The intoxicating impression of sensuality depends for the most part on this factor; if the habit of the saint had been reproduced in a realistic sense, it would have formed such a contrast to the passionate movement of the figurative parts and so hidden the motif of the movement in Teresa's figure that, in spite of all the pathos, the master would never have realized the genuine emotion which was, above all, his intent. To a certain degree, the existing drapery is also contrasted with the motif of the body's movement, or rather, it is moved independently of the body; but it at least lets the existence of the body be assumed and in its effect supports the body's ardour. The dress of the Seraph, who as far as possible is nude, is much more quiet, the folds of his thin drapery much less deep.

The ideality is heightened by the painterly quality of the work. For in its composition and emplacement the *St. Teresa* is, without doubt, the work by Bernini in which "painterly" intentions were achieved with least restraint.

The group stands in an . . . apparently round chapel in which the direction of the light is regulated with the utmost care. Only the marble group stands out from the half darkness of the aedicule in a stream of light. It does not seem to rest solidly, but to float in a dreamlike, visionary twilight. Emile Zola has used the impression of this magical illumination to literary effect in *Rome*. The exquisitely characterized aesthete Narciss, who in the Sistine Chapel admired only the frescoes of the Quattrocento, goes every day to S. Maria della Vittoria to see the *St. Teresa*. One time he loves her in the early morning under the pale light of dawn which clothes her in white, then in the afternoon with all the glowing passion of the blood of the

[19] *Cicerone*, p. 190.

martyr, and in the oblique rays of the setting sun whose flames seem to quiver in her.[20]

The effect of this light is reinforced by the finish on the flesh and the drapery. The distinction between the youthful skin of the angel and the more full-blown, womanly skin of Teresa and between both of the garments is rendered in the finest gradations.

Behind both figures flashes a shower of golden rays which, as a result of the subtle structure of the illumination, seem to float in the air and radiate the mysterious light.

The structure of the group is ordered entirely according to painterly principles. The diagonal, the prominence of which Strzygowski sees as the proper characteristic of the painterly and the Baroque style, is the directional axis. It follows the figure of the saint from upper right to lower left and is emphasized by the especially deep folds of the drapery. However, a somewhat less clear diagonal from upper left to lower right is established, which runs from the right wing of the Seraph, across his left arm, to the deep shadows beneath the breast of Teresa. This creates an implicit Cross of St. Andrew, the arms of which diverge at the most important point of the group, that is, where the hand of the angel touches the breast of the saint.[21]

But Bernini still further enhanced the ideal quality of his work—the mystical atmosphere of his aedicule—by effectively contrasting the quietness of the white marble suspended above the altar with the rich gilding and the carefully chosen polychrome sculptural decoration of the Cornaro chapel itself. All the figurative decorations, which were executed by his pupils according to Bernini's specifications, stand in a direct relationship to the main group and guide the viewer again and again to the miracle of the vision which takes place over the altar.

Beginning from the viewpoint of a cultural conception of art, one will arrive at the judgment of the master himself and may consider the group of St. Teresa his best work. In a similar way, it is as characteristic for the seventeenth century as is the *Colleoni* for the Quattrocento. . . .

The master returned to the theme of ecstasy several more times.

In 1648 Bernini created a group of St. Francesca Romana with an angel for the church of the saint in the Forum. Unfortunately the work no longer exists; it may have followed the concept of the *St. Teresa*.

[20] Emile Zola, *Rome*. Bibliothèque Charpentier, Paris, p. 308.

[21] On the importance of the Cross of St. Andrew as a formal principle of construction cf. Josef Strzygowski, *Das Werden des Barock bei Raffael und Correggio*. Strassburg 1898, pp. 23 and 99.

The relief, which is exhibited in the church today as the work of Bernini, is so conventional in conception and coarse in form, that any thought of its being the work of the master must be excluded. One look at the plump hands of the saint is enough to reject even the assumption that a pupil of Bernini's had assisted him in this work.

In the second half of Bernini's life the number of works with an ecstatic character increases. The piety to which he was more and more devoted apparently gained a stronger, direct influence on his art. Among the emotions which enliven his statues, the religious one now takes a more important role. The four Doctors of the Church, who carry the Cathedra Petri, also belong to this group: the storm of passion which rages in these powerful figures originates in a religious emotion of reverence for the reliquary. The figures of angels for the Ponte Sant'Angelo and those in S. Andrea delle Frate are absorbed with such tender love and such intense anguish in the instruments of the passion assigned to them that one can justifiably number them among representations of the ecstatic state.

In a similar way, emotion springing from inner, religious motives governs the whole figure in the two statues in the Cathedral of Siena which Alexander VII donated in 1658. St. Jerome is bent with closed eyes over the Crucifix that he draws to his breast. He has pressed the head of the Savior to his cheek. The Magdalene stands with one foot on her ointment jar and looks steadfastly to Heaven, her head supported on folded hands and her mouth slightly open. In both statues the drapery is handled according to the Berninesque principle of garments and is combined with the striking naturalism of the figure for a painterly effect.

For his family chapel in S. Maria del Popolo, Alexander VII also wanted two statues by Bernini to complete the decoration. In this way the prophets *Daniel* (1656) and *Habakkuk* (1657) came into being. Daniel rests on one knee; holding his folded hands upward, he prays to Heaven with a fervent gaze. The drapery here covers only part of the body and is wholly worked according to the painterly principles of the artist. The group of Habakkuk with the angel who brings him a message is too lively for the narrow niche; the prophet sits on a rock in an ungainly position and only the Seraph who grasps him by the hair of his head, a charming brother of the angel in the Teresa group, can bear comparison with the more famous work. Nevertheless, here too, through the excellent representation of the half-open mouth and the wide-open eyes, the impression of immediate emotion at the angelic touch is achieved.

The full effect of his chief work, however, Bernini was to attain

only once more in the statue of the *Blessed Ludovica Albertoni* (1675; Rome, S. Francesca a Ripa).

Once again Bernini sought to reproduce an ecstasy, the highest excitement of religious emotion. But he no longer chose the moment of a vision but that of dying. Again it is a physiological foundation upon which the psychic process is constructed. Since the blessed Ludovica is alone and no youthful angel appears to her, any idea of lasciviousness is excluded from the beginning. Therefore the statue should hold its own against modern criticism (and perhaps actually lies closer to the feelings of some) better than the group of *St. Teresa.* Jacob Burckhardt numbers the *Blessed Ludovica* among the best works by Bernini, though it is hard to believe that he actually saw her, for he writes that it is no longer suffering, but the peaceful moment of death which is represented. In reality the wind of emotion still gusts in this blessed one whose half-open eyes, looking on high, see the blessedness of Paradise and whose mouth even expels a last moan. Her head rests on a richly worked pillow and her thin body rests on a kind of bier, which rises above a drapery of colored marble. The left leg is drawn up in pain or convulsion; she presses both her hands to her breast, as if she feels her last breath. The psychic excitement is here again exploited in the drapery which winds and twists in wild folds over her head, her hands, her feet, and in particular over the lap of the saint. By this time the proportions have become overly long; while less apparent in the body as a consequence of the many interruptions in the drapery, the fingers especially have become unnaturally long and thin. The execution of the statue was carried out with the greatest care down to the smallest detail. The head of the *Blessed Ludovica*, with the extremely moving expression of its dimming eyes, belongs with the most beautiful works by the master. Also in this statue the ancillary means which Bernini employed for the attainment of an extreme effect are used. The polishing was done with the greatest subtlety. The direction of the light is also decidedly controlled here, though no longer through one of those apparently round chapels, but because the figure is placed in a very deep niche at the end of a chapel, it receives its illumination from a window which is invisible from the chapel. While the viewer finds himself in half darkness, full light floods the reclining figure of she who dies.

The statue is the last sculptural work that we know by Bernini since the *Blessing Christ* of four years later has disappeared. It repeats once more, so to speak, all his principles, which, as we have seen, had been formed from the changing, confused currents of the Catholic Counter-Reformation.

THE DRAWINGS OF
GIAN LORENZO BERNINI

Heinrich Brauer and Rudolf Wittkower

The works of Bernini express a profound understanding of the great unity of organic nature as opposed to the realm of the inorganic, of ideas and of art. His creations are to be understood neither by means of theoretic-rationalistic categories, nor by means of naturalistic ones: they are borne by a pathetic intensity which obeys its own laws. But the transformation of naturalistic images of representation into a self-governing sphere is first shaped in the course of the development of the work. Again and again, a change takes place from the static to the dynamic, from what is causally motivated to images of free fantasy, from the objectively and traditionally bound to the final subjective confessions. In this way, in the drawings of Bernini, the origin of the high Baroque world of forms becomes comprehensible. One participates in the formation of a way of perceiving that had a decided influence—also in Germany and Austria—on the following generations. The drawings reveal with a rare clarity the power of a brilliant personality to form a style.

It is the purpose of the present study to interpret the drawings as documents in this sense. . . .

The documentary conception of the drawings leads necessarily to a new analysis of the works which are freed from their isolation. The drawings yield insight into the continuity of the leading ideas, which in ever new transformations acquire form. . . .

"The Drawings of Gian Lorenzo Bernini." From Heinrich Brauer and Rudolf Wittkower, *Die Zeichnungen des Gianlorenzo Bernini* (Berlin: H. Keller, 1931; reprint ed. New York: Collector's Editions, 1970). Excerpts trans. by George C. Bauer. Reprinted by permission of Heinrich Brauer and the publisher, Collector's Editions.

THE RAPE OF PROSERPINA

The representation of the abduction of a woman on a sheet in Leipzig (Fig. 4) can be considered a preliminary sketch for the Rape of Proserpina. It is the earliest preserved drawing by Bernini that prepares a sculptural work, and is therefore of exceptional importance. On one hand, one is clearly directed to the sources of Bernini's drawing style, and on the other, one finds all the potentialities of the later draftsman prepared. The pointed, unnatural structuring of the joints as, for example, in the knee and ankle of Pluto, continues the trend of Zuccari's late mannerist draftsmanship, whereas the fluid contour and the lively modeling are the heritage of the Carracci circle. Yet the sheet in Leipzig is distinguished from the drawing style of this circle and placed in the oeuvre of Bernini by the same passionate conception which appears in the sculptural work of his early period. Already on this sheet the graphic characteristics have appeared which in sketches always belong to Bernini's personal handwriting. Already one finds the lumpy formation of the hands, as well as the studying of a motif within the limits of a few structural lines (the leg on the left edge of the sheet). The outline of Cerberus, the hound of Hell, can be recognized in the few strokes behind the leg of Pluto.

In the drawing, the derivation of the compositional idea from a battle between men is quite clear. Bernini picked up the thread of the familiar representations of the struggle of Hercules and Antaeus. The ancient formulation of the theme had already been assimilated in the fifteenth century. In the drawings of Michelangelo[1] it reaches that chiastic interlacing of the bodies—also characteristic of Bernini's drawing—through which, despite all the liveliness of movement, the structure is closed in an almost mathematical way.

The development that takes place between the Leipzig design and the executed work is extremely instructive and, even at this stage of the artist's career, of typical significance. Both in formal composition and in the representation of her physical energy, the ravished woman of the drawing seems completely coordinated with the man. However, the woman in the drawing struggles in violent horror, whereas in the marble, Proserpina is no longer the vehemently wrestling adversary of the god, but in her helpless anguish enters into a psychic contrast with him. In this development of the theme from physical to psychic tension is contained the preparatory process which again and again Bernini had to retrace anew. The formal coordination,

[1] C. Frey, *Die Handzeichnungen Michelagniolos Buonarroti*. Berlin 1909, pl. 145.

expressed in the drawing by the upper, horizontal termination of the outstretched arms and by the isocephaly, begins to give way in the executed work to a dynamic interpretation of the two figures. The inner stability of the group in the drawing, the revolution of the figures around a point of gravity lying at their center, is superseded by an ideal center displaced outward into space. The closed, Cinquecento quality of the drawing metamorphoses into the Seicento interconnection of the work with the viewer who ponders the group as its living counterpart. Upon this depends the single frontal viewpoint of the work and the extension of both bodies so that overlapping is avoided as much as possible. In the drawing, by contrast, the figures were closely entwined, the bodies overlapping, and, as sculpture, the group would have offered several views. Therefore the drawing continues, not only in technique, but also in its underlying sculptural sense, the style of late Mannerism. That the exaggerated, mannerist proportions of the figures are reduced to natural ones also lies within the scope of the whole developmental process from drawing to execution.

The drawing, therefore, constitutes in technique, conception, composition, and formal language the connecting link between the old and the new. It shows how in the initial stage of his composition, Bernini stood wholly on traditional ground and makes clear the span of the thought process that, even in earliest youth, was traversed from the beginning to the end of a work.[2]

THE PORTRAIT OF SCIPIONE BORGHESE

For portrait commissions Bernini was accustomed to make his first drawings after the freely moving figure. Domenico Bernini reports fully on this method of preparing a portrait and claims that it was peculiar to his father.[3] Referring to the words of Bernini himself, he

[2] The sheet in the Dresden Cabinet, published by A. Venturi, *Studi dal Vero*. Milan 1927, pp. 385–88, ill. 264 as a study by Bernini for the *Rape of Proserpina* is an early Seicento copy after G. da Bologna's *Rape of the Sabines*.

[3] Domenico Bernini, *Vita del Cavalier Gio. Lorenzo Bernino*. Rome 1713, pp. 133–34: *"Tenne un costume il Cavaliere, ben dal commune modo assai diverso. . . : Non voleva che il figurato stasse fermo, mà ch'ei colla sua solita naturalezza si movesse, e parlasse, perche in tal modo, diceva, ch'ei vedeva tutto il suo bello, e'l contrafaceva, com'egli era, asserendo, che nello starsi al naturale immobilmente fermo, egli non è mai tanto simile a sè stesso, quanto è nel moto, in cui consistono tutte quelle qualità che sono sue, e non di altri, e che danno la somiglianza al Ritratto."* [The Cavalier observed a custom very different from the usual manner. . . : He did not wish that the person represented be still, but that he moved and spoke with his usual

explains that a man only discloses the character which is his alone through movement, and that this must be captured in the first sketches. In the *Vita* of Gaulli, Pascoli, perhaps independently of Domenico Bernini's account, speaks of the same eccentric method of preparing portraits, and says that Baciccio had learned it from Bernini.[4] From the diary of the Sieur de Chantelou one discovers in detail just how such first sketches were drawn for the bust of Louis XIV.[5] On different days Bernini first observed the king, who moved as usual without regard for the artist, and then laid down in a fleeting sketch on paper a characteristic moment. Twice this even took place during a Cabinet Council. Of drawings of this type only a single example can be identified which is therefore of quite special importance. It is the study preserved in the Morgan Collection (Fig. 15) for the bust of Scipione Borghese of about 1632.[6] If one did not know from the literary sources how drawings of this kind originated, it would easily be recognized here. The Cardinal has been observed and drawn while in conversation with a third person. Insofar as it is possible to impart an expression of transience through the eyes and form of the mouth alone, that has been done. It is not the state of spiritual tranquility which has been captured, but an instant from a continually changing, quickly passing life.

Bernini, as an exponent of the seventeenth century, could thoroughly grasp the personality of a man only in a state of inner and outer agitation. His goal is to realize the personality in the movement, not movement for its own sake. His novel working procedure presupposes a new view of the world, which by inference, one can also gather from the sheet in the Morgan Collection. There, man is not represented as in the sixteenth century (for instance by Tintoretto) as a quiescent appearance sufficient in himself, as a spiritually and formally isolated and distinctly delimited existence, as a representative of the infinite. The new man requires the resonance of those about him; he seeks to affect friend and foe alike; he lives only through others. It is an intermingling, a hither and thither flow of spiritual powers; it is the

unselfconsciousness, because in this way, Bernini said, he saw all his beauty and he imitated him as he was, asserting that in keeping naturally still without moving, one is never as similar to himself as he is in motion, in which consists all those qualities which are his alone and which give likeness to the portrait."]

[4] L. Pascoli, *Vite de' pittori, scultori, ed architetti moderni.* Roma 1730, I, p. 207.

[5] M. de Chantelou, *Journal du voyage du Cav. Bernini en France*, ed. L. Lalanne, Paris, 1885, pp. 37, 40, 50. German ed. by Hans Rose. Munich 1919, pp. 30, 32f., 46.

[6] Published in: *J. Pierpont Morgan Collection of Drawings by the old masters formed by C. Fairfax Murray.* London, privately printed, 1912. Vol. IV, pl. 176.

framing of man within a net of connections which radiate from him and reverberate in him. The opposition between two ways of viewing the world becomes apparent here: man as the cosmos and man in the cosmos. The completely new conception of the world which was expounded by the philosophers of the seventeenth century can be illustrated paradigmatically by Bernini's creative practice.

In the marble bust of Scipione Borghese a moment very similar to that in the sketch has been represented. Each viewer now plays the part of the unseen correspondent of the drawing. One asks oneself how it is possible for the prevailing tone to be identical in the momentary sketch and in the detailed realization of the marble. The key is provided by the above mentioned passage by Domenico. In the early sketches what is important is to establish the nature, or the typical character of the model.[7] The idea of the character of the person to be represented, first derived from the observation of the model, must also determine the inner attitude of the final work. During the work on the marble, the sketches serve to keep the "idea" constantly in sight and to preserve its vividness.[8] It is the identity of this idea that guarantees the uniform effect of the sketch and marble.

VERITÀ

The description of Domenico Bernini[9] shows without doubt that Bernini, indignant at his defeat in the affair over the tower, began to

[7] Chantelou, op. cit., p. 107: *"que la première chose que doit regarder pour la ressemblance celui qui fait un portrait est le général de la personne, avant que de penser au particulier."* ["that the first thing that one who makes a portrait must consider for the likeness is what is general to the person, before thinking of what is specific."] German ed., p. 123.

[8] Especially revealing for this is a passage in the *Mémoires des Ch. Perrault* (Avignon 1759, p. 78), from which it also appears that the sketches for the portrait of Louis XIV must have looked like the sheet in the Morgan Collection: Bernini *"se contenta de dessiner en pastel deux ou trois profils du visage du Roi, non point, à ce qu'il disoit, pour les copier dans son buste, mais seulement pour rafraîchir son idée de temps en temps, ajoutant qu'il n'avoit garde de copier son pastel, parce qu'alors son buste n'auroit été qu'une copie, qui de sa nature est toujours moindre que son original."* ["was content to draw in pastel two or three profiles of the visage of the king, never, as he said, to copy them in his bust, but only to refresh his idea from time to time, adding that he took care not to copy his pastel, because then his bust would have been only a copy, which by its nature is always less than its original."] (new edition of the *Mémoires* by P. Bonnefon. Paris 1909, pp. 61–62). The idea, that Bernini did not make preliminary studies *(modelle)*, in order to then copy himself is also found in Filippo Baldinucci, *Vita di Bernini*. Florence 1682, p. 71 and in Dom. Bernini, op. cit., p. 134. The "idea" cannot be copied, but must always be felt vividly.

[9] Domenico Bernini, op. cit., pp. 80–81.

carve the *Truth unveiled by Time*. The beginning of the work, therefore, can be dated to the year 1646. A letter of 30 November 1652 from Gemignano Poggi to Francesco I of Modena suggests that at that time the *Verità* must have been almost as we know it today, while the god of Time had not yet been begun.[10] Apparently even later the plan to execute the god of Time was not abandoned, for after Bernini's death the block intended for the *Chronos* was still in his house.[11]

Two fundamentally different stages in the development of the scheme are preserved in several drawings. Both may be dated to 1646, even though on stylistic grounds substantial parts of the work on the marble may have been done only after the completion of the *Teresa*—therefore about 1651 or 1652. Bernini's first composition (Fig. 24) is preserved in a masterful chalk drawing in Leipzig.[12] A great spherical segment was to serve as the common base for the shrinking *Verità*, who falls back, and the flying god of Time, who unveils her. The pictorial character of the design argues that in this first stage Bernini was not yet considering its execution in sculpture. Other evidence can be adduced which gives this hypothesis a high degree of certainty. All known compositions by Bernini in which an isolated, rocky coulisse serves as the base for the figures show the same structure. And the draftsman of a Lamentation over Christ, a pictorial design from Bernini's closest circle, relies on this *Verità* composition by Bernini for the figure of Christ.[13] Evidently it was only later that Bernini resolved to demonstrate to the world in a monumental stone group that he had been wronged. In order to be feasible in marble, the composition now had to be developed according to completely different criteria. The main problem was to make statically possible

[10] Imparato in *Archivio stor. dell'Arte*, III (1890), p. 136; Fraschetti, *Il Bernini*. Milan 1900, p. 172; Steinmann in *Münchner Jahrb.*, II (1907), p. 39. Until now the dating of the *Verità* was nowhere definite: in Fraschetti, p. 440, too early: 1645; in Brinckmann, *Barockskulptur*, 1919, pp. 243–44, too late: 1647.

[11] Baldinucci, op. cit., p. 35.

[12] Two replicas of this sheet in pen from Bernini's closest circle are preserved: a) Ariccia. Until now the sheet was always considered as an original design for the sculptural group. Illustrated in Fraschetti, p. 174, Steinmann, op. cit., p. 44, Muñoz in *Rassegna d'Arte*, III (1916), p. 167. The sheet was probably copied after the study in Leipzig so that Alexander VII might have the *concetto*. b) Leipzig 73–132. Pen over chalk underdrawing. H. 312, W. 337. On the back: ". . .*primo pensiero.*" The drawing is not completed. The executed part conforms exactly with the sheet in Ariccia, but is of lesser quality. Apparently like that one, this outline drawing was to be washed.

[13] Mention may also be made of a drawing ascribed to Poussin in the Museum in Chantilly, in which Bernini's design has been used in the opposite sense. Illus. in Grautoff, *Nicolas Poussin*. 1914. I, p. 207.

the figure of Chronos, who flies in the air. A description of the final model, in which the god of Time was emplaced above ruined and fallen columns, obelisks, and tombs, is preserved in the diary of Chantelou.[14] Thus for the sculptural realization it proved necessary to give up the unifying spherical segment—the symbol of the earth over which both personifications jointly rule—and consequently to erect each figure on its own base. The necessity of straightening the pose of *Verità* follows from this alone, to say nothing of the obvious demands made by the sculptural process.

Two sheets in Leipzig (Fig. 25), which originally formed a single one,[15] are of value for the working through of the *Verità* for the sculptured group. They prepare the model described by Chantelou. In them Bernini's thoughts revolve around three problems: the sitting-motif, the base, and the connection of the block with the god of Time. The absence of this figure argues that the principal organization of the sculptural masses was fixed and that the female figure had to be composed within a block whose shape was decided.

In the study at the far left Bernini first renounced the compositional ideas of the pictorial design and returned to the solutions of other works. With the *Chronos* approaching from the right, the *Verità* would have formed a group that, with the two figures seen in succession and profile, repeats the motif of the *Apollo and Daphne*. The disposition of the body of the *Verità* was adapted from that of the *Teresa*, which was then in progress.[16] In this position it was possible to push the upper body of the female figure all the way to the right edge of the block, which, within the structure of the determined composition, was necessary for the sculptural realization and which, in the sketch at the far right, Bernini also achieved through a complicated motif of movement—more in the sense of the first idea. In the three sketches on these sheets the small globe upon which Truth rests her foot has already been considered. The sitting-motif, on the other hand, is still not clarified. The attempt to seat her on a great globe—a clear reduction of the pictorial idea—had to be rejected. Near the upper edge of the sheet the same fold of drapery, apparently the gathering of the cloth where it is grasped by the god of Time, is drawn three times.

[14] Chantelou, ed. Lalanne, op. cit., p. 116. The German translation by Rose, p. 135, distorts the sense of the passage.

[15] In the illustration both sheets have again been joined. The sketch in the lower right corner of the left sheet is continued on the right sheet.

[16] In this sketch one can see only a momentary adoption of the motif of the Teresa and cannot, conversely, derive the Teresa-motif from it. The dating of the *Verità* after the *St. Teresa* can also be corroborated from this point of view.

From this one sees that fairly precise ideas for the *Chronos* must have existed by the time these sketches were made.[17] For the striking representation of the abstract thought—*il tempo scuopre la verità*—Bernini had found the most brilliant and unparalleled motif in the chalk drawing in which the bodies are turned to, and the eyes absorbed in, one another. The act of unveiling only provides the presupposition for the interrelation of both heads, in which the symbolic content of the action was intended to be mirrored again.[18] In this way Bernini, from the beginning, gave form to the theme, even though the conception of the *Verità* was considerably altered. If in the sketch she lay curled in the pose of one overpowered by sleep who, first aroused and then frightened by the approach of the god of Time, raises a defensive hand, in the executed work she welcomes with joy her liberator and of her own volition extends to him her symbol, the sun; for it vanquishes darkness as Truth does ignorance. In the pen sketches *Verità* was already granted her active role, and the disk of the sun had been added as well.[19]

[17] On the left half the executed sketches of both parts of the sheet are laid down once again in a few characteristic strokes; on the right half the body of the woman is indicated in an abbreviated way in the sense of the second version.

[18] Cf. Domenico Bernini, op. cit., p. 81.

[19] The drawing in the Corsiniana (Inv. 127545) published by Fraschetti, p. 172 as a design for the *Verità* is by the hand of Giovanni Paolo Schor. Muñoz in *Rassegna d'Arte*, XVIII (1918), p. 95 wanted to recognize the sheet as a design of Bernini's for a virtue on a tomb. The Schwerin *Verità bozzetto*, published by Steinmann, op. cit., p. 39 and then by Brinckmann, *Barockbozzetti*, 1923, I, pl. 39, must also be rejected as an original.

BERNINI'S *ST. LONGINUS*

Hans Kauffmann

The form of St. Longinus, who pierced the side of the Crucified Christ
with his lance and was cured of blindness by His blood, has remained
fairly constant in the figurative arts since the Carolingian period (Sta.
Maria Antigua).[1] Among the not overly numerous, later representa-
tions (in general his adoration has not been widespread) two basic
forms emerge depending upon whether he is shown as a saint among
saints or beneath the Cross in the scene of his conversion. Mantua,
whose church of S. Andrea shelters his grave, offers fully developed
examples: works by Andrea Mantegna, Giulio Romano, and his
followers.[2] Either alone or with other figures, he is shown bearded, in

"Bernini's *St. Longinus*" (Berninis Hl. Longinus) by Hans Kauffmann. From *Miscella-
neae Bibliothecae Hertzianae* (Munich: Anton Schroll & Co. GMBH, 1961), pp.
366–374; trans. by Marianne Armstrong and George C. Bauer. Reprinted by
permission of the author, the publisher, and the Bibliotheca Hertziana.

[1] *Legenda aurea.* German trans. by R. Benz. Jena 1925, Vol. 1, 306f.; H. Detzel:
Christl. Ikonographie, Freiburg 1896, Vol. 2, 490f.; Fr. v. S. Doyé: *Heilige und Selige*,
Leipzig 1929, Vol. 1, 695; L. Réau: *Iconographie de l'Art chrétien*, Paris 1958, Vol. 3,
pt. 2, 812ff.; Lutz-Perdrizet: *Speculum hum. salv.* (1907–1909), 31 and 203. Ancillary
symbolic ideas that have been attached to Longinus are enumerated in Phil.
Picinellus, *Mundus symbolicus*, Coloniae 1687, 230.

[2] Mantegna's *Madonna della Vittoria* (Louvre) and his engraving, B. 6; Giulio
Romano's altar painting from the Longinus chapel (Chapel of Isabella Boschetta) of
S. Andrea in Mantua (about 1532–1534; F. Hartt: *Giulio Romano.* New Haven 1958,
Vol. 1, 208ff. and Vol. 2, fig. 441). In a Mary altar filling the wall of one of the north
chapels in the same place (by an unknown hand, about 1600), which has two great
carved figures of Andrew and Longinus (the latter the type of G. Romano's altar
figure), Longinus looks across to the Crucifixion fresco on the neighboring wall. An
alabaster figure by Jacques Dubroeucq in St. Waudru-Mons *(De Triomf van het
Manierisme.* Exhibition catalogue, Amsterdam 1955, 166, No. 315).

the dress of a Roman soldier, which sometimes includes a sword, and with the plumed helmet either on his head or humbly set on the ground. He holds the lance—from which he supposedly took his name—neither as a weapon nor to support himself, but either embraces it gently or expressly displays it. In Giulio Romano's altar picture he also holds the ostensorium with the blood of Christ. On the other hand, in depictions of the events of Calvary he appears more or less conspicuously and is frequently seen on horseback. Still blind, his hand guided by one with sight, he directs the blade of his lance at the breast of the Savior on the Cross (Konrad von Soest and, although admittedly with his eyes open, Ruben's *Coup de Lance*); or miraculously healed and converted, he professes his faith in Christ. When pathos formulas became popular in the sixteenth century, the affective expression previously associated with the Magdalene and with St. John under the Cross was transferred to Longinus. Thus in Lorenzo Lotto's largest altar painting of 1531 for S. Maria in Telusiano (Monte S. Giusto) the mounted Longinus throws open his arms in passionate devotion to the Savior while his hallowed lance, of great size and singularly magnificent, lies against the neck of his white horse.[3] Rinaldo Mantovano, as Vasari convincingly reports, using a model by Giulio Romano, drew attention to him still more emphatically in the Crucifixion fresco of the Longinus chapel in S. Andrea in Mantua. Holding the glass ostensorium in his left hand, he kneels in the foreground beside the discarded lance with his worshipful eyes fixed on the high Crucifix and both hands raised,[4] and is not unlike Rembrandt's rendering of the "kneeling captain" in the master's *Three Crosses* (B. 78, 1653).

Bernini's statue does not fit into either of these traditions. Its uniqueness and novelty are found in the blending of both types, the representative and the narrative (Fig. 13). The sculptor transforms the figure into an event; he animates the statue with a narrative content. The attributes of Longinus are no less particular than when he is represented alone, but his gesture bears witness to his conversion on Calvary. Bernini founded his synthesis on a broader perspective and the works in Mantua may have been known to him before the monument of the Countess Matilda drew his attention to that city. His *Longinus*, however, surpasses all earlier images of this saint in the

[3] *Mostra di Lorenzo Lotto.* Cat. a cura di P. Zampetti. Venice 1953, 133ff., No. 80; A. Banti: *Lorenzo Lotto.* Florence 1953, 42ff. (notice on the wishes of the donor, Bishop Bonafede).

[4] F. Hartt: op. cit., I, 208ff. and II, fig. 439.

almost symmetrical extension of the arms. Thrusting the lance, which is the illustration of the relic preserved in St. Peter's,[5] away from himself with the right hand and placing it before the viewer, with the equally outstretched left hand, he affirms pious submission.[6] Bernini actualized the experience under the Cross—as indeed he sought to characterize and individualize all his saints, as well as his mystical and allegorical figures, and perhaps under their influence—not so much through the attributes as through a spiritual state. He created the personality in the mold of its vocation: the martyr in his martyrdom *(St. Lawrence)*, the confessed as confessing *(St. Bibiana)*, the penitent in penance (the *Magdalene*), the seeker of protection seeking protection *(Daniel)*, the visionaries in their visions *(St. Teresa)*. Among the four statues in the niches of the crossing piers in St. Peter's, the *Longinus* is exalted by its historical declaration (Fig. 11).

The gesture of devotion with which the Longinus iconography was enriched belongs to an older tradition. Around 1600, it was given wider currency by Federico Barocci, Ludovico Carracci, Guido Reni, El Greco, and Rubens;[7] among Roman works an example such as Giovanni Lanfranco's *Virgin in Glory* (dome of S. Andrea della Valle, 1628) bears the forcible imprint of Caravaggio's *Conversion of St. Paul* (S. Maria del Popolo). Sculptors were naturally more reluctant to attempt the open silhouette and Germain Pilon's marble altar figure of St. Francis, for the Valois Chapel at St. Denis opposite the tomb of Henry II and Catherine de' Medici,[8] appears all the more remarkable. With only a few, scattered precursors among Italian sculptors,[9] Bernini

[5] Like Bernini's *St. Bibiana* on the high altar above the sarcophagus of her and her mother (A. Nibby: *Roma nell'anno 1838*. Rome 1839, 134ff.), the Longinus statue is a reliquary figure between the altar in the grotto and the reliquary niche with the relief of the relic's apotheosis above the balcony; on the Holy Lance cf. Giovanni Severano: *Memorie sacre delle Chiese di Roma*. Rome 1630, 160ff.; E. Mâle: *L'Art religieux du XVII^e siècle*. Paris 1951, 105.

[6] It is strange how much S. Fraschetti: *Bernini*, Milan 1900, 75, has misunderstood the figure: ". . .apre le braccia erculee in atto battagliero, brandendo fieramente la lancia sottile. . .sembra uscire dal seno d'una rupe." [". . . he opens his arms in a warlike gesture, fiercely brandishing the slender lance. . .he seems to issue from the depth of a cliff."].

[7] A selection in G. Weise and G. Otto: *Die religiösen Ausdrucksgebärden des Barock und ihre Vorbereitung durch die Kunst der Renaissance*. Stuttgart 1938.

[8] Now in the Parisian church of St. Jean-St. Francois. J. Babelon: *Germain Pilon*. Paris 1927, 64f., No. 17, about 1583; catalogue of the exhibition "Trésors d'Art des Eglises de Paris," 1956, No. 61.

[9] Niccolò Roccatagliata's *St. Stephan* in S. Giorgio Maggiore, 1539; L. Planiscig: *Venezianische Bildhauer*. Vienna 1921, 598, 604, and 609f.

seized upon the gesture early in his career: from the outspread hands of his *St. Lawrence* emanates the pathos of the martyr. In addition to the left hand, which also helps to support the reclining figure, the right is raised with failing strength, its palm turned up in harmony with the yearning, upturned face.[10] The artist returned to this gesture for the *Longinus*, though now it is extended to its greatest projection. By virtue of it, the pose of the figure is invested with a symbolic quality which tellingly characterizes Longinus and his condition. For just as in the scene of the stigmatization, Germain Pilon, El Greco, and Federico Barocci made sensible the assimilation of St. Francis to the Crucified Christ through the devoutly opened arms, and as Giotto (Stefaneschi Altar), Piero della Francesca, Titian, and others had already done in a similar way in representing John at the foot of the Cross,[11] Bernini may have intended his *Longinus* to resemble the Crucified Christ, so that the presence of the Crucifix might be felt in its reflection.[12] It was the Cross which Bernini chose as the crowning touch of the bronze Baldachin.[13] If one were to separate the statue of the saint from this correspondence, the spark which ignites it would die, its gesture exhausted in a void. It also finds a twofold echo in the relief above the balcony where the lance held by the large, draped angel parallels that of *Longinus* and where the devout gesture and heavenly glance of the saint are repeated by one of the putti. This image guided Bernini's designs for the statue even in the early stages of its development.

To be sure, of the twenty-two models, "all three spans high, in wax," which the artist was able to show to Joachim von Sandrart, who was in Italy until 1635, none are preserved except, perhaps, for one *bozzetto* (Fig. 14) in terra-cotta (Fogg Art Museum).[14] In this slender

[10] Bellori: *Vite*, 1728, 163f. on the *St. Andrew* of F. Duquesnoy: *"distende aperta la sinistra in espressione di affetto e di amore divino nella gloria del suo martirio."* ["he opens out his left arm in an expression of emotion and divine love in the glory of his martyrdom."].

[11] F. Zeri: *Pittura e Controriforma*. Turin 1957, ill. 83 and 84.

[12] This idea, already expressed by A. Riegl (*Baldinucci, Vita des G. L. Bernini*. Vienna 1912, 94), has been supplanted by interpretations like that of A. E. Brinckmann (*Handb. der Kunstwissenschaft: Barockskulptur*. 3d ed. 1931, 198). For the motif of the assimilation to the Crucified Christ, I mention Lutz-Perdrizet: *Speculum hum. salv.*, pl. 89 and 140. For Bernini the idea is known from his drawing of St. Jerome in devotion over a Crucifix, a variation on Lorenzo Lotto's version preserved in the little panel in the Galleria Doria (Brauer–Wittkower: *Zeichnungen*, p. 153, 1665).

[13] H. Kauffmann: "Berninis Tabernakel." *Münchner Jahrb. d. Bild. Kunst*, VI, 1955, 222ff. The *Longinus* can also be understood as an inversion of the Christ figure originally projected for the Baldachin.

[14] J. v. Sandrart's *Academie der Bau- usw. Künste* (1675), ed. with commentary by

figure the idea has taken form to the extent that leading motifs exist, but its maturation is still in progress.

From the *bozzetto* we can judge the nature and extent of the final development of the sculptor's most monumental statue of a saint. For in this *bozzetto* the frequently noted similarity between Bernini's *Longinus* and the *St. Andrew* of Francois Duquesnoy is even more striking than in the marble. The upper torso protrudes from within a widely opened mantle, which encloses it like the lip of a shell, and the easy stance of the figure pulls the robe into tense folds and brings about the fluttering movement of the short mantle on the side of the non-supporting leg.[15] Such relationships are evidence for dating the *bozzetto* to the early thirties, if not even earlier, to the period from the end of 1629 to the summer of 1631, when Bernini's work on the design is documented.[16] This would conform with the flowing folds of the thin robe which closely outline the parts of the body and which are characteristic of the allegories in the memorial plaque of Carlo Barberini of 1630 (S. Maria Aracoeli). Finally an indisputable similarity relates the *bozzetto* to the statue of the Countess Matilda and, above all, to the Christ in the *Pasce oves meas* relief (1633).[17] Consequently we must recognize that a certain period of time elapsed before Bernini began the marble in 1634–1635, which then occupied him until the Spring of 1638. During this final phase in the realization of the statue new impulses interposed.

In the meantime the Congregation on the Rite of St. Peter's had made, in 1633, a new and final decision on the distribution of the four statues in the niches of the crossing piers according to the relative rank of the relics.[18] When the full-scale models were tried out in March of 1632 only Francesco Mochi's *Veronica* occupied the position it has always had. In contrast, the *Longinus* was placed in the south-eastern

A. R. Peltzer. Munich 1925, 286; the *bozzetto* in the Fogg Art Museum published by R. Wittkower: *G. L. Bernini*. London 1955, 192.

[15] M. Fransolet: *Bull. de l'Institut historique belge de Rome*. XIII, 1933, 227ff.; idem: *Francois Dequesnoy*. Brussels 1942, 112ff.

[16] S. Fraschetti: *Bernini*, 69ff.; documents in O. Pollak: *Die Kunsttätigkeit unter Urban VIII.*, Vol. 2: *Peterskirche*. Vienna 1931, 454ff., No. 1770–1796; most recently R. Wittkower: op. cit., 192f. It is worth mentioning that Lodovico Totti in his *Ritratto di Roma moderna* (10ff.), which was published in Rome in 1638, speaks about all four statues as if they were already in place.

[17] For the dating, R. Wittkower: *Bernini*, London 1955, is now standard.

[18] G. P. Chattard: *Nuova descrizione del Vaticano o sia di S. Pietro*. Rome 1762, 136ff., 182ff., 195ff., 206ff. gives an account of this on the strength of Torrigio, F. M.: *J sacri trofei romani* (1639); Totti, L.: *Ritratto. . .* , 530, speaks only of one interchange which had affected the *Longinus* and the *Andrew*.

niche in which we now see the *Andrew* of Duquesnoy, but which at that time was placed in the niche now used for Andrea Bolgi's *Helena*, while the *Helena* occupied the niche now containing the *Longinus*. Bellori speaks of the complaints with which Duquesnoy reacted to the order for the rearrangement as if it had been done intentionally to damage the Fleming.[19] He had adjusted his statue of St. Andrew to the light and optical conditions of the northwest pier, and now saw it exposed to view under the unfavorable conditions of the diametrically opposed one: ". . . *mutargli il lume e la veduta, convenendosi ora girare per vederla in faccia.*"[20] In contrast to the equal value given to several different views in the mannerist period, this is a clear confession of frontality and the adaptation of sculpture to the means through which painting makes its effect. On the other hand, how Bernini had rethought and reorganized his *Longinus* in response to its transposition from the southeast to the northeast niche, that is, to a change of sides, appears in the shift in the pose which distinguishes the marble from the terra-cotta and exposes another side of the statue. In the *bozzetto* the figure is displayed parallel to the front edge of its base, but is nevertheless open on its right to a view from that side: we look into the hollow formed by the inward sway of the body and the drapery billowing behind, and into the loop around the chest and left arm; and because it is drawn back, the free leg does not obscure the supporting leg. By turning its right side out, the marble figure is inverted. The body is projected forward on a diagonal from the helmet to the foremost foot and likewise from the left hand to the right hand holding the lance to create an oblique face designed to be seen from its left and to form a transition to the dominant front view. In both cases someone entering the crossing from the nave—up to 1633 by looking to the left and later by looking to the right—was to see the expressive gesture immediately. Bernini had composed from the time of the *Aeneas and Anchises* group according to a primary view, but only now did he clarify a side view in such a way that the ruling motif was most unequivocally and constantly displayed. The *bozzetto* for the *Longinus* and the marble are the earliest witnesses for a procedure which Bernini followed in the years of the Chigi chapels by designing the *Daniel* (Rome) as well as the *Jerome* and the *Magdalene* (Siena) so that they can also be viewed from the entrance to the chapel; and the

[19] G. P. Bellori: *Le Vite.* 2d ed. Rome 1728, 163f. and G. B. Passeri: *Vite.* Rome 1772, 89ff. and in the annotated ed. of J. Hess (Leipzig-Vienna 1934), 108–111.

[20] [". . . the light and view having been changed, now making it necessary to go around to see it from the front."]

chief example of such a first view calculated to be effective from a distance can be found by approaching the *St. Teresa*, enclosed in her aedicula, from the nave of S. Maria della Vittoria. These observations, along with the dating indicated by its style, allow us to identify the *bozzetto* as a design still intended for the niche now occupied by the *Andrew* and to consider it to have been created before the four statues were rearranged. If, however, the artist responded to the conditions imposed by the location in this early phase, the marble is developed beyond the *bozzetto* in the precision and the consequences of its optical calculations,[21] for in its final form the light from the dome of St. Peter's was first given a decisive role. The folds were reorganized so that the light from above no longer falls smoothly and is almost unbroken as on the *bozzetto*, but rather strikes higher, transverse ridges to create sharply accentuated pockets of shadows—a play of contrasts which also animates the twisted columns of the bronze Baldachin and those of the aediculas over the pier niches. The subtly shaped relief of Longinus's mantle achieves the greatest exactitude and an astonishing, nowhere weakened, optical effectiveness that equals the significance of the silhouette. In contrast an individual field of light plays across the open, shadowless hand and across the chest which supports the ecstatic head.

From the *bozzetto* to the marble the figure itself assumes a different nature. It was not only a matter of an intensified powerfulness and a new, broad weightiness. The entire habitus was renewed: the movement, almost streaming into space (*bozzetto*) dampened into restraint; the pendulous sway straightened; the posture markedly lifted.[22] Whereas in the *bozzetto* the head and its position emerge from and are the culmination of a movement involving the whole body, in the marble the turn of the head breaks the rigid frontality of the body through a single counterstroke. The strong symmetry of the neckband, with its right angles above the square of the chest, greatly strengthens the impression that the head is abruptly thrown to the side, and the enlargement of the head, which is also effected by the luxurious,

[21] Analogous to the Longinus are the papal statue and the Virtues on the tomb of Urban VIII which are turned out for the view from the Crossing. A relationship to, if not a dependence on, Caravaggio's procedure in the martyrdoms of Peter and Paul in S. Maria del Popolo (L. Steinberg: "Observations in the Cerasi Chapel." *The Art Bull.*, XLI, 1959, 183ff.) is unmistakable.

[22] To some extent analogous distinctions between the Greek and Roman styles of art have recently been pointed out by H. Kähler: *Wesenszüge der Römischen Kunst.* Saarbrücken 1958.

flame-like locks, elevates it to the center of expression. The change from an unstable ponderation[23] to that of tense stillness is a decisive one. The body is drawn together more compactly, the arms are more isolated and they project more vigorously. By means of the new interpretation of the ponderation of the figure a new, inner emotion becomes sensible. Longinus no longer shrinks away. With locked knees he stands erect, as if spellbound, stunned, and frightened. Whatever suggested change and a fluid movement of the body in the *bozzetto*, is now arrested—even the helmet which was originally tipped over, finally lies firm. But his spiritual longing is intensified all the more. Only in the marble does he thrust out his chest against the restraining roll-like folds of the mantle whose tense lines join the two arms and greatly contribute to the enraptured sense of the outstretched arms. Whereas in the *bozzetto* the mantle was set into a lateral vibration, in the marble it falls from the shoulder as a result of the upward impetus of the figure. Against its sudden fall—its jerky course, without precedent in Bernini's earlier repertoire of forms, may betray the influence of Guido Reni and a work such as the *St. Michael*[24]—the centurion is all the more prominently charged with an all pervading tension. Thus in the initial state of its development, Bernini remained close to what was conventional in his creation of the bold, unusual gesture, but he overcomes this in a subsequent development, which is completely personal, through the compelling power of expression.[25]

Bellori praised the *St. Margaret* (S. Caterina dei Funari) by Annibale Carracci for the way the saint looks up into the light and it was not only painters who admired and used this new invention.[26] Being struck by light from on high and looking up into it was a prominent part of the religious expression of Bernini's saints from his early career up to the *Constantine*; and through the radiance of her countenance, the *Verità* acquires one of the features which characterize her nature. The light that descends on Longinus is like an

[23] With regard to it, Wittkower's judgment of the *bozzetto* (op. cit., 193): "calm and classical" is justified. That the distinction between the free and supporting legs in the marble is scarcely expressed was remarked by Riegl (*Baldinucci*, op. cit., 95).

[24] 1630–1635, Rome, S. Maria della Concezione; *Mostra di Guido Reni*. Bologna 1954, 105, No. 43.

[25] This development of the conception resembles the developmental process of both the *Moro* and the *David* as it is elucidated by Brauer–Wittkower: *Die Zeichnungen des G. L. Bernini*, p. 50ff. and 57f.

[26] To be sure we would not overlook older examples such as Parmigianino's *St. Roch* of 1527 in S. Petronio in Bologna; most recently *De Triomf van het Manierisme*, Amsterdam 1955, No. 89.

enlightenment and gives his emotion the profundity of a revelation;[27] he is touched by something Divine and through his consciousness of it, the light acquires a sacred character. In the experience of one man the transcendental is mirrored.

The more passive than active nature of the *Longinus* is part of an expansion of the possibilities of representation. During the course of the seventeenth century, experiential contents were made visible which had been closed to earlier sculpture. Insofar as the figure is opened up and turned expressively outward, it awaits an impulse external to itself. The transcendental appears in its reflection; both its proximity and distance are palpable. With the *Longinus*, Bernini created a new type of the monumental statue.

More like one of wood than of stone, the gigantic statue is made up of five pieces. Whatever we may yet learn from a more complete survey of the structure of the larger Mannerist and Early Baroque marble figures, in the *Longinus* we see the integrity of the block destroyed by the expansive gesture. As early as Alberti, and later for Galileo, the more radically a creation overcame and concealed the material and its limitations, the more highly was its artistic accomplishment valued.[28] Sculpture of the sixteenth century appears preformed by the shape of the block, which encases the completed statue like a spatial carapace. The block circumscribes the radius of the figure's movements, reducing these—to say it briefly—to rotating ones and their variations either along the torso or all around (peripheral or tangential). Thus restricted, the agile and flexible body revels in contrapposto; the motif of its movement resolves into a whole cycle of interlinked, individual movements. One turn answers a counter-turn and the direction, angle, and view of the members appear reciprocally adjusted. Through this differentiation, which is worked through limb by limb, an enrichment of the composition is achieved in such a way that the richly permutable constellation is further multiplied when seen from different sides: invention stands under the sign of *Varietà*. In the *Longinus* Bernini has freed himself from the confines of a surrounding cube or cylinder, as well as from the postulate of *Varietà*. A single action is asserted and exhausted in one view. To what extent this was still being developed in the shaping of the marble figure can be measured by again comparing it to the *bozzetto:* there are fewer motifs and fewer movements. The figure is compacted; the upper and

[27] It says "illuminatio" in the text of the *Speculum hum. salv.* (Lutz-Perdrizet, Chap. XXX and p. 222).

[28] E. Panofsky: *Galileo as a Critic of the Arts.* Den Haag 1954.

lower parts of the body coalesce with the drapery to create an interblended unity in which the articulation of the limbs is weakened. In spite of all the differences of theme and solution, the master of the *Daphne*, with her smooth contrapposto sinuously flowing into the upward growth of the tree, is still recognizable. If it is possible, the thin, ascetic arms, already apparent in the *bozzetto*, even more boldly deny *Varietà*: both the left and right arms are equally extended and both lie open to view in a single, unforeshortened plane. The entire span is almost uninflected—except for the fine crescendo from the slight bend on the left to full extension on the right, which accompanies the increasing height and is anticipated in the opposition between the closed and open hand—as well as without noticeable differences in its position or in the view it presents. In the *Aeneas and Anchises*, Bernini, for the first time, had created a vertical group of figures, one above the other in the tradition of the sixteenth century (Giovanni Bologna and his followers), whose bodies are oriented frontally on one side and as mirror images of each other, but without torsion or twisting; in the *Pluto and Proserpina* he had recourse to parallel poses from the right and from the left. In the 1630's the *Triton* on the shell for the Barberini fountain offers an astonishing example of bilateral symmetry; unlike the displacement of the body in its mannerist predecessors, the position of the arms and hands are not contrasted—in conformity with the shell which opens on either side. In addition to a freer, more natural movement of the body, Bernini also strived for a heightened expression within a fixed moment.

Because the *Longinus* is opened up to display its greatest verticals and horizontals, it contrasts with the niche. Against the vertical stripes of this ground its quivering contours stand out with sharpened precision. The elevation of the arms which obliquely intersect the horizontal entablature at shoulder height is similarly accentuated. Both expanded by the same deep breath, the extension of the figure and the swelling space of the niche are completely fused—an analogy between organism and architectural form which Bernini was later to recall in the shape of the colonnade.

To be sure, in its general type the *Longinus* depends upon Roman Caesar figures with which Bernini had come into contact in his collaboration with Alessandro Algardi on the memorial statue of Carlo Barberini on the Capitol, done after earlier examples such as the one for Francesco Aldobrandini (1602).[29] But the thrilling appearance of

[29] G. A. Borboni: *Delle Statue in Roma*. Rome 1661, 287–321; R. Wittkower: *Bernini*, 191, no. 27. The *bozzetto* for the *Longinus* also reveals in a detail such as the twisted

the *Longinus* draws its vitality from the fact that the straight lines are tensed throughout by impulses of movement. An emotional agitation, which has the definition and the exclusiveness of an image of violent movement, suffuses the body to its extremities.[30] The *Longinus* reaches a limit of what can be achieved and this unites it with the *Triton* (Barberini Fountain), as well as with the *David* and *Daphne*.

In these two brilliant, vigorously thought out creations of the twenties Bernini had realized exemplary models. Seized by pathos, their animation is brought to a point which is close to the precipice of sudden change. One should not therefore describe their action as simply transitory; rather it reaches a peak where, as at the apex of a swinging pendulum, a momentary suspension occurs, a moment of balance between ascent and return. At the height of the cycle its progress is affected as if arrested, intercepted in the midst of its execution and brought to a standstill. It is from this choice of a moment of rest or of inert being as the consequence of the most intense movement, that just as much latent energy is inherent in Bernini's figures as "restraint." It is the moment of pause and stabilization at the verge of a discharging span, the volatile condition at a turning point, which has acquired permanence in the sculpture.[31] As a result, Bernini, in the wake of Caravaggio and Annibale Carracci, thought out a manifestation of life, upon which each of these figures is concentrated and within which they become absorbed, directly from the theme; and with his objective striving for the truth of a characterization of the person, made nothing short of an interpretation of their nature serve his purpose—just as Bellori in the Carracci frescoes of the Galleria Farnese found praiseworthy that: ". . .*in tanta*

roll of the mantle the influence of an ancient model of the type represented by the Claudius and Augustus (no. 550) statues in the Vatican.

[30] If it is permissible to expand the presuppositions for the *Longinus* to images of movement of the type of the Leinberger *George* and *Christopher* (Munich, Frauenkirche, A. Feulner and T. Müller: *Geschichte der deutschen Plastik*. Munich 1953, 331ff., and the catalogue of the Leinberger–Stethaimer exhibition in Landshut 1932, No. 160), then we may see in Bernini's figure something Ancient imbued and inspired by something of the late Gothic. Hence the parallelism between Bernini's *Longinus* and the Zürn *Sebastian* in Karlsruhe (*Zeitschr. d. Dt. Ver. f. Kunstw.* 1943, 83). Also, Lodovico Carracci's *St. Roch*, Bologna, Pinacoteca (H. Bodmer: *Lod. Carracci*. Burg b. M. 1939, 127, No. 30, "about 1602–1605") should not be ignored.

[31] Bernini has paradigmatically formulated the hazardous venture on the razor's edge in the drawing of Heracles who balances an obelisk (Brauer–Wittkower: *Die Zeichnungen des G. L. Bernini*. Berlin 1931, p. 143 and pls. 110–112): canted just so far that his diagonal is plumb, he manages to sustain this position. The tension lies in the precise state of extremity, in the being made to stand out from a process of movement, in the dwelling on an apparent threat, the physical point of a motor experiment.

moltitudine di figure vivono i sensi e le passioni di ciascuna."[32]
Daphne and David experience a true crisis; in their culminating
movement something fateful is condensed: for the maiden Daphne,
her metamorphosis, for the youthful David, his victory with the sling.
Both act out before our eyes what is constituted by their destiny; the
fulfillment of their nature is realized and frozen into an image.[33] The
critical, apparently fleeting moment harbors what is enduring and
reveals the permanent existence that lies beyond it.

It was in this way then that Bernini's struggle to realize the
Longinus theme ended in a representation of character which has an
ultimate validity. The experience which distinguishes and transforms
the saint,[34] imposes upon him a gesture that exhausts his personal and
historical calling. It completely overwhelms him; he stands there
enraptured to the limits of his possibility. The ecstasy leaves him no
freedom; the tension permits no expectation of release. So decidedly
determined, his movement appears abstracted from the flux of events
and the sculpture eternalizes a moment of decision at the zenith of his
existence.

[32] Bellori: *Vite* 1728, 32 [". . .in such a multitude of figures live the senses and
passions of everyone."]; almost identical in the *Vita* of A. Algardi (p. 156) on his
relief of Leo and Attila: "*e tutte le figure sono animate nella proprietà degli affetti
loro.*" ["and all the figures are animated in the property of their emotions."].

[33] Recently R. Wittkower: *Art and Architecture in Italy 1600 to 1750.* The Pelican
History of Art. London 1958, 96ff. has expressed similar ideas. In this connection the
disagreement of A. W. Schlegel with Winckelmann and Lessing may be recalled
(*Vorlesungen*, Stuttgart 1884, 141f.): Sculpture can and may eternalize the moment,
"if it is worthy of this. . . . It only requires that the movement, free and
self-determined, comes from within. So may Apollo eternally stride. . . ."

[34] The conversion, through which Longinus has been transformed, also forms the
leitmotif of the lines which I. M. Silos (*Pinacotheca sive Romana Pictura et
Sculptura.* Rome 1679, 177f.) composed on Bernini's statue:

> *Non hic dedidicit miles vel saxeus hastam*
> *vulnificam dira fronte vibrare suam.*
> *Vibrat: sed Crudo, proh! quam mutatus ab illo*
> *Longino: nempe est idem, aliusque simul.*
> *Improbitas olim movit truculenta lacertos*
> *trajecitque Dei pectora nuda chalybs:*
> *Nunc pietas vultu est: ferro ceu vellet eodem*
> *pro Christo pectus dilacerare suum.*
> *Saxa animas, Bernine, manu: hoc sed pulchrius esse*
> *nempe pium, exuto marmore, marmor idem.*

[Neither the soldier nor figure of stone forgot/With ominous brow to threaten the
wound-giving lance./He swings—but oh, wait! of Longinus what has changed?/
Surely he is the same, and at once yet another./Earlier it was boldness that roused
his truculent limbs,/To pierce the unclothed flesh of God did he hurl his

Like the *Longinus*, each of Bernini's figures exists in its own sphere, removed from a viewer of whom it is unaware.[35] They are separate from and superior to our realm—like the *Teresa* in the Divine light of her chapel niche separated from the Cornaro lords who dwell in the light of day. In his aspiration to create a quintessential embodiment of existence, Bernini succeeded in thinking out each figure completely from within itself and placing it in a telling act of experience that illuminates, *sub specie aeternitatis*, what is most personal. From the diversity of the tasks grew the multiplicity of his world of forms: each theme demanded of him a new invention, each gesture appears only once in his work, each portrait even behaves in its own way. There are as many formal structures as tasks. More explicitly than his predecessors he differentiated the various kinds of works—altar, tomb, fountain, freestanding figure. His power to fathom the natural conditions and become their master is rooted in an empirical understanding that also enabled him to transform a given disposition and incorporate it in a new context of his own invention, as for example, he built within the old shell of the Scala Regia in such a way that the meanness of the situation, changed into an effect of heightened splendor, is forgotten. Through a keen sense for the particular and a drive to individualize, his first fruits grew into maturity—creations like the *Daphne* group, the Four Rivers Fountain, and the Cornaro Chapel with its Teresa altar, which were never surpassed later. And yet his creative gifts were perhaps never more convincingly apparent than in the face of the unparalleled and unrepeatable tasks presented by papal Rome, tasks like the Cathedra Petri and the Ponte Sant'Angelo, which were rooted in the most distant past and for all that offered no precedent. As in all his greatest creations, Bernini concentrated on the *Longinus* the whole of his genius.

sword:/Now in his glance comes compassion: by steel or that lance/For the Christ he would render asunder his very own breast./By your hand, Bernini, you quicken the stones: more beautiful/Yet becomes the marble revealed become marble devout. Trans. by Margaret Murata.]

[35] The frequently recurring statements on the communication with the space of the viewer therefore require a certain qualification. Also, through their pictorially restrained frontality (the predominance of a main view, to which admittedly many reproductions do not do justice), the figures become removed into an objectifying plane. For this, the characteristics of Bernini's architecture as opposed to Borromini's that E. Panofsky: "Die Scala Regia im Vatikan und die Kunstanschauungen Berninis." *Jahrb. d. Preuss. Kunstsammlungen*, Vol. 40, 1919, 241ff., has worked out should be recalled.

THE *ARS MORIENDI* AND THE *SANGUE DI CRISTO*

Irving Lavin

BERNINI AND THE JESUIT "ARS MORIENDI"

The idea of preparing for death received the widest possible currency in the late fifteenth century through the *Ars Moriendi*. This was one of the most popular publications of the period, reprinted throughout Europe in dozens of editions, translations and adaptations.[1] It was specifically an instruction manual in the "art" ("crafte" or "cunnynge," as it was often rendered in English) of dying well, that is, the method of achieving salvation during the final hours of life. In its extended version, the only one used in Italy, the work is divided into six parts.[2] The first is a commendation of death in which the reader is urged, when the time comes, to give up willingly and gladly, without any grudging or contradiction. Part 2, the real core of the work, is devoted to the wily temptations used by the devil in his ultimate struggle with God for the soul of the dying man, and the countering responses offered by *moriens's* guardian angel. The essential character of the book, which was determined by its divulgatory purpose, lies in the relation between the text and the pictures in this and the following

"The *Ars Moriendi* and the *Sangue di Cristo*" by Irving Lavin. From "Bernini's Death" by Irving Lavin, with minor abridgment and translation of the footnotes by the editor. From *The Art Bulletin*, Vol. LIV, No. 2 (1972), pp. 162–71, where the complete footnotes and full illustration of the text can be found. Reprinted by permission of the author and publisher. See above, pp. 38–43.

[1] In general, cf. A. Tenenti, *Il senso della morte e l'amore della vita nel Rinascimento*, Turin, 1957, 8off. In particular, M. C. O'Connor, *The Art of Dying Well*, New York, 1942, with an exhaustive list of manuscripts and editions; R. Rudolf, *Ars Moriendi*, Cologne, 1957. For a recent discussion of the early illustrations, see H. Zerner, "L'art au morier," *Revue de l'art*, XI, 1971, 7–30.

[2] O'Connor, *Art of Dying Well*, 157, n. 313.

section. The five temptations (against Faith, to Despair, Impatience, Vainglory and Avarice) and the responses to them, are each described and illustrated in a woodcut, in which *moriens* is shown on his deathbed alternately beset by devils and rescued by angels. Part 3 is devoted to the Interrogations, a series of questions posed to the dying man which, answered rightly, will help to assure his salvation. This section is accompanied by an eleventh woodcut showing the death scene, with the soul of the deceased received by his guardian angel.[3] Text and illustrations thus proceed *pari passu*, and are independent of yet complementary to one another. Part 4 contains an Instruction to the dying man, which is that he should take Christ's death on the Cross as his model. Part 5 gives instructions to those present, such as not to deceive *moriens* with false assurances of his recovery, or to give precedence to medical over spiritual aid in their ministrations. The dying man must also have before him holy images, especially the Crucified Christ and the Virgin. Chapter 6 provides prayers to be said by a faithful friend.

It is evident that Bernini's death was in many respects a literal enactment of the *Ars Moriendi*. His prodigal charities, which displayed his ultimate disdain for the things of this world; his patient, indeed willing acceptance of the inevitable; the very scene of the end conjured up by the biographers' accounts—including the pious image by his bed and the colloquies with Father Marchese—all seem to fulfill the recommendations of the *Ars Moriendi*. The imagery of the *Sangue di Cristo* composition (Fig. 33), the Crucifixion with the Virgin Mary and the angels, especially the guardian angel, recalls that of the early illustrations. Even the use of a special sign language to communicate without speech belongs in this context, since its purpose no doubt was to enable Bernini to respond to the crucial interrogations.[4]

To find an echo of the *Ars Moriendi* in the late seventeenth century is in itself remarkable since the impetus of the original work in Italy was by then long spent, although it was never forgotten. But no less significant are the differences in Bernini's death from that

[3] The latest illustrated Italian edition I have found is *L'arte del ben morire*, Rome, 1596.

[4] Also known as "Anselm's questions" (cf. J. P. Migne, *Patrologiae cursus completus*, Paris, 1844ff., *Series latina*, CLVIII, cols. 685ff.), the interrogations had been a standard part of the ritual of death until they were omitted in the official *Ritual Romanum* of 1614; but they continued to be popular (e.g., V. Auruccio, *Rituario per quelli, che havendo cura d'anime. . .* , Rome, 1615, 49ff., reprinted 1619, 1624, 1625), and O'Connor, *Art of Dying Well*, 31ff., esp. 35, records a number of instances of their use into the 19th century.

envisaged in the *Ars Moriendi*: style in the Art of Dying Well had changed considerably. Some of these differences were personal to Bernini, while others reflect more general developments in the *Ars Moriendi* tradition.

Apart from editions of the *Ars Moriendi* itself, a number of Italian works of the late fifteenth and early sixteenth centuries, for which it served more or less directly as the model, give a measure of its immediate influence.[5] Such, for example, are the *De modo bene moriendi* written about 1480 by Pietro Barozzi, Bishop of Padua and chancellor of the university there, published in Venice in 1531, and the *Dottrina del ben morire* by one Pietro di Lucca, published at Venice in 1515.[6] The intimate connection between text and pictures that characterized the original *Ars Moriendi* determined the very structure of its most famous emulation in Italy, the sermon preached in Florence by Savonarola on All Souls' Day in 1496, published afterwards with the title *Predica dell'arte del ben morire*.[7] The sermon develops around three images, illustrated as woodcuts in the published editions, which Savonarola exhorted his listeners to have painted for themselves. The first of these is a reminder of the Last Judgment, a grandiose composition representing Heaven and Hell, which the still-healthy listener was urged to keep in his room and look at frequently, while he thought of death and said to himself, "I might die today." The second picture shows the man sick in bed, with death as a skeleton knocking at his door. The third scene shows the man now on the point of death, with the skeleton seated at the foot of his bed.

A common tendency may be discerned in these treatises. Savonarola is concerned not only with death as such and the immediate preparations for it, but also with the healthy man, to whom his first image is directed. The same concern is evident in the works of Pietro Barozzi and Pietro di Lucca. Thus the Art of Dying was extended into a life-long process, and contemplation of death and preparation for it became in themselves a kind of art of living well. In the course of the sixteenth century the literature devoted to the art of dying diminished, and ultimately almost disappeared.[8] In the early seventeenth century, however, there was a great revival of interest in

[5] For what follows, see *ibid.*, 172ff., and Tenenti, *Senso della morte*, 112ff., 330ff.

[6] On Barozzi, cf. *Dizionario biografico degli italiani*, Rome, 1960ff., VI, 510ff.

[7] M. Ferrara, *Savonarola*, 2 vols., Florence, 1952, II, 66ff. For the text, cf. *Girolamo Savonarola. Prediche sopra Ruth e Michea*, 2 vols., ed. V. Romano, Rome, 1962, II, 362ff.

[8] Tenenti, *Senso della morte*, 321.

the theme, which centered at Rome in the Jesuit order.[9] Two factors were particularly significant in this revival, both of which incorporate the tendency to extend the preparations for death back from the deathbed to include the individual's whole life.

One was the publication in 1620 of the *De arte bene moriendi* by Roberto Bellarmino, the great theologian for whose tomb in the Gesù, the mother church of the Jesuits, Bernini carved the portrait two years later.[10] Bellarmino's treatise is divided almost equally into two parts, of which only the second is devoted to the preparations for death at the time it comes near. Here he follows the *Ars Moriendi* tradition closely, including the temptations of the Devil (where he cites Pietro Barozzi among his sources), and the ministrations of the faithful friend. Part I, on the other hand, deals with remote preparations for death, which include practice of the theological and moral virtues, and the sacraments beginning with Baptism and ending with Extreme Unction. Bellarmino devotes most of the book to these central acts of faith, and places particular emphasis on the Eucharist, "the greatest of the sacraments, in which is contained not only copious grace but also the very author of grace." In contrast to Savonarola's exhortation to the constant contemplation of death, the keynote for Bellarmino is provided by his title to the opening chapter, "He who would die well, should live well."

The second major factor in the *Ars Moriendi* revival, a direct outgrowth of Bellarmino's concern with the subject, was the foundation of the Confraternity of the Bona Mors at the Gesù.[11] The congregation differed from earlier such organizations devoted to death in that it was not conceived primarily to carry out an act of mercy, that of burying the dead, but to institute a program of devotions and exercises through which its members might assure themselves the benefits of a good death. The essence of its spiritual program is evident from the organization's full name, "Congregazione del Nostro Signore Gesù Cristo moribondo sopra la Croce e della Santissima Vergine Maria sua Madre Addolorata, detta della Buona Morte." The congre-

[9] For the vast Jesuit literature on death, see the listings in A. De Backer and C. Sommervogel, *Bibliothèque de la Compagnie de Jésus*, 12 vols., Brussels, 1890–1960, x, cols. 510–19; also E. Mâle, *L'art religieux après le concile de Trente*, Paris, 1932, 206ff., J. De Guibert, *La spiritualité de la Compagnie de Jésus*, Rome, 1953, 384ff.

[10] R. Bellarmino, *Opera Omnia*, 12 vols., Paris, 1870–1874, VIII, 551ff.

[11] A thorough history of the organization has yet to be written. Cf. A. L'Hoire, *La congrégation de Notre-Seigneur Jésus-Christ mourant en Croix et de la Très Sainte Vierge, Sa Mère participant a ses douleurs dite de la Bonne Mort*, Paris, etc., 1904; G. B. Piazza, *Opere pie di Roma*, Rome, 1679, 684ff.; P. Pecchiai, *Il Gesù di Roma*, Rome, 1952, 314.

gation was founded in 1648 by Vincenzo Caraffa, who was then *praepositus generalis* of the Society of Jesus, of which the principal activity was regular Friday devotions to the Crucified Christ and His wounds, to the Sorrows of the Virgin, and to the Eucharist. A great altarpiece, now lost, showing the Crucified Christ and the Mater Dolorosa was painted for the congregation and unveiled before the High Altar of the church each Friday.[12] The Bona Mors was a phenomenal success, and by the end of the century branches had been established throughout Europe.

From Bellarmino's treatise and the foundation of the Bona Mors a continuous tradition was established at the Gesù, in which Bernini directly participated. In 1649 the first moderator of the congregation, Giovanni Battista Manni, published a volume describing its Friday devotions, and subsequently brought out several illustrated works concerned with death.[13] The confraternity's second moderator during Bernini's lifetime was one Giuseppe Fozi. In 1669, in connection with the canonization of Maria Maddalena de' Pazzi in that year, Fozi put into print a life of the saint that had been left in manuscript by one of her early biographers, the Jesuit Virgilio Cepari.[14] Since Bernini, as his son reports, attended the devotions of the Bona Mors for forty years, he must have participated from its very inception. In the true spirit of the revived *Ars Moriendi*, preparation for death became for him a

[12] Piazza, *Opere pie*, 685f., and Manni, *Breve ragguaglio*, 100f. (cited in the following note).

[13] A list of moderators is in the Archive of the Gesù: *Catalogus Moderatorum Primariae Congregationis sub invocatione D. N. G. C. in Cruce moribundi ac Beatissima Mariae Virginis ejus Genetricis Dolorosae vulgo Bonae Mortis ab ejus Fundatione anno 1648 ad annum 1911.*

G. B. Manni, *Breve ragguaglio e pratica instruttione degli esercitii di pietà cristiana che si fanno nel Giesu di Roma ogni venerdì mattina, e sera, per la divotione della Bona Morte da ottenersi per li meriti della Passione, & agonia di Cristo in Croce: e de' dolori della sua Madre Santiss. sotto la Croce*, Rome, 1649; *idem, L, Varii, e veri ritratti della morte disegnati in immagini, ed espressi in essempij al peccatore duro di cuore*, Venice, 1669; *idem, La morte disarmata, e le sue amarezze raddolcite con due pratiche, per due acti importantissime, l'una del ben morire, e l'altra d'ajutare i moribondi*, Venice, 1669.

Cf. De Backer and Sommervogel, *Bibl. de la Compagnie*, V, cols. 500, 502. Manni was later closely involved in the negotiations for the decorations of the Gesù (see n. 29 below); Pecchiai, *Il Gesù*, 113ff.

[14] *Vita della Serafica Verg. S. Maria Madelena de' Pazzi Fiorentina. . .Scritta dal Padre Virgilio Cepari della Compagnia di Giesù. Et hora con l'aggiunta cavata da' Processi formati per la sua Beatificazione e Canonizatione del Padre Giuseppe Fozi. . .*, Rome, 1669. Cf. De Backer and Sommervogel, *Bibl. de la Compagnie*, II, 957, III, 914. Among Fozi's other works is one on priestly assistance to the dying, *Il sacerdote savio, e zelante assistente a' moribondi*, Rome, 1683.

life-long process. The basic imagery of his *Sangue di Cristo* composition was clearly inspired by the congregation's invocation of the Crucifixion and the sorrowing Virgin, and its particular devotion to the Eucharist. Bernini himself explained that he made the work as a personal votive offering for the benefit of the world at large;[15] this may well have been in fulfillment of the members' obligation to assist others to obtain a good death. Giuseppe Fozi, in preparing the biography of Maria Maddalena de' Pazzi, must certainly have become familiar with the passage, cited on the *Sangue di Cristo* engraving, in which she invokes the Holy Blood and the intercession of Christ and the Virgin; he must have noted its striking correspondence to the dedication and devotions of the Bona Mors, and he may have originally brought it to Bernini's attention.

FATHER FRANCESCO MARCHESE

The son of Bernini's older sister, Beatrice, was born in 1623. He became a priest of the Oratorio, the order founded by St. Philip Neri with its headquarters in the building by Borromini adjoining Santa Maria in Vallicella. Father Marchese is described as very learned, a fervid and assiduous executor of the rules and obligations of the order, to which he added his own severe application to studies sacred and profane.[16] He is best known as a zealous opponent of the Quietist

[15] "1671. *Il Sig. Cavalier Bernino dice che havendo in vita sua fatti tanti disegni per Pontefici, Rè, è Prencipi, uole sigillare con fame uno à gloria dell'offerta che si fà al Padre Eterno del pretiosissimo Sangue di Christo; stando jn questo pensièro gli è parso, che si possi prègare la gloriosissima Vergine, a fare lej per noi, à Padri Theòloghi, et altri spirituali. Jl pensiero gliè parso bellissimo, è molto utile per tutti; stante questo hà fatto il presente disegnio, et in sua presènza l'hà fatto intagliare per poteme dare à molti, è mandarne per Jl mondo a gloria del Sangue di Christo.*" ["1671. The Cavalier Bernino says that having during his lifetime made so many designs for pontiffs, kings, and princes, he wishes to finish by making one to the glory of the offering which is made to the Eternal Father of the Most Precious Blood of Christ; with this in mind it seemed to him that one can pray to the Most Glorious Virgin for her intercession, to the doctors of the Church, and to other holy persons. The idea appeared most beautiful to him, and very useful for everyone; considering this he has made the present drawing and has had it engraved in his presence to be able to give it to everyone and send it across the world to the glory of the Blood of Christ."]: a dispatch to the court of Modena, first published by F. Imparato, "Documenti relativi al Bernini e a suoi contemporanei," *Archivio storico dell'arte*, III, 1890, 142f., then by Fraschetti, *Bernini*, 420, n. 2.

[16] Marchese di Villarosa, *Memorie degli scrittori filippini o siano della Congregatione dell' Oratorio di S. Filippo Neri*, Naples, 1837, 168–70; pt. 2., Naples, 1842, 70. C. Gasbarri, *L'oratorio romano dal cinquecento al novecento*, Rome, 1962, 177ff.

leader Miguel de Molinos, whose downfall he was instrumental in bringing about during Molinos's trial by the Inquisition in the 1680's; an important manuscript volume of the materials he gathered against Molinos still exists in the Vallicella library.[17] Apart from four other works which he left unpublished at his death in 1697, the standard bibliography of Oratorian authors lists no fewer than twenty-one books by Marchese, which bear a strongly individual stamp and display a remarkable development. They are mainly of two kinds, biographies of saints and devotional works. While they do indeed show a formidable knowledge of sacred and profane history and literature, they are neither scholarly reconstructions of the past, nor abstract theological speculations. Of the three works Marchese published before 1670 (the significance of which date will emerge presently), the first was a vast compilation in three volumes of prayers to the Virgin gathered from an incredible variety of sources and so organized as to provide devotions for every day of the year;[18] the second was a book of meditations on the Stigmata, and the third a life of the Spanish mystic, St. Pietro d'Alcantara.[19] They are thus eminently practical and edifying works, and focus primarily on the mystical nature of piety. This was characterized by Marchese not in quietistic terms of passive contemplation, but as a process of active, passionate devotion. This gifted nephew, at once learned and intensely concerned with the welfare of the human spirit, must have provided an ideal counterpoint for Bernini's own reflections on death and salvation—the "faithful friend" of the *Ars Moriendi*. Although Marchese was the man of letters, their conversations must have been truly reciprocal: witness Giovanni Paolo Oliva's remark that talking to Bernini on spiritual matters was like discoursing with a professional.

In 1670 Father Marchese published two books which have as their central theme the efficacy of the sacrifice of Christ to save the sinner who repents before he dies. The message of one is stated in its title, *Unica speranza del peccatore che consiste nel sangue del N. S.*

[17] Cf. L. von Pastor, *The History of the Popes*, 40 vols., St. Louis, Mo., 1938–52, XXXII, 447ff.; Marchese's role in the process against Molinos is described at length in P. Dudon, *Le quiétiste espagnol Michel Molinos (1678–96)*, Paris, 1921, *passim;* also M. Petrocchi, *Il Quietismo italiano del seicento*, Rome, 1942, 66, n. 32, 102, 193ff.

[18] *Diario sacro dove s'insegnano varie pratiche di divotione per honorare ogni giorno la Beatissima Vergine raccolte dall' historie de' santi, e beati correnti in ciascun giorno dell' anno e dalle vite d'altri servi di Dio. . .*, 3 vols., Rome, 1655–58.

[19] *Il divoto delle sacre stimmate di S. Francesco*, Rome, 1664; *Vita del R. Pietro d'Alcantara*, Rome, 1667.

Giesù Cristo. The other book, entitled *Ultimo colpo al cuore del peccatore,* is conceived as the final call to the hard of heart to accept the gift of grace offered by the Crucifixion. A third work by Marchese, published posthumously, belongs explicitly to the genre of the *Ars Moriendi;* the *Preparamento a ben morire* is a spiritual guide to salvation through penitence, devotion to the Eucharist, invocation of the Virgin, the saints and angels, and through prayer.[20]

Many of the most striking aspects of Bernini's death are elucidated in the writings of Father Marchese. The *Unica speranza,* an octavo volume of two hundred pages, was actually written to accompany the *Sangue di Cristo* print; Marchese states this in the preface, where he describes the design and urges him who desires salvation either to fix his eye upon the image, or to read the text.[21] The print in turn served as the frontispiece to Marchese's book.[22] The

[20] *Unica speranza del peccatore che consiste nel sangue del N. S. Giesù Cristo spiegata con alcune verità, con le quali s'insegna all'anima un modo facile d'applicare a se il frutto del medesimo sangue. . . . ,* Rome, 1670; *Ultimo colpo al cuore del peccatore,* Rome, 1670; *Preparamento a ben morire opera postuma del Vener. Servo di Dio Francesco Marchesi preposto della Congregatione dell'Oratorio di Roma. . . ,* Rome, 1697.

[21] *"Sangue di Giesù Crocefisso al Cuore di chi legge. . .Ah che l'huomo carnale non penetra le cose superne, e che da Dio prouengono: perciò à farle meglio capire, l'infinita carità del Signor Iddio hà ora con particolar prouedimento disposto, che da mano di divoto artefice sia delineata l'Imagine del Salvatore Crocefisso, grondante Sangue in tanta copia, che se ne formi un ampio mare, e che per mani della Beatissima Vergine Maria conforme al pio sentimento di S. Maddalene de Pazzi io sia del continuo offerto all'eterno Padre à favore de' peccatori, (per la cui esplicatione si è composto il presente libro) affinche con tali mezi agli occhi dell'huomo carnale rappresentati, il tuo cuore sia più facilmente disposto à udire, e ad ubidire à suoi celesti ammaestramenti. Apri adunque l'orecchio del cuore, mentre fissi l'occhio alla diuota imagine, ò leggi questi fogli."* ["The Blood of Christ Crucified to the Reader. . .Alas that the man of flesh does not fathom things divine which come from God: therefore to make them better understood, the infinite mercy of the Lord God has now ordained with special providence that by the hand of a devout artist should be drawn the Image of the Savior Crucified, pouring Blood in such abundance that it forms a broad ocean, and that by the hands of the Most Blessed Virgin Mary, in accordance with the pious thought of S. Maddalena de' Pazzi, I may be continuously offered to the Eternal Father on behalf of sinners (for the explanation of which the present book has been written); so that, represented by such means to the eyes of the man of flesh, your heart should be more readily induced to hear and to obey his celestial instructions. Open therefore the ear of the heart while you fix your eye on the devout image, or read these pages."].

[22] Copies with the engraving are in the Vatican Library and the British Museum. The print has heretofore been known only separately (Bernini also distributed it so; cf. n. 15 above), and its connection with Marchese's book was unsuspected. The composition has been variously related to Molinos's *Guía espiritual* and Father

Sangue di Cristo and the *Unica speranza* were thus conceived together as complementary parts, text and illustration, of a modern *Ars Moriendi*. It is in the light of this specifically propagatory function that the original format of Bernini's work, a drawing intended to be engraved, may be understood.

The text of the *Unica speranza* helps clarify the meaning of Bernini's image, both in itself and as part of a sequence of ideas leading to salvation. The substance of the work lies in "fifteen truths" formulated by Father Marchese. The first three describe the unhappy condition of the sinner in the world and in the hereafter. The fourth truth is that the sole remedy for the sinner's ills is the Precious Blood of Christ, and the fifth is that the Savior ardently desires the sinner's participation in His Blood. Here a lengthy passage is devoted to expressing the universal efficacy of the Eucharist, through the metaphor of the Blood of Christ as an infinite sea that covers the world. Marchese relates the concept to that of the Blood as a fountain and as a river; he cites a variety of sources, including the prophets Job (38:11, "and here shall thy proud waves be stayed?") and Micah (7:19, "and thou wilt cast all their sins into the depths of the sea"), St. John Chrysostom (Hom. 41 in Ioann., "This Blood, poured out in abundance, has washed the whole world clean"), and Maria Maddalena de' Pazzi, who described the era of grace, in which the Incarnate Word sent the Blood of Christ into this small world, as the second flood, following that of Noah.[23] The succeeding truths assert that the Blood of Christ is communicated easily through the Holy Sacraments, especially Penitence and the Eucharist. The treasure of the Blood can also be obtained with the assistance of indulgences, but neither good works nor penances actually erase sins, only the Blood itself. The twelfth truth is specifically related to Bernini's composition, and states that the treasure of the Blood is offered and dispensed through the hands of the Virgin; it is here that the passage from Maria Maddalena de' Pazzi, which in abbreviated form provided the subtitle to the *Sangue di Cristo* engraving, is cited in full from the source, Part II, Chapter 6 of Vincenzo Puccini's life of the saint: "I offer you, Eternal Father, the Blood of the humanity of your Word; I offer it to you yourself, Divine Word; I also offer it to you, Holy Spirit; and if

Oliva's sermons (W. Weibel, *Jesuitismus und Barockskulptur in Rom*, Strassburg, 1909, 10ff.; Lanckorońska, *Decoracja*, 71, n. 110 [cited in n. 29 below]; R. Kuhn, "Gian Paolo Oliva und Gian Lorenzo Bernini," *Römische Quartalschrift*, LXIV, 1969, 229ff.).

[23] *Unica speranza*, 32ff. The ocean metaphor occurs again in the *Ultimo colpo*, 29. See also in the text below.

anything is wanting in me, I offer it to you, Mary, that you may present it to the Most Holy Trinity." [24] Marchese's thirteenth truth establishes the relevance of the others to death, which is that he who lives devoted to the Blood of Christ may hope to die well.

Other aspects of Bernini's death find a context in Father Marchese's *Ultimo colpo*. In particular, echoes may be heard here of those aphoristic statements of doctrine and belief which Domenico Bernini calls his father's "shortcut" to heaven. For example, in the *Ultimo colpo* Marchese thus expresses the notion that it is an insult to God's magnanimity to doubt His forgiveness: "It would be a manifest injury to the sovereign Goodness to doubt obtaining from it the remission of our sins, while such efficient means of reaching it are offered to us." Marchese uses the fiscal metaphor of God as a beneficent capitalist in His dealings with the sinner, in a long passage in the same work, which concludes, "Who would not wish to deal with such a liberal merchant, who sells his very rich goods at so low a price?" The idea of sins being drowned or tinted to another color in the sea of Blood also occurs in the *Ultimo colpo*: "Therefore, make therein this happy shipwreck of yourself, and of all sins, precisely in the way that a drop of water thrown into a river is immediately absorbed by it and transmuted into it. Do you not see that the benign aura of Divine goodness often lifts its amorous odes toward you from the breast of this bloody sea, to drown you in itself, and then, having become all white, to raise you up as high as the Throne of God, where it illuminates you?" [25]

Above all, the extraordinary thought of preparing for death by practicing dying must have been a matter of special study by Bernini and his nephew. In the *Preparamento a ben morire* Father Marchese devotes no less than four chapters to exercises of this kind.[26] For one of the most important of them he follows the ancient *Ars Moriendi* tradition which recommended contemplation of the Crucifixion and the Virgin at the time of death. Marchese urges the reader, "turned in his heart and with his eyes toward a Crucifix, to take great confidence in the immense value of the Blood of the Savior shed for his love, and to offer it by the hands of the Blessed Virgin Mary, our most clement advocate, to the Divine Trinity—as was often done by Santa Maria Maddalena de' Pazzi in satisfaction of the grave debt contracted by

[24] *Unica speranza*, 83. The original text in V. Puccini, *Vita della Madre suor Maria Maddalena de' Pazzi fiorentina*, Florence, 1609, 241ff.

[25] Cf. *Ultimo colpo*, 33, 32, 29f.

[26] Chapters 11–14 (*Preparamento a ben morire*, 99–137).

her with eternal justice." [27] It is here, one may suppose, that the *Sangue di Cristo* was to serve its primary purpose, as it did for Bernini himself when he subsequently had the composition painted and placed before his own deathbed.

THE GENESIS OF THE "SANGUE DI CRISTO" COMPOSITION

The essential point of the *Sangue di Cristo* is that Salvation is achieved through the sacrifice of Christ, which His mother offers to the Father.[28] The genesis of this deceptively simple concept may best be approached through a drawing in Leipzig which perhaps represents a prior stage in Bernini's thinking, and which in any case follows a closely related tradition (Fig. 34).[29] Christ is shown seated with His

[27] *Ibid.,* 121.

[28] A drawing of the composition in the Tylers Stichting, Haarlem, bears an old adscription to Bernini, and the license of the papal censor. It is probably by Baciccio according to H. Brauer and R. Wittkower (*Die Zeichnungen des Gianlorenzo Bernini,* Berlin, 1931, 155, n. 4); J. van Regteren Altena supported the attribution to Bernini (*Cristina Queen of Sweden,* exh. cat., Stockholm, 1966, 464, No. 1146; cf. *Le dessin italien dans les collections hollandais,* exh. cat., Paris-Rotterdam-Haarlem, 1962, 101f., No. 166); B. Canestro Chiovenda reaffirms Baciccio's authorship ("Ancora del Bernini, del Gaulli e della regina Cristina," *Commentari,* XX, 1969, 223ff.).

On the various painted versions of the composition, see L. Grassi, *Bernini pittore,* Rome, 1945, 49f., figs. 81–82; V. Martinelli, "Le pitture del Bernini," *Commentari,* I, 1950, 103; Canestro Chiovenda, "Ancora del Bernini."

[29] Brauer and Wittkower, *Zeichnungen,* 166f., pl. 128, regarded the Leipzig sketch as a study for the *Sangue di Cristo* (cf. R. Wittkower, *Gian Lorenzo Bernini. The Sculptor of the Roman Baroque,* 2nd ed., London, 1966, 257). The precedence of the Leipzig drawing is doubtful, however, and it may have been made for another purpose: it was evidently the point of departure for the dome fresco of the Gesù, executed 1672–75 by Baciccio with advice from Bernini (cf. K. Lanckorońska, *Decoracja kościoła "Il Gesù" na tle rozwoju baroku w rzymie,* Lwów, 1936, 19ff., 51f.; F. Haskell, *Patrons and Painters,* New York, 1963, 82; R. Enggass, *The Painting of Baciccio,* University Park, Pa., 1964, 32ff., 135f.).

Presuming a direct connection between the Leipzig sketch and the *Sangue di Cristo,* Lanckorońska was led to the conclusion that certain Baciccio drawings related to the latter, in Düsseldorf and Berlin, were studies for an alternate version of the Gesù dome. B. Canestro Chiovenda suggested, instead, that the Baciccio drawings were preparatory for the mosaic in the dome of the vestibule of the Baptismal Chapel in Saint Peter's, a commission Baciccio received and began but never completed ("Cristina di Svezia, il Gaulli e il libro di appunti di Nicodemo Tessin d. y. [1687–1688]," *Commentari,* XVII, 1966, 177); it appears that this hypothesis is substantially correct, since the composition envisaged in the drawings is reflected in the mosaic subsequently executed by Francesco Trevisani (cf. F. R. DiFederico, "Documentation for Francesco Trevisani's Decoration for the Vestibule of the Baptismal Chapel in Saint Peter's," *Storia dell'Arte,* VI, 1970, 155ff.).

back to the spectator on a bank of clouds, arms extended around a cross; the hands are opened, palms up, in a gesture of offering to the Father, who appears above with arms outstretched. The Virgin kneels facing Christ at the right, head inclined, her hands pressing her breast. Panofsky, who first published the drawing, showed that the composition refers to a later medieval devotional formula, derived from the *Speculum humanae salvationis*.[30] This illustrates the intercessional roles in the process of salvation of Christ, who offers His sacrifice to the judging Father, and of the Virgin, who offers her motherhood.

What requires emphasis here is the fact that this theme was central to the ideology of death in general, and to the *Ars Moriendi* in particular. It appears, notably, in the interrogations, where *moriens* is advised, should God wish to judge him, to reply thus: " 'Lord, I will place the death of your son and our Lord Jesus Christ between me and your damnation to the torments; I have no wish to contend with you.' And if He should say that you deserve eternal death, say thus, 'I place the death of the same Jesus Christ between you and my demerits, and I offer the merit of His most worthy passion for the merit I should have and, woe is me, do not yet have.' And add, 'I also put the death of Our Lord Jesus Christ between me and your wrath.' "[31] The thought and phraseology of these passages seem to reverberate in that from Maria Maddalena de' Pazzi cited on the engraving, and in Bernini's idea, recorded by his son, of the humanity of Christ as the protective "Veste de' Peccatori."

In the *Ars Moriendi* itself the invocation had been illustrated paratactically, as it were, by the presence of the Crucifixion with the grieving Virgin at the deathbed; the full dedication of the Bona Mors confraternity also juxtaposed the Crucifixion and the Mater Dolorosa with death. The *Speculum humanae salvationis* and the *Ars Moriendi* thus represent two complementary but distinct conceptions; the one focuses upon the process of intercession through which salvation is attained, the other upon the sacrificial act which the dying man invokes.

In the *Sangue di Cristo* engraving these ideas are merged. Bernini was not the first to combine them. Indeed, striking evidence that he

[30] "Imago Pietatis," in *Festschrift für Max J. Friedländer zum 60 Geburtstage*, Leipzig, 1927, 294. Cf. J. Lutz and P. Perdrizet, *Speculum humanae salvationis*, Mulhouse, 1907–09, 293ff., pls. 137f.; D. Koepplin, s. v. "Interzession," in *Lexikon der christlichen Ikonographie*, Rome, etc., 1963ff., II, cols. 346ff. A further example is a panel ascribed to Bartolomeo di Giovanni in the Museum of Fine Arts, Montreal (A. Neumeyer, *Der Blick aus dem Bilde*, Berlin, 1964, fig. 16).

[31] *Dell'arte del ben morire*, Naples, 1591, 28.

intended the merger is provided by the fact that a similar line of thought produced what is in some respects the nearest antecedent for his design. This occurs in a stained-glass votive window in the cloister of the Cistercian monastery at Wettingen, Switzerland, dated 1590.[32] *Moriens* is shown below giving up the ghost, while the interceding Virgin, Christ Crucified, God the Father and the Dove are represented above as a cloud-borne apparition. The chief difference between this and ordinary intercessional scenes is that, as in the *Ars Moriendi*, Christ is shown on the Cross; as in the *Speculum* tradition, however, He points with one hand to the chest wound. The key to such a depiction evidently lies in the donor: since the historical Crucifixion is invoked by him, he is the subject of the scene; and since the symbolic intercession is enacted for him, he is also the object.

This is the context to which the *Sangue di Cristo* belongs, and its fundamental innovation was the superimposition of the Eucharist as the dominant theme. Though always present in the ritual of death in the form of the viaticum, we have seen that the Eucharist had been given new emphasis in Bellarmino's *De arte bene moriendi*; special devotions to and exposition of the Sacrament had followed upon prayers to the Crucified Christ and the Mater Dolorosa in the Friday services of the Bona Mors congregation; for Father Marchese the Eucharist was the *sine qua non* of the dying man's aspiration. In the *Sangue di Cristo* it is, literally and figuratively, the solution in which the act of sacrifice and the process of intercession are fused. The result was, in effect, a new, synoptic presentation of the scheme of salvation, and it entailed a variety of changes in the old formulations. One important invention concerned the Virgin. Kneeling beneath the Crucifixion, she no longer presses her breast, but extends her hands to receive and offer the Blood to God the Father. Shown thus, the figure is a conflation of the interceding Virgin with the personification of Ecclesia, often represented standing beneath the Crucifixion holding a chalice to collect the Blood, in allusion to the sacrificial liturgy of the Mass. From a theological point of view the conflation was wholly justifiable, since Mary intercedes as Mater Domini while as Mater Ecclesia she expresses the intermediary role of the Church. By having her kneel, and giving her a gesture of offering as well as receiving the Blood, Bernini was able to make the Virgin intercede through the Eucharist—in conformity with the pious sentiment of Maria Maddalena de' Pazzi, as Father Marchese says in the preface to *Unica speranza*.[33]

[32] Lutz and Perdrizet, *Speculum*, 294.

[33] On Ecclesia with the chalice, cf. C. Schiller, *Ikonographie der christlichen Kunst, 2*

The most dramatic new feature of the design, however, was the introduction of the Sea of Blood metaphor to portray the universality of redemption. The metaphor had ancient roots: witness Father Marchese's own citations and that from Paul's Epistle to the Hebrews which provided the main caption for the engraving. The liquidity and universality of the Eucharist had often been linked, as through the imagery of the Fountain of Life and the river of blood, to which Marchese refers.[34] An example of the latter whose visionary character anticipates Bernini is a woodcut design by Botticelli, to which Vasari gives the title *Triumph of the Faith*.[35] This depicts an actual vision described by Savonarola in one of his sermons; the Crucifixion is shown in a circular landscape signifying the world, and the Blood pours down from the Cross to form a river in which converts to the faith cleanse themselves of sin. An analogous theme is that of Christ in the Wine Press, which, in the frontispiece to a Protestant bible of 1641 is accompanied by the passage from Hebrews cited on the *Sangue di Cristo* engraving.[36] Yet, none of these texts explicitly identifies the Eucharist as an ocean, and the idea had not to my knowledge been depicted before. As evident from the very title of Marchese's *Unica speranza*, it was the desire to convey the eschatological aspect of the

vols., Gütersloh, 1966–68, II, 117ff. As a floating figure the Virgin also recalls the flying angels that often receive the Blood in chalices in Crucifixion scenes. The Virgin and angels occasionally have upturned hands, but as a gesture of dismay, not in connection with the Blood.

The notion of the Virgin offering the sacrifice is related to that of her priesthood; in a Flemish engraving of the early 17th century she is shown kneeling, cloud-borne, before an altar, and offering the chalice to God the Father and the Holy Spirit above (G. Missaglia, et al., *La madonna e l'eucaristia*, Rome, 1954, fig. 102).

The emphasis placed in the *Sangue di Cristo* and by Father Marchese on the transmission of the offering through the Virgin's *hands*, is based on St. Bernard: *"É Sentimento assai comune de' Santi Padri, e singolarmente di S. Bernardo non dispensarsi a' fedeli alcuna gratia dal Signor' Iddio, che non passi per le mani della Beatissima Vergine nostra signora"* ["It is the very common opinion of the Holy Fathers, and especially of St. Bernard, that the Lord God dispenses no grace to the faithful that does not pass through the hands of Our Lady, the Most Blessed Virgin."] (*Unica speranza*, 82); compare St. Bernard, "De aquaeductu," Migne, *Patr. lat.*, CLXXXIII, cols. 441, 448.

[34] Panofsky also saw the relationship of the *Sangue di Cristo* composition to the Fons Vitae and the Christ in the Wine Press (see below); "Imago Pietatis," 284. For the relation to the Fons Vitae, see recently M. Wadell, *Fons Pietatis. Eine ikonographische Studie*, Göteborg, 1969, 84f.

[35] The woodcut was first identified with that mentioned in Vasari by Ferrara, *Savonarola*, II, 59ff.

[36] Illustrated in Schiller, *Ikonographie*, II, fig. 812.

Sacrament, again to relate death and salvation, that motivated the extension of the metaphor to a universal deluge.[37]

A final innovation in the engraving is that the Crucifixion forms the central focus of the composition and is shown on a diagonal axis viewed from below, floating in mid-air. The perspective treatment has been related to the diagonally oriented crosses that had become popular in narrative scenes of the Crucifixion, probably on the basis of Northern depictions of the three crosses on Mount Calvary.[38] The device helps to create the impression that the observer is an incidental bystander, hence specifically a witness of the event. But Bernini seems to have been influenced by other, visionary themes. The arrangement, with God the Father above, recalls depictions of the Trinity in which the Crucifixion appears aloft, often in sharp perspective. Though Bernini omits the Dove, a reference to the Trinity is implicit from the text of Maria Maddalena de' Pazzi quoted on the print, in which the sinner's ultimate appeal is to the Trinity. The idea of a monumental cross suspended in foreshortening was familiar from sacramental images illustrating the Exaltation or Triumph of the Cross. An example Bernini certainly knew was the fresco by Cherubino Alberti in the Aldobrandini chapel, dedicated to the Sacrament, in Santa Maria sopra Minerva, where the Cross is borne by angels through a circular opening painted in the vault.[39]

In the case of Alberti's fresco the foreshortening is calculated for the spectator approaching the chapel from the front. The angle of vision in Bernini's engraving bears an uncanny resemblance to that from which *moriens* sees the Crucifixion in the *Ars Moriendi* illustrations.[40] One cannot repress the suspicion that the whole image was

[37] Compare a panel of the early 15th century by Giovanni di Paolo, in which blood from the feet of the Man of Sorrows appears to flow on the ground to a group of the Saved in a scene of the Last Judgment (cf. C. Eisler, "The Golden Christ of Cortona and the Man of Sorrows in Italy," *Art Bulletin*, LI, 1969, 115, 233, fig. 18.

[38] Van Regteren Altena, *Le dessin italien* (cited n. 28 above) refers to Crucifixions by G. B. Castiglione in this connection.

[39] For this fresco, datable 1609–11, see L. Venturi, *Storia dell'arte italiana*, 11 vols., Milan, 1901–07, IX, pt. 5, fig. 539; F. Würtenberger, "Die manieristische Deckenmalerei in Mittelitalien," *Römisches Jahrbuch für Kunstgeschichte*, IV, 1940, 112ff. See also the examples by Pietro da Cortona in the sacristy of the Chiesa Nuova, and by Lanfranco in the Cappella della Pietà in Saint Peter's (G. Briganti, *Pietro da Cortona*, Florence, 1962, 205, No. 50).

[40] A striking parallel illustrated in David de la Vigne, *Spiegel van een salighe Doodt*, with engravings by R. de Hooghe, probably published at Antwerp in 1673 (cf. J. Landwehr, *Romeyn de Hooghe as Book Illustrator*, Amsterdam, 1970, 79). De

conceived to be seen exactly as Bernini saw it, at the foot of his own deathbed. Whereas the artists of the *Ars Moriendi* represented the death scene, Bernini isolated the vision and made the viewer its witness.

Hooghe's imagery is also closely analogous to that of the chapel of St. Anne and the Beata Ludovica Albertoni in San Francesco a Ripa, which Bernini designed at this same period; there the altar painting appears as a devotional picture beside Ludovica's deathbed.

Other scenes of visions of the Crucifixion should be compared as well; e.g., Pietro Liberi, Santi Giovanni e Paolo, Venice, before 1660 (F. Zava Boccazzi, *La basilica dei Santi Giovanni e Paolo in Venezia*, Padua, 1965, fig. 113), Luca Giordano, Santa Maria del Pianto, Naples, 1660–61 (O. Ferrari and G. Scavizzi, *Luca Giordano*, Naples, 1966, fig. 94).

Biographical Data

Gian Lorenzo Bernini was born at Naples on 7 December 1598, the son of Angelica Galante and the Florentine sculptor, Pietro Bernini. In or about 1605, Pietro Bernini removed his family to Rome, where the boy was trained in his father's shop. The papal commissions on which his father was employed brought the young Bernini to the attention of Pope Paul V Borghese (1605–1621) and his nephew, Cardinal Scipione Borghese (d. 1633), whose patronage was to play a major part in the artist's early career. In 1621, before he was twenty-three years old, Bernini was knighted by Gregory XV Ludovisi (1621–1623) and elected president of the Academy of St. Luke. A few years later, the elevation of Cardinal Maffeo Barberini to the Throne of Peter as Urban VIII (1623–1644) marked the beginning of his quasi-official career in the service of the Roman pontiffs and from this time on his works were predominantly religious ones. Supported by the Barberini and bolstered by both official appointments—Master of the Papal Foundry (1623), Architect to St. Peter's (1629) and of the Acqua Vergine (1629), among others—and the direction of large collaborative projects, Bernini had a virtually unassailable hegemony in the artistic life of Rome during Urban's reign. The initial antipathy of the next pope, Innocent X Pamphili (1644–1655), for the Barberini and those identified with them, marks a momentary caesura in the artist's official career; but whatever the real extent of Innocent's hostility, no seventeenth-century pope could easily ignore the artist's genius, and when Bernini replaced Borromini as the designer of the Fountain of the Four Rivers in the Piazza Navona, his earlier position was vindicated. Alexander VII Chigi (1655–1667), who succeeded Innocent, was cut to the measure of the great Sixtus V Peretti (1585–1590) whose projects had transformed the face of Rome, and the considerable talents which Bernini had already shown as the designer and supervisor of huge collaborative ventures were put to good use. At this time the artist made his only extensive journey outside Rome when, in 1665, he went to Paris to prepare designs for Louis XIV's rebuilding of the Louvre. In his later years there are fewer commissions, but, as those executed testify, this seems to have been due to a general decline in Roman patronage,

rather than to a weakening of the artist's creativity. A basic list of the artist's *oeuvre* is provided by the biographies of Domenico Bernini and Filippo Baldinucci. This has been supplemented and organized chronologically by the vast quantity of documents which have been published in the twentieth century; and in 1966 Wittkower published the second edition of his exemplary catalogue of the artist's works. Both Domenico Bernini and Baldinucci emphasize Bernini's amazing precocity. Errors of sequence and context in their accounts, however, have led modern historians to take a more conservative view (Wittkower, 1966 and 1973; D'Onofrio, 1967); but the fundamental veracity of their statements has been impressively defended by Lavin (1968) in a new chronology of the early works. Roman art of the past and present was the major formative influence on Bernini's style. The theme, style, and technique of his earliest known sculpture, the *Goat Amalthea nursing the Infant Zeus* (Rome, Galleria Borghese; Wittkower, ca. 1615; Lavin, 1609) reveal the study of ancient sculpture, and the rigorous handling and vigor of the portrait and religious sculpture of this early period forecast his later achievements in these categories. Among the portraits may be mentioned the commemorative bust of Monsignor Giovanni Santoni (d. 1592) in S. Prassede (Wittkower, ca. 1616; Lavin, 1610), the bust of Antonio Coppola for the Archconfraternity of the Pietà in S. Giovanni dei Fiorentini (payments of 1612) made after a death mask, the bust of Giovanni Vigevano (d. 1630) in S. Maria sopra Minerva (Wittkower, 1617–1618; Lavin, ca. 1620) made from life, and the portrait bust of Pope Paul V Borghese (Rome, Galleria Borghese; Wittkower, ca. 1618). The early religious works include full-length figures of Sts. Lawrence (Florence, Contini-Bonacossi Coll.) and Sebastian (Lugano, Thyssen-Bornemisza Coll.), as well as two busts representing the "blessed" and "damned" soul. Lavin dates the *St. Lawrence* to ca. 1614, the *St. Sebastian* to slightly later; Wittkower dates both to ca. 1617 and the two busts to just before the masterly, lifesize sculptural groups which open the next phase of the artist's career. The first of these was the *Aeneas, Anchises, and Ascanius* of ca. 1619 when a payment for the pedestal is recorded. It was followed by the *Neptune and Triton* (London, Victoria and Albert Museum) commissioned by Cardinal Alessandro Peretti (d. 1623), the *Pluto and Proserpina* (1621–1622), the *David* (1623), and the *Apollo and Daphne* (1622–1625). With the exception of the *Neptune and Triton*, they were executed for Cardinal Borghese and today are again reassembled in the Borghese Gallery. During this period when the influences of hellenistic antiquity and Annibale Carracci are apparent, the artist was also employed in the restoration of ancient sculpture: the *Hermaphrodite* (Paris, Louvre), the *Barberini Faun* (Munich, Glyptothek), and the *Ares Ludovisi* (Rome, Museo delle Terme). Bernini's work for Urban VIII begins with the *St. Bibiana* (1624–1626), the first of the draped religious statues, and the Baldacchino (1624–1633), the first of his many projects for St. Peter's. The work on the crossing of St. Peter's also included the systematization of the piers with their great statues below and reliquary niches above (decision to decorate all four niches in June 1627; upper niches completed in 1641). In addition to

drawings and models, Bernini himself carved the *St. Longinus* (installed by June 1638). Other works which the artist designed, supervised, and executed to a greater or lesser extent for Urban in St. Peter's are the tomb of the pope (begun 1628; major work 1639–1647), the tomb of the Countess Mathilda (1633–1644), and the *Pasce oves meas* relief over the central portal in the portico (1633–1646). Bernini also did many additional works for the Barberini: numerous busts of the pope and his family; memorial inscriptions for Carlo Barberini (1630) and Urban (1634–1636) in S. Maria d'Aracoeli, the Triton Fountain in the Piazza Barberini (finished by August 1643), and the Memorial Statue of Urban in the Conservator's Palace (begun October 1635, unveiled in September 1640). In the splendid portraits of Cardinal Borghese (1632; Rome, Galleria Borghese) and his mistress, Costanza Bonarelli (ca. 1635; Florence, Museo Nazionale), the artist developed a new dynamic and intimate style of portraiture in sculpture. Among others, he also did busts for Charles I, King of England (1632, probably destroyed) and Cardinal Richelieu (1640–1641; Paris, Louvre). In addition, there were designs for tomb monuments and the Raymondi Chapel in S. Pietro in Montorio (datable 1642–1646). According to Domenico Bernini, it was his unjust treatment by Innocent which prompted Bernini to carve the *Truth Unveiled* (ca. 1646–1652; Rome, Galleria Borghese) and his brilliant design for the Fountain of the Four Rivers (design approved July 1648; unveiled June 1651) which reinstated him to papal favor. From 1645 to 1648 he designed and supervised the vast project of decorating the nave piers of St. Peter's. At this time he also did several busts of Innocent and one of Francesco I d'Este (1650–1651; Modena, Museo Estense), as well as designs for a "Noli me tangere" in SS. Domenico e Sisto (ca. 1649–1650) and the tomb of Cardinal Pimentel (d. 1653) in S. Maria sopra Minerva. Commissions for large projects for Alexander followed quickly on his election. The artist's design for the Colonnade before St. Peter's was accepted in July 1656, his first project for the Cathedra Petri in March 1657, and the Scala Regia in the Vatican Palace was built between 1663 and 1666. For the chapels of the pope's family he carved four lifesize marble figures; a *Daniel* and a *Habakkuk* for the Chigi Chapel in S. Maria del Popolo (both in place by November 1661) and a *St. Jerome* and a *Magdalene* for the Cappella del Voto in the Cathedral of Siena, the pope's native city (ca. 1661–1663). The huge equestrian statue of Constantine, begun as early as 1654 for Innocent, but abandoned at his death, was taken up again by 1662 as the focal point for the new Scala Regia (unveiled November 1670). From Bernini's stay in Paris is the bust of Louis XIV (finished October 1665; Versailles), and on his return to Rome he began to work on an equestrian statue of the king (*bozzetto* of ca. 1670 in the Borghese Gallery; completed in 1677). It was during the reign of Alexander that his gifts as an architect were most utilized. In addition to the Colonnade and the Scala Regia, he designed and decorated three churches: S. Tomaso di Villanova in Castelgandolfo (1658–1661), S. Maria dell'Assunzione in Ariccia (1662–1664), and S. Andrea al Quirinale in Rome (1658–1670). From the late years are large projects—the Ponte Sant'Angelo (1667–1671), the tomb of

Alexander VII (1671–1678), and the altar for the Sacrament Chapel in St. Peter's (1673–1674)—as well as more modest commissions—the portrait of Gabriele Fonseca (1668–1675?) in S. Lorenzo in Lucina and the altar statue of the Blessed Ludovica Albertoni (ca. 1671–1674). An indefatigable and energetic worker to the end of his days, Bernini was carving a marble bust of the Salvator Mundi (Norfolk, Va., Chrysler Museum?) when his strong arm finally failed him. He died on 28 November 1680.

Notes on the Editor and Contributors

Domenico Stefano Bernini (1657–1723). Domenico was the last born of the eleven children of Gian Lorenzo Bernini and his wife, Caterina Tezio. A scholar and author, he published several works related to the history of the Church. The best known of these, perhaps, is his *History of all the Heresies* in four volumes.

Gian Andrea Borboni. Nothing is now known about Borboni except what is recorded on the title page of his book, where he is described as a Sienese priest and theologian. His momentary appearance at this time was probably due to Pope Alexander VII's patronage of his countrymen.

Francesco Milizia (1725–1798). Milizia was an architect and one of the foremost Italian critics of the late eighteenth century. His ideas and opinions were published in several widely influential books on the theory and history of art and architecture.

John Moore (1730–1802). Born in Scotland, Moore was trained and practiced as a doctor. His popular travel writings, from which the selection here is drawn, were based on a five-years' stay on the Continent, where he had accompanied the Duke of Hamilton. He also published works on medical subjects and the French Revolution and was the author of two novels.

George Stillman Hillard (1808–1879). Hillard was an American lawyer and man of letters. He was active both politically and as a writer. Of his several memoirs and numerous articles the *Six Months in Italy* is perhaps the most substantial.

Jacob Christoph Burckhardt (1818–1897). Burckhardt was born in Basel. He studied at Berlin under Ranke. In 1844 he returned to his native city as a lecturer in art and history, where he remained, except for a short period, for the rest of his life. Most widely known today for his now classic *Civilization of the Renaissance in Italy*, his *Cicerone* introduced generations of German travelers to Italian art.

Stanislao Fraschetti (1875–1902). Fraschetti was an Italian art historian. In view of the incredible accomplishment which his book on Bernini represents, his premature death was most unfortunate for the study of Italian Baroque art.

Walther Weibel. Born in 1882, Weibel completed his influential Bern dissertation on the influence of the Counter-Reformation on Bernini's sculpture in 1909. It was reprinted in the same year, the first of his several books.

Heinrich Brauer. A former director at the Staatliche Museen in Berlin, Brauer was born in 1899. He completed his dissertation on Bernini's drawings at Leipzig in 1928. The publication of the drawings by Brauer and Wittkower of 1931 is one of the major monuments of modern Bernini scholarship.

Rudolf Wittkower (1901–1971). As both a teacher and scholar in Europe, England, and the United States, Wittkower was one of the most distinguished art historians of his generation. His numerous works on art and architecture have often been fundamental for our understanding of the problems he discussed.

Hans Kauffmann. Born in 1896, Kauffmann is now a Professor Emeritus of Art History. His published works include studies of both Northern and Italian artists. Since the publication of his first articles on Bernini, his original approach to the artist has been highly influential on later scholars.

Irving Lavin. Professor of Art History at the Institute for Advanced Study in Princeton, New Jersey, Lavin's wide-ranging interests have resulted in a many-sided contribution to our knowledge of art history. Among his studies of Renaissance and Baroque sculpture, those devoted to Bernini have been recognized for both their originality and the new light they shed on the artist and his career.

George C. Bauer. Bauer teaches art history at the University of California, Irvine. He was awarded his Ph.D. by Princeton University for a dissertation on Bernini's architecture and decoration.

Selected Bibliography

Askew, P. "The Relationship of Bernini's Architecture to the Architecture of the High Renaissance and of Michelangelo." In *Marsyas*, V (1947–1949), pp. 39–62.

Baglione, Giovanni. *Le vite de' pittori, scultori, architetti.* . . . Rome, 1642.

Baldinucci, Filippo. *Vita del Cavaliere Gio. Lorenzo Bernino.* Florence, 1682. English trans. by Catherine Enggass. University Park and London, 1966.

Barton, E. D. "The Problem of Bernini's Theories of Art." In *Marsyas*, IV (1945–1947), pp. 81–111.

Battaglia, R. *Crocifissi del Bernini in S. Pietro in Vaticano.* Rome, 1942.

———. *La Cattedra berniniana di San Pietro.* Rome, 1943.

Benkard, E. *Giovanni Lorenzo Bernini.* Frankfurt, 1926.

Bernini, Domenico. *Vita del Cavalier Gio. Lorenzo Bernino.* Rome, 1713.

Bertini, Calosso, A. "Il classicismo di Gian Lorenzo Bernini e l'arte francese." In *Arte*, XXIV (1921), pp. 241–56.

Bialostocki, J. *Dwuglos o Berninim (Baldinucci i Chantelou).* Wroclaw-Warszawa-Kraków, 1962.

Blunt, Anthony. "The Palazzo Barberini: the Contributions of Maderno, Bernini, and Pietro da Cortona." In *Journal of the Warburg and Courtauld Institutes*, XXIX (1958), pp. 256–87.

Boehn, M. v. *Lorenzo Bernini, seine Zeit, sein Leben, sein Werk.* 2d ed. Leipzig, 1927.

Brauer, Heinrich, and Wittkower, Rudolf. *Die Zeichnungen des Gianlorenzo Bernini.* Berlin, 1931. Reprint ed. New York, 1970.

Brinckmann, A. E. *Barockskulptur.* Berlin-Neubabelsberg, 1919.

———. *Barock-Bozzetti.* Frankfurt, 1923–1924.

Bruhns, L. "Das Motiv der ewigen Anbetung in der römischen Grabplastik des 16., 17. und 18. Jahrhunderts." In *Römisches Jahrbuch für Kunstgeschichte*, IV (1940), pp. 253–432.

Busiri Vivi, A. "L'Arsenale di Civitavecchia di Gianlorenzo Bernini." In *Palladio*, VI (1956), pp. 127–36.

Chantelou, Paul Fréart, Sieur de. *Journal du voyage du Cav. Bernini en France* [1665]. Ed. L. Lalanne. Paris, 1885.

Cust, L. "Notes on pictures in the Royal Collections. The triple portrait of Charles I by van Dyck, and the bust by Bernini." In *Burlington Magazine*, XIV (1908–1909), pp. 337–40.

Donati, U. "Gli autori degli stucchi in S. Andrea al Quirinale." In *Rivista del R. Istituto di archeologia e storia dell'arte*, VIII (1940), pp. 144–50.

Donati, M. C. "Il Bernini e gli angeli di ponte S. Angelo." In *Commentari*, XVII (1967), pp. 349–52.

D'Onofrio, Cesare. *Le fontane di Roma*. Rome, 1957.

―――, ed. *Gian Lorenzo Bernini. Fontana di Trevi. Commedia inedita.* Rome, 1963.

―――. "Priorità della biografia del Dom. Bernini su quello del Baldinucci." In *Palatino*, X (1966), pp. 201–8.

―――. *Roma vista da Roma*. Rome, 1967.

Dworschak, F. "Der Medailleur Gianlorenzo Bernini." In *Jahrbuch der Preussischen Kunstsammlungen*, LV (1934), pp. 27–41.

Einem, H. von. "Bemerkungen zur Cathedra Petri des Lorenzo Bernini." *Nachrichten der Akademie der Wissenschaften in Göttingen* (I. Philologisch-historische Klasse), 1955, pp. 93–114.

Evers, H. G. *Die Engelsbrücke in Rom*. Berlin, 1948.

Fagiolo dell'Arco, M. and M. *Bernini*. Rome, 1967.

Faldi, Italo. *Galleria Borghese. La scultura dal secolo XVI al XIX.* Rome, 1954.

―――. *La scultura barocca in Italia*. Milan, 1958.

―――. "Il cav. Bernini, il cav. Baglione e il cav. Guidotti Borghese." In *Arte antica e moderna*, No. 13–16 (1961), pp. 297–99.

Fokker, A. T. "The Career of Gian Lorenzo Bernini." In *The Art Quarterly*, III (1940), pp. 245–66.

Fraschetti, Stanislao. *Il Bernini*. Milan, 1900.

Frey, D. "Berninis Entwürfe für die Glockentürme von St. Peter in Rom." In *Jahrbuch der kunsthistorischen Sammlungen in Wien*, XII (1938), pp. 203–33.

Golzio, V. *Documenti artistici sul Seicento nell'archivio Chigi*. Rome, 1939.

Grassi, L. *Bernini pittore*. Rome, 1945.

―――. *Gianlorenzo Bernini*. Rome, 1962.

Gurlitt, C. *Geschichte des Barockstiles in Italien*. Stuttgart, 1887.

Harris, A. S. "New Drawings by Bernini for 'St. Longinus,' and other contemporary Works." In *Master Drawings*, IV (1968), pp. 383–91.

Haskell, Francis. *Patrons and Painters*. Oxford, 1963.

Hibbard, Howard. *Bernini*. Harmondsworth, 1965.

HIBBARD, HOWARD, and JAFFE, IRMA. *"Bernini's Barcaccia."* In *Burlington Magazine*, CVI (1964), pp. 159–70.

HUSE, NORBERT. "La Fontaine des Fleuves du Bernini." In *Revue de l'art*, VII (1970), pp. 7–17.

INCISA DELLA ROCCHETTA, G. "Notizie sulla fabbrica della chiesa collegiata di Ariccia." In *Rivista del R. Istituto di archeologia e storia dell'arte*, I (1929), pp. 349–77.

JUNQUERA, M. L. "Sobre el bronce de Bernini en el Prado." In *Archivo Español de Arte*, XXII (1949), pp. 281–85.

KAUFFMANN, HANS. "Romgedanken in der Kunst Berninis." In *Jahresberichte der Max Planck Gesellschaft*. Göttingen, 1953–1954, pp. 55–80.

———. *Giovanni Lorenzo Bernini. Die figürlichen Kompositionen*. Berlin, 1970.

KITAO, T. K. "Bernini's Church Facades: Method of Design and the *Contapposti*." In *Journal of the Society of Architectural Historians*, XXIV (1965), pp. 263–84.

———. *Circle and Oval in the Square of St. Peter's: Design and Meaning in Bernini's Plan*. New York, 1973.

KRUFT, H.-W., and LARSSON, L. O. "Entwürfe Berninis für die Engelsbrücke in Rom." In *Münchner Jahrbuch der bildenden Kunst*, XVII (1966), pp. 145–60.

———. "Porträtzeichnungen Berninis und seiner Werkstatt." In *Pantheon*, XXVI (1968), pp. 130–35.

KNAB, E. "Über Bernini, Poussin und LeBrun." In *Albertina Studien*, No. 5–6 (1967–1968[1970]), pp. 3–32.

KUHN, R. "Die Entstehung des Bernini'schen Heiligenbildes." Dissertation. Munich, 1966.

———. "Die Unio mystica der Hl. Therese von Avila von Lorenzo Bernini in der Cornarokapelle in Rom." In *Alte und Moderne Kunst*, XII, No. 94 (1967), pp. 2–21.

———. "Gian Lorenzo Bernini und Ignatius von Loyola." In *Argo. Festschrift für Kurt Badt*. Cologne, 1970, pp. 297–323.

LAURAIN-PORTEMER, M. "Mazarin et le Bernini a propos du 'Temps qui découvre la Verité.'" In *Gazette de Beaux-Arts*, LXXIV (1969), pp. 186–200.

LAVIN, IRVING. Review of D'Onofrio, ed., *Fontana di Trevi*. In *The Art Bulletin*, XLVI (1964), pp. 568–72.

———. "Five New Youthful Sculptures by Gian Lorenzo Bernini and a Revised Chronology of his Early Works." In *The Art Bulletin*, L (1968), pp. 223–48.

———. *Bernini and the Crossing of St. Peter's*. New York, 1968.

———. "Bernini's Death." In *The Art Bulletin*, LIV (1972), pp. 158–86.

MÂLE, ÉMILE. *L'art religieux après le Concile de Trente*. Paris, 1932.

MARIANI, V. "Bozzetti Berniniani." In *Bollettino d'Arte*, IX (1929–1930), pp. 59–65.

———. "Bernini regista e scenografo." In *Studi. . .in onore di L. de Gregori*. Rome, 1949, pp. 254–64.

MARTINELLI, V. "Contributi alla scultura del Seicento. IV. Pietro Bernini e figlio." In *Commentari*, IV (1953), pp. 133–54.

———. "Le pitture del Bernini." In *Commentari*, I (1950), pp. 95–104.

———. *I ritratti di pontefici di G. L. Bernini*. Rome, 1956.

———. "Novità berniniane. 3. Le sculture per gli Altieri." In *Commentari*, X (1959), pp. 204–27.

MARTINELLI, V. and PORTOGHESI, P. S.v. "Bernini." In *Encyclopedia of World Art*. New York, 1959–68.

MATZULEVITSCH, G. "Tre bozzetti di G. L. Bernini all'Ermitage di Leningrado." In *Bollettino d'Arte*, XLVIII (1963), pp. 67–74.

MERCATI, A. "Nuove notizie sulla tribuna di Clemente IX a S. Maria Maggiore da lettere del Bernini." In *Roma*, XXII (1944), pp. 18–22.

MESSERER, W. "Zu Berninis Daniel und Habakuk." In *Römische Quartalschrift*, LVII (1962), pp. 292–96.

MILIZIA, FRANCESCO. *Le vite de' più celebri architetti*. Rome, 1768.

MOLINARI, C. "Note in margine all'attività teatrale di G. L. Bernini." In *Critica d'arte*, II (1962), pp. 1–15.

MUÑOZ, A. *Roma barocca*. Milan, 1921.

———. "La scultura barocca a Roma." In *Rassegna d'Arte*, III (1916), pp. 158–68, 208–22; IV (1917), pp. 68–80, 131–47; V (1918), pp. 78–104.

———. "La scultura barocca e l'antico." In *Arte*, XIX (1916), pp. 129–60.

———. *G. L. Bernini architetto e decoratore*. Rome, 1925.

NIÑO, F. "Bernini en Madrid." In *Archivo Español de Arte*, XVIII (1945), pp. 150–61.

NORTON, R. *Bernini and other Studies*. New York, 1914.

PANE, ROBERTO. *Bernini architetto*. Venice, 1953.

PANOFSKY, ERWIN. "Die Scala Regia im Vatikan und die Kunstanschauungen Berninis." In *Jahrbuch der Preussischen Kunstsammlungen*, XL (1919), pp. 241–78.

———. "Mors Vitae Testimonium." In *Studien zur Toskanischen Kunst: Festschrift L. H. Heydenrich*. Munich, 1964, pp. 221–36.

PASCOLI, L. *Vite de' pittori, scultori ed architetti moderni*. Rome, 1730.

PASSERI, G. B. *Vite de' pittori, scultori ed architetti*. Rome, 1772. Ed. by J. Hess, *Die Künstlerbiographien*, Leipzig and Vienna, 1934.

PECCHIAI, P. "Il Bernini furioso." In *Strenna dei romanisti*, X (1949), pp. 181–86.

PERGOLA, PAOLA DELLA. *Galleria Borghese: i dipinti*. Rome, 1959.

PETERSSON, R. T. *The Art of Ecstasy. Teresa, Bernini and Crashaw*. New York, 1970.

PIROTTA, LUIGI. "Gian Lorenzo Bernini principe dell'Accademia di San Luca." In *Strenna dei romanisti,* XXIX (1968), pp. 295–305.

POLLAK, O. *"Die Kunsttätigkeit unter Urban VIII."* Vienna, 1927–1931.

POPE-HENNESSY, JOHN. *Italian High Renaissance and Baroque Sculpture.* London, 1963. 2d ed., 1970.

PORTOGHESI, P. "Gli architetti italiane per il Louvre." In *Quaderni dell' Istituto di storia dell'architettura,* VI–VIII, No. 31–48 (1961), pp. 243–68.

PREVITALI, G. "Il Costantino messo alla berlina o berninia su la porta di S. Pietro." In *Paragone,* XIII, No. 145 (1962), pp. 55–58.

RANKE, W. "Berninis Heilige Teresa." In *Das Kunstwerk zwischen Wissenschaft und Weltanschauung.* Cologne, 1970, pp. 12–25.

REYMOND, M. *Le Bernin.* Paris, 1911.

REIDL, P. A. *Gian Lorenzo Bernini. Apollo und Daphne.* Stuttgart, 1960.

RIEGL, ALOIS. *F. Baldinucci. Vita des Gio. Lorenzo Bernini.* Mit Übersetzung und Kommentar von Alois Riegl. Ed. by A. Burda and O. Pollak. Vienna, 1912.

ROSSACHER, K. "Berninis Reiterstatue des Konstantin an der Scala Regia: Neues zur Werkgeschichte." In *Alte und Moderne Kunst.* XII (1967), pp. 902–11.

SACCHETTI SASSETTI, A. "Gian Lorenzo Bernini a Rieti." In *Archivi d' Italia,* XII (1955), pp. 214–27.

SCHIAVO, A. La donna nelle sculture del Bernini. Milan, 1942.

———. "Il viaggio del Bernini in Francia nei documenti dell'Archivio Segreto Vaticano." In *Bollettino del Centro di Studi per la Storia dell'Architettura,* No. 10 (1956), pp. 23–80.

SCHUDT, L. "Berninis Schaffensweise und Kunstanschauungen nach den Aufzeichnungen des Herrn Von Chantelou." In *Zeitschrift für Kunstgeschichte,* XII (1949), pp. 74–89.

SOBOTKA, G. "Filippo Baldinuccis Vita des Gio. Lorenzo Bernini." In *Repertorium für Kunstwissenschaft,* XXXVI (1913), pp. 107–13.

———. *Die Bildhauerei der Barockzeit.* Herausgegeben von H. Tietze. Vienna, 1927.

TETIUS, H. *Aedes Barberinae.* Rome, 1642.

THOENES, C. "Studien zur Geschichte des Petersplatzes." In *Zeitschrift für Kunstgeschichte,* XXVI (1963), pp. 73–145.

TITI, F. *Studio di pittura, scoltura et architettura nelle chiese di Roma.* Rome, 1674. Ed. of 1686 with title: *Ammaestramento utile e curioso. . . .*

TOTTI, L. *Ritratto di Roma moderna.* Rome, 1638.

VOSS, H. "Über Berninis Jugendentwicklung." In *Monatshefte für Kunstwissenschaft,* III (1910), pp. 383–89.

———. "Berninis Fontänen." In *Jahrbuch der Preussischen Kunstsammlungen,* XXXI (1910), pp. 99–129.

WEIBEL, WALTHER. *Jesuitismus und Barockskulptur in Rome.* Strassburg, 1909.

WEIL, MARK. *The History and Decoration of the Ponte S. Angelo.* University Park, 1974.

WEISBACH, W. *Der Barock als Kunst der Gegenreformation.* Berlin, 1921.

WELCKER, LUISE. "Die Beurteilung Berninis in Deutschland im Wandel der Zeiten." Dissertation. Cologne, 1957.

WILKINSON, CATHERINE. "The Iconography of Bernini's Tomb of Urban VIII." In *L'Arte,* IV (1971), pp. 54–68.

WINNER, M. "Berninis Verità." In *Festschrift für H. Kauffmann. Minuscula Discipulorum.* Berlin, 1968, pp. 393–413.

WITTKOWER, RUDOLF. "Le Bernin et le baroque romain." In *Gazette des Beaux-Arts,* XI (1934), pp. 327–41.

————. "A Counter-project to Bernini's 'Piazza di San Pietro.' " In the *Journal of the Warburg Institute,* III (1939), pp. 88–106.

————. "Il terzo braccio del Bernini in Piazza S. Pietro." In *Bollettino d'arte,* XXXIV (1949), pp. 129–34.

————. *Bernini's Bust of Louis XIV.* London, 1951.

————. *Art and Architecture in Italy 1600–1750.* Harmondsworth, 1958. 3d rev. ed., 1973.

————. *Gian Lorenzo Bernini. The Sculptor of the Roman Baroque.* London, 1955. 2d ed. rev. and enlarged, 1966.

————. "The Vicissitudes of a Dynastic Monument: Bernini's Statue of Louis XIV." In *De Artibus Opuscula XL, Essays in Honor of Erwin Panofsky.* New York, 1961, pp. 497–531.

————. "The Role of Classical Models in Bernini's and Poussin's Preparatory Work." *Studies in Western Art. Acts of the Twentieth International Congress of the History of Art.* Princeton, 1963, pp. 41–50.

List of Illustrations